THE ESSENTIAL
LIGHTING
MANUAL FOR
PHOTOGRAPHERS

A RotoVision Book

Published and distributed by RotoVision SA
Route Suisse 9
CH-1295 Mies
Switzerland

RotoVision SA
Sales and Editorial Office
Sheridan House, 114 Western Road
Hove BN3 1DD, UK

Tel: +44 (0)1273 72 72 68
Fax: +44 (0)1273 72 72 69
www.rotovision.com

10 9 8 7 6 5 4 3 2 1

ISBN: 978-2-940378-46-3

Art Director Luke Herriott
Book designed by Richard Wolfströme

Reprographics in Singapore by
ProVision Pte.
Tel: +65 6334 7720
Fax: +65 6334 7721

Printing and binding in Singapore by
Star Standard Industries (Pte) Ltd.

THE ESSENTIAL
LIGHTING

Roto\

CONTENTS

6 INTRODUCTION

10 UNDERSTANDING LIGHT

30 METERING AND EXPOSURE

46 USEFUL EQUIPMENT

70 NATURAL LIGHT

114 LOW-LIGHT AND NIGHT PHOTOGRAPHY

134 CLOSE-UP AND MACRO LIGHTING

142 THE DAYLIGHT STUDIO

152 ARTIFICIAL LIGHT

178 STUDIO LIGHTING

202 APPENDIX

INTRODUCTION

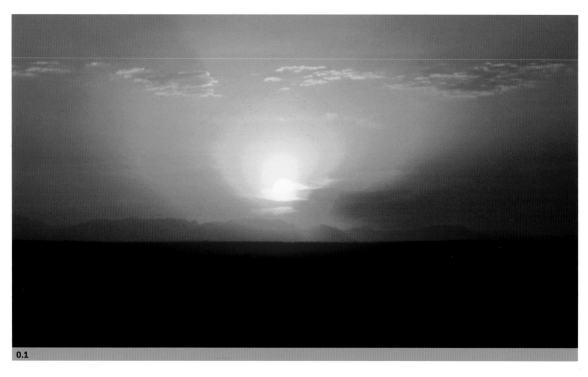

0.1

WHAT YOU SEE IS NOT NECESSARILY WHAT YOU GET

Before you read this book, put it down and try this little exercise.

Look at a scene in front of you and close one eye. It doesn't matter which one. Now, with your open eye, squint and take some time to examine what you're seeing. Notice the lack of information that you have available to you. Can you see how much more difficult it is to distinguish distance from, and separation between, objects? How contrast between light and dark has increased, with detail-less blacks and whites? And how objects that before appeared three-dimensional now appear flat?

Okay, you can open both eyes now. What's the point of this exercise? Well, what you just saw is pretty much exactly what your camera would have seen if pointed at the same scene. You see, the key to great photography is the ability to visualize the image you are trying to create

and to distinguish between how we see light as bi-optic, thinking beings, and how cameras see light as one-eyed, inanimate tools.

In a nutshell, that is what this book is all about—seeing light and learning how to use it effectively.

Light is the photographer's primary tool. Without it there would be no photographs. Yet it is amazing to me how many would-be photographers take light for granted, or imagine that there is only one way to light a subject. Here's an example. I was taking photographs of Alnwick Castle in Northumberland, England, and had been for the best part of a week. One morning a young man arrived, set up his tripod and, within a few minutes, had fired some shots and packed away his gear. Just before he set off, he said, "Well, that's the castle done." I simply nodded, dumbfounded, and turned back to my own camera.

My point is this: I took several photographs of Alnwick Castle that week, and not one is the same. In each, the light is different, lending every picture a unique mood and a different story. Each one says, "This is what Alnwick Castle looked like on this day, at this time, and under these conditions." This is the wonder of photography.

How we illustrate these moments is through our interpretation and manipulation of light. Light gives photographs character. It transforms them from two-dimensional images on paper to three-dimensional embodiments—not only of the scene before you—but your personal interpretation of it, molded by your experiences, emotions, and desires. Without an ability to control light you can't stamp your photographs with your own imprint, and they will rarely live up to your expectations.

So, learning how to use light to its maximum potential is a fundamental requirement if you are to get beyond the confines of technical mediocrity, and set yourself apart from the photographic also-rans. The fact that you have gotten this far is enough to tell me that you want your pictures to say something different. In essence, you want your photographs to have that something special that might be called the "wow" factor.

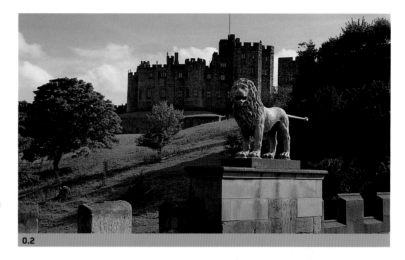

0.2

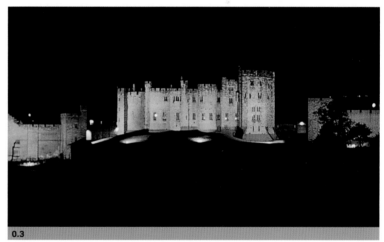

0.3

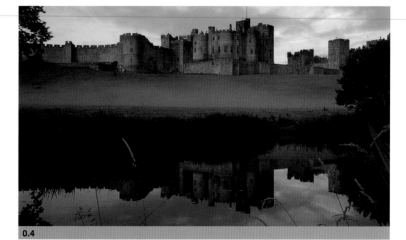

0.4

0.1 *African sunset, Kruger National Park, South Africa.*

0.2—0.4 *These images of Alnwick Castle were all taken on the same day. Notice how the changing light, as well as perspective, gives each a completely different visual presence from the other.*

Let me give you a feel for what to expect from the rest of this book. On a recent photographic workshop, I was explaining the intricacies of calculating exposure. It took just ten minutes. At the end of the workshop, one of the delegates came up to me and said, "Thanks for a great day and thank you for the most informative and simple-to-apply explanation of exposure I've ever heard. If only people would write books that way."

Well, the comment pleased me so much I decided to do just that. And, while not solely about exposure, this book is written, I hope, to counter and clarify the overly technical approaches on lighting for photography that do nothing to demystify the subject. I am not predisposed to complicated, scientific tomes. I want a manual to give me information I can follow easily and readily apply in the field or studio.

In these pages, you will find straightforward explanations of the nature of light and lighting, uncomplicated guidance on lighting techniques throughout the day, the seasons of the year, and other conditions, well-informed examples of how to handle complex lighting situations, and clear supporting diagrams of studio set-ups. But, throughout, by keeping things simple, and as jargon-free as possible (without losing the complexity), I don't stray too far away from the main point, the reason we are photographers: because we enjoy it!

As your ability to understand and manipulate photography's basic ingredient—light—develops, always remind yourself of the sheer joy that is the art of photography, and that will see you through. I have enjoyed writing this book, and hope that my own love of photography, and of light, shines through, and helps you to remember why you want to know more.

0.5 *Light gives your pictures character and can turn what would be an ordinary portrait shot into a photograph full of emotion.*

0.5

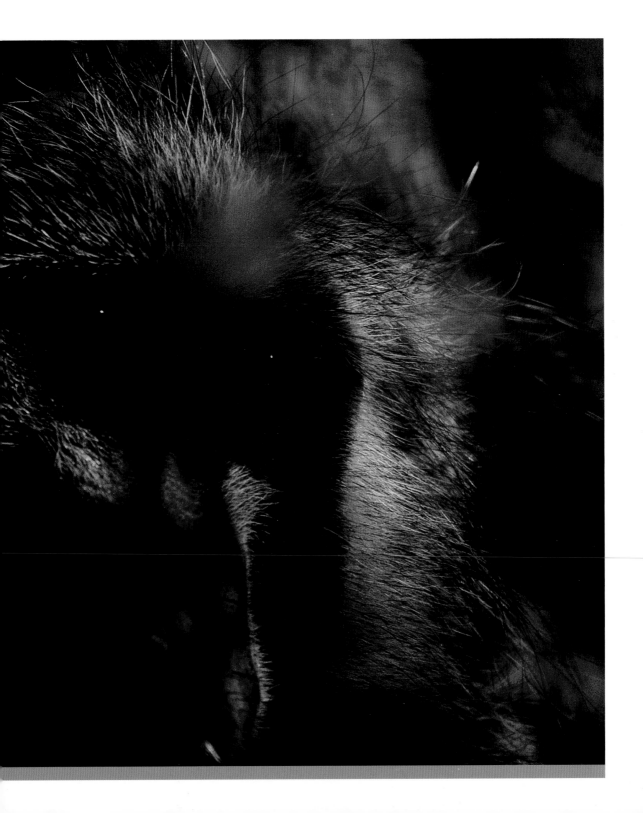

UNDERSTANDING LIGHT

12 How light works
 The color of light
 Colors by addition
 Colors by subtraction
 Color temperature
 White balance

14 Reflected light
 Transparency
 Absorption

16 Reflectance
 Scattering
 Refraction

18 Multiple-surface reflectance
 Intensity of light

20 Size of light source

22 Diffusion

24 Contrast
 High dynamic range
 (HDR) imaging

26 Direction of light
 Frontal lighting
 Overhead- and side-lighting
 Backlighting

28 The key points
 Common errors to avoid

When you woke up this morning and went about your daily routine you saw things. In fact, you saw any number of things until you shut your eyes to go to sleep. And everything you saw was entirely dependent on one thing: light.

Light is all your eyes ever see. Whether you are admiring the landscape or works of art, watching children play, or marveling at the beauty of comets and shooting stars, what you are actually seeing is reflected light.

Of course, exactly the same can be said of the camera. In its simplest form, when you open the eye—the lens aperture—of the camera, an image is formed and recorded on light-sensitive material. The camera has no concept of the subject's form or being, it simply records the different waves of light that pass through the lens.

So, what we see and what the camera records is light, and understanding how light works is the basis for mastering the photographic art.

HOW LIGHT WORKS

This section is a tiny bit technical, but bear with me because it is essential to understanding the photographic process, enabling you to capture compelling images.

For simplicity, I refer to light in terms of waves, since this gives the best explanation for the many ways in which we observe light. In relation to photography, there are two important things to consider. Firstly, waves come in many different sizes and we can see only a very small fraction of wavelengths—known as "visible light" (see 1.1). Secondly, light waves also come in many frequencies, and it is these frequencies that, in visible light, give us color.

The color of light

Six principal colors, or lights of different frequencies, are visible to the naked eye: red, orange, yellow, green, blue, and violet. Mixing some of these colors produces many more colors—or frequencies— and combining all the colors in the visible spectrum will produce white, colorless light.

Colors by addition

One way of making colors is by adding two or more together. For example, let's take red, green, and blue. Mixing equal parts of red and blue will give you magenta. The same combination of blue and green will produce cyan, and green and red will produce yellow. An equal mix of all three will take us back to white (see 1.2). By adding various combinations of red, green, and blue light, all the colors of the visible spectrum can be produced, and this is how the color filter arrays in most digital cameras work.

Colors by subtraction

Color is also made another way, by absorbing some of the light frequencies, removing them from the combination. This is how paint and color dye is produced, and it can be witnessed in nature. For example, the leaves of green plants contain a pigment called chlorophyll which *absorbs* blue and red from the light spectrum while *reflecting* green— hence the apparent color of green leaves.

Now, think back to the days of the color darkroom, or take a look at the inks in your color printer. A color enlarger has three color dials: yellow, magenta, and cyan (which, by the way, match the principal inks used in basic color printing). Mixing an equal portion of yellow and cyan will produce green; cyan and magenta will produce blue, and magenta and yellow will produce red. Where all three are mixed equally, all light frequencies are absorbed and you get black (see 1.3).

This method of color by subtraction is also how color correction filters work in combination with photographic film and photo sensors.

Color temperature

Imagine heating a piece of metal in a furnace. As well as getting hotter, something else happens—it changes color. First it turns red, then orange, yellow, and finally, blue/white. As the metal cools down, its color reverts back.

The exact same thing happens to the color of natural light as the sun rises throughout the day. At sunrise light is red, turning orange in early morning, yellow in mid to late morning, and blue/white at midday. As the sun sets, light's color reverts back to yellow in early afternoon, orange in late afternoon, and red at sunset. These changes are caused by the color temperature of light, which is measured in degrees on a scale known as the Kelvin (K) scale (see Kelvin Scale table, page 13).

Different sources of light also have different color temperatures that cause the light to give off a color cast. However, humans don't see the color cast of light (either natural or artificial) at different temperatures because our brains have a built-in white balance control that effectively

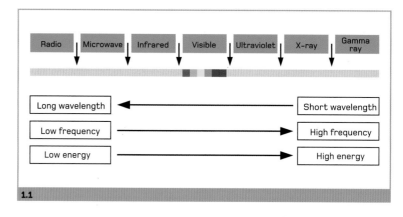

1.1

1.1 *Human beings are able to see only "visible" light waves. Film and digital photo sensors, on the other hand, can be sensitive to other elements of the electro-magnetic spectrum, such as ultraviolet light.*

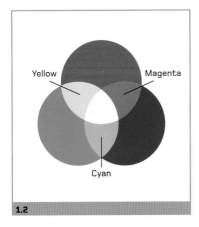

1.2

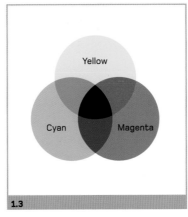

1.3

1.2 It is possible to produce millions of colors by adding combinations of red, green, and blue. This is how color filter arrays in digital cameras create color.

1.3 Alternatively, color can be made by subtraction, which is how photographic enlargers and computer printers work.

enables us to see all light, whatever its source, as neutral white light. When you look at the light from a fluorescent strip it appears to be white, but is actually green. Light from a household light bulb similarly appears white, but isn't. Have you ever photographed indoors, using room lighting, on film balanced for daylight? If so, you'll know that the resulting image has a strong orange cast—that's because tungsten light is orange/red.

In their native states, film and digital sensors record light as it actually appears, complete with a color cast. Sometimes it's appropriate to nullify this color cast, which is done either with filters (in the case of film) or using the white balance control on a digital camera (although optical filters can still be used with digital).

White balance

When photographing with film, white balance is managed using optical filters. For example, you might apply an orange filter to remove the blue color cast of midday sunlight, and a blue filter to remove the orange/red color cast of tungsten light. The aim is to match the filter to the prevailing color temperature in order to achieve a neutral white light that matches the light we see with the naked eye.

With digital cameras, the same result can be achieved without using optical filters by setting an appropriate white balance value. This can be done by either matching the preset WB settings to the conditions (see Digital White Balance Settings table, page 15) or by setting a specific K value. For example, to remove the orange/red color cast caused by tungsten light, set the WB preset value to the tungsten icon. This will have the same effect as using a blue optical filter. In the auto WB setting the camera will always try and return a cast-free result, where the color of light appears as we see it—neutral white.

KELVIN SCALE	
Candlelight	1,500K
Incandescent lamp (40W)	2,680K
Incandescent lamp (200W)	3,000K
Sunrise/sunset	3,200K
Tungsten lamp	3,400K
1-hour before dawn/dusk	3,400K
Fluorescent light	3,800 – 4,200K
Xenon lamp/ light arc	4,500 – 5,000K
Clear daylight (midday)	5,500K
Electronic flash	5,500 – 5,600K
Overcast daylight	6,500 – 7,500K
Deep shade	7,500 – 8,000K
Blue sky	9,000 – 12,000K

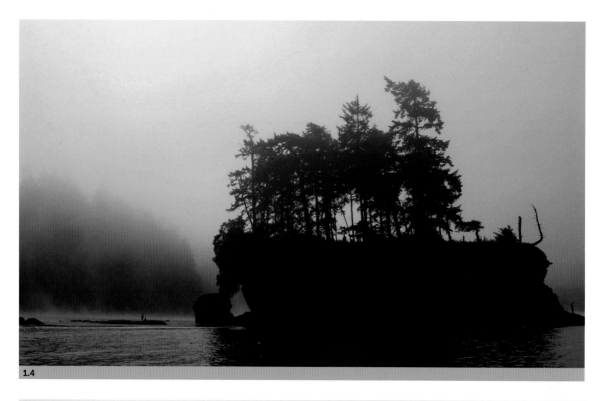

1.4

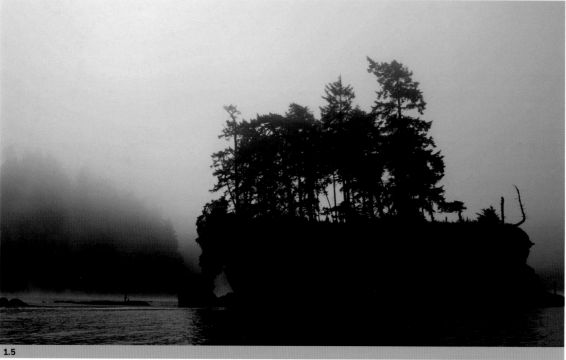

1.5

Reflected light

I have explained that what the camera records through the lens, is reflected light. Well, here's another science bit. Light is a form of energy made up of "photons", which are produced by energizing "electrons" orbiting the nucleus of an atom. When light falls on an object, its reaction depends on a number of things, including the energy of the light wave, the frequency at which electrons vibrate in the subject material, and the strength with which the atoms in the subject material hold on to their electrons. Based on these factors, when light falls on an object it will respond in one of the following ways: through transparency, absorption, reflectance, scattering, refraction, and multiple-surface reflectance.

Transparency

When the energy of the light is far greater or far lower than the frequency needed to make the subject material vibrate, then the light will pass straight through, and the object is considered transparent (see 1.6), which is what happens with glass objects.

Absorption

When the frequency of the incoming light is similar to that of the vibration frequency of the subject material, then light is absorbed. The absorption of light makes an object dark or opaque to the frequency of the light wave. This is what happens with wood, which is opaque to visible light, and glass, which is opaque to ultraviolet light (although transparent to visible light) (see 1.7).

DIGITAL WHITE BALANCE SETTINGS		
Preset setting	Standard K value	Manually selectable range
Daylight	5,200K	4,800 – 5,600K
Cloudy	6,000K	5,400 – 6,600K
Shade	8,000K	6,700 – 9,200K
Tungsten (Incandescent)	3,000K	2,700 – 3,300K
Fluorescent	4,200K	2,700 – 7,200K
Flash	5,400K	4,800 – 6,000K

1.6

1.7

1.4 & 1.5 *The color of light affects our emotional response to a picture. Compare these two images. How much warmer does the picture above feel compared to the picture below?*

1.6 *Transparency.*

1.7 *Absorption.*

Reflectance

Where a subject material consists of atoms that hold on to their electrons loosely, light waves end up being reflected by the surface. This is the case with most metals, which appear shiny to the eye. In this instance, the incoming light waves are reflected at the same angle and frequency. In physics, this is referred to as the "Law of Reflectance". A perfect example of this is a mirror. If you look in a mirror, you will see that the colors of your clothes are exactly the same in the reflection as they are in real life.

Scattering

Reflectance is the result of light waves bouncing off a smooth surface. When the surface is rough, however, then you get scattering, with the light waves reflecting in an indiscriminate pattern. The earth's atmosphere is a good example of a rough surface, being made up of molecules of different sizes, such as oxygen, water vapor, and pollutants. The different molecules scatter the light waves we see as blue (high energy), which is why the sky appears blue.

1.8 *Reflectance.*

1.9 *Scattering.*

1.10 *Light scattering from the rough surface of the earth's atmosphere causes the sky to appear blue.*

1.8

1.9

1.10

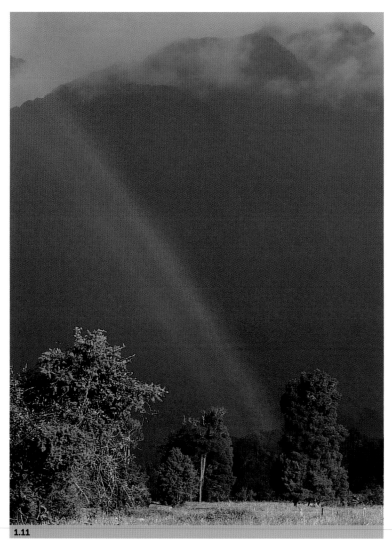

1.11

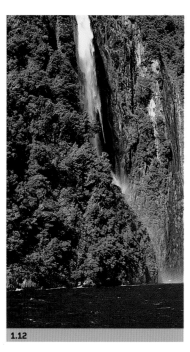

1.12

Refraction

When the natural vibration frequency of the subject material matches that of the light wave, then refraction occurs. Without getting into the technicalities, what this means is that the light bends inside the object. Refraction can be very clearly seen in objects such as diamonds and crystals. Refraction is also responsible for the order of colors in a rainbow. This is because light of different frequencies bends at slightly different angles (see 1.13).

1.11 & 1.12 *Refraction. Bending light is responsible for the order of colors in a rainbow.*

1.13 *Refraction.*

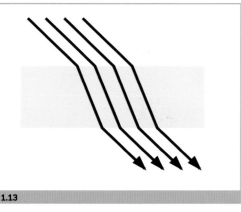

1.13

Multiple-surface reflectance

Have you ever noticed the rainbow colors in soap bubbles, or the rainbow patterns on oil spills on a wet road? This is caused by light waves passing through an object with two reflective surfaces. Take the oil spill as an example. The oil reflects parts of the light waves, while others penetrate the oil and are reflected by the road surface. This forces them out of sync and they interfere with each other, leading to the formation of a new color, or frequency.

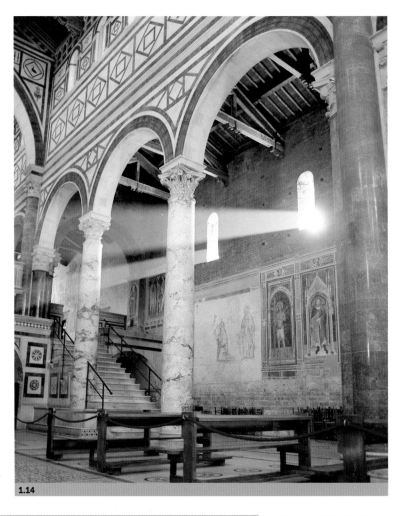

1.14

1.14 *On a cloudy day, the sun acts as a diffused light source. However, when entering through a small window, such as the one seen in this church, the window turns the soft diffused light into a point source.*

1.15 *Multiple-surface reflectance.*

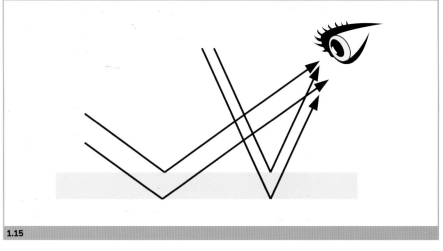

1.15

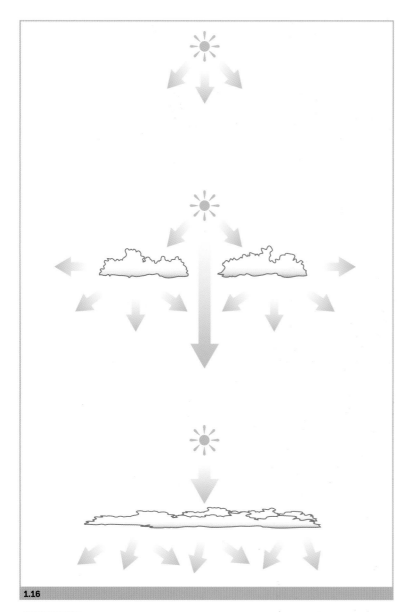

1.16

INTENSITY OF LIGHT

The intensity of light depends on two criteria: the distance between the light source and the subject, and the size of the light source.

The closer the light source is to the subject, the greater the intensity of light and illumination. Moving the light source closer or farther away from the subject alters the level of light falling on the subject. For example, if you halve the distance between your subject and a point light source, such as a small flash unit, you will increase by four times the amount of light reaching the subject (this is referred to as the "inverse square law"). Halving the distance between the light source and the subject quadruples the illumination, and doubling it reduces illumination to one quarter. In photographic practice, this allows you greater control over exposure settings since more light gives you greater choice of lens aperture/ shutter speed combinations.

A practical result of the inverse square law is exposing multiple subjects at varying distances from a point light source. For example, if one subject is twice as far away from the light source as a second subject, then it will receive only a quarter of the illumination, and will require an exposure four times as long. Depending on your photographic material, this may not be possible. One solution is to move the light source *much* farther away, so that the ratio of nearest-to-farthest distance is reduced.

By way of example, when photographing outdoors in direct sunlight the inverse square law no longer applies, because the distance between the sun and different points of the earth—the summit and base of a mountain, for example—is so great that, to all intents and purposes, all surfaces will receive the same intensity of light, and variations will only be caused by atmospheric conditions.

TIP

When using natural light indoors with the sun entering through a doorway or window, the opening will act as a compact point light source and light intensity will alter with distance.

1.16 *Light from a point source illuminates your subject at four times the brightness with every halving of the distance between the light and the subject. Inversely, every doubling of the light-to-subject distance will reduce illumination by one quarter. This is known as the "inverse square law".*

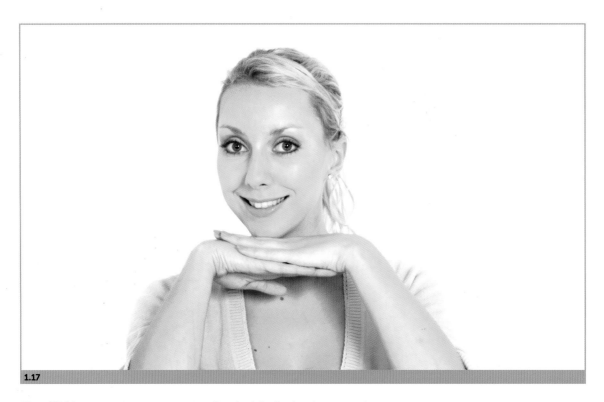

1.17

Size of light source

Another solution is to alter the size of the light source. The size of your light source is governed by two things: the physical size, and its distance from the subject being photographed. Distance is important. Take the sun, for example. The sun is a massive light source but, being so far away from the earth, it acts like a small point light source. However, add some cloud cover and the effect is much like adding a soft box to a flash unit, turning the point source into a larger source of light.

The size of the light source will determine the effect created. Small light sources are referred to as "hard" because they produce hard-edged shadows and high contrast. Large light sources are considered "soft" because shadows are poorly defined and levels of contrast are reduced.

Now, back to the inverse square law: because light travels in straight lines, the fall-off of light is most pronounced when photographing using a point light source, such as a flash unit. Diffusing a point light source using a soft box, for example, creates a more even spread of light across a wider area.

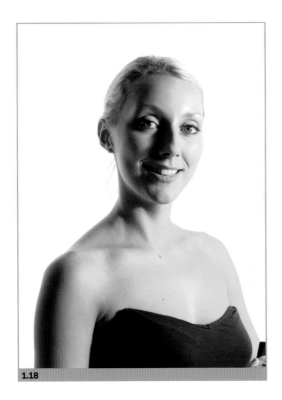

1.18

1.17—1.19 *Light from a point source tends to create a higher level of contrast than that from a diffused light source. Compare these two images. The first (1.17) was taken with a diffused light source, and the second (1.18) was taken with a point light source, such as the small unit below (1.19). Notice how the shadows appear soft in the first image and well-defined in the second image.*

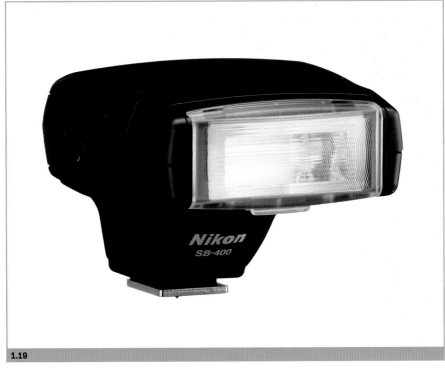

1.19

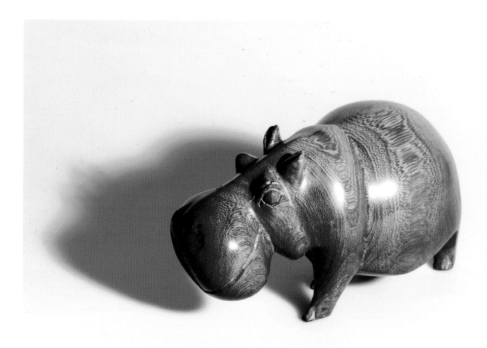

1.20

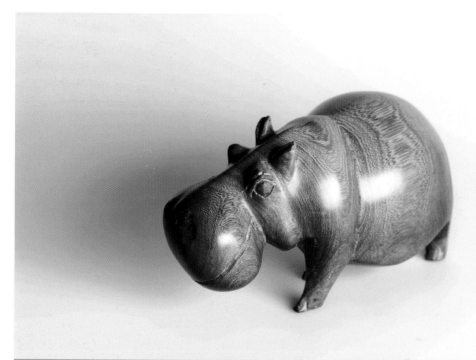

1.21

DIFFUSION

Diffusing light has two main purposes. I have discussed the first purpose by explaining how a diffused light source provides more even illumination over a wider surface area. The second reason you may want to diffuse light is to soften shadow areas in a picture. For example, when light comes from a single point and reaches a subject, the shut-off of illumination is sudden and pronounced. However, when light is diffused, the direct light scatters into many more light points emanating in all directions from the area of diffusion. Some of this extra light will fall around the subject, rather than directly onto it, and areas previously in full shadow will receive at least some illumination.

In outdoor photography, this is where atmospheric conditions come into play. A prime example of a diffused light source is sunlight on a cloudy day. The sun acts as a point light source but as soon as that light hits the clouds it scatters in very many new straight lines of light. The same is achieved with artificial light by bouncing the flash light off a large wall or umbrella, or by using a sheet of opaque material such as a soft box directly in front of the light source.

TIP

How light affects the type of shadows created is sometimes referred to as the "quality" of light. Hard light, i.e. that coming from a direct, compact light source, causes sharp-edged, dark shadows. Soft light, such as sunlight on an overcast day, produces soft, graduated shadows.

1.20 & 1.21 *The strength of the shadow is determined by the size of the light source. A point (small) light source will produce dark, well-defined shadows, such as that seen in 1.20, while a diffused (large) light source will give light shadows with softer edges, as shown in 1.21.*

1.22 *Even on an overcast day, a small window can turn a large point source into a direct point source.*

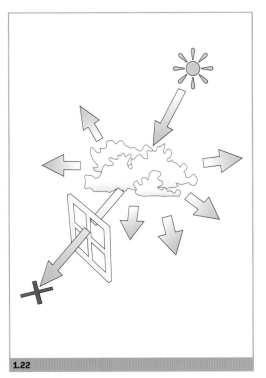

1.22

NOTE

A diffused light source can be turned back into a point light source by blocking much of the light and allowing just a small amount to pass through onto the subject. For instance, in an earlier example I explained how, when photographing indoors under natural light, a window or doorway would act as a point light source. This would be true in overcast conditions where the solid walls surrounding the opening would block a large amount of the light present from reaching the subject.

CONTRAST

Another condition affected by the type of lighting used is contrast. Contrast refers to the difference in brightness between the shadow areas and highlight areas of your subject. When we look at a scene or subject, our eyes automatically compensate for different levels of brightness and we can see detail with a high degree of latitude. Photosensitive material, however, is far less clever and has only a narrow latitude. For example, positive (transparency) film has latitude of about five stops, negative film about seven stops, and digital photo sensors (where latitude is referred to as dynamic range) between five and nine stops.

So, if you were photographing a scene using positive film, where the shadow areas were six stops darker than the highlight areas, it would be impossible, without additional fill-in lighting, to record detail in both highlight and shadow.

Contrast is greatest when using direct lighting from the side or directly above the subject. You can see, then, that photographing a landscape on a bright, sunny day at around noon will give an image with a lot of contrast. This is one of the reasons that landscape photographers prefer not to shoot at midday.

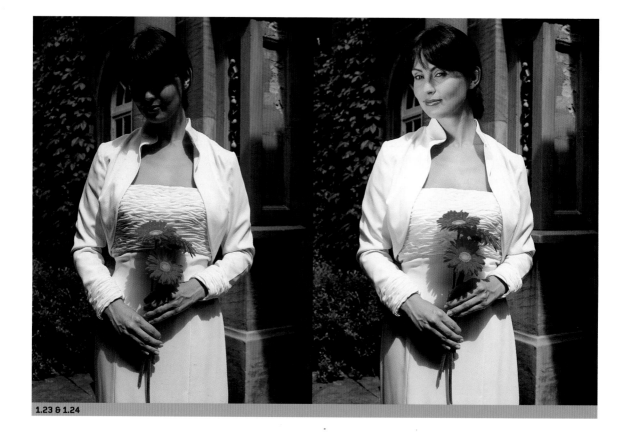

1.23 & 1.24

HIGH DYNAMIC RANGE (HDR) IMAGING

Scene contrast (dynamic range) often exceeds the camera's ability to record detail in shadow and highlight areas simultaneously (camera dynamic range). When this is the case, optical filters, such as graduated neutral density filters, may be the solution, particularly if contrast falls in a linear plane.

Another solution is to create a HDR image. HDR imaging is relatively new to still photography, but has been used in the graphics industry for many years. The underlying theory of HDR imaging is that, when it is impossible to capture full scene dynamic range within a single image, it can be captured in its entirety by exposing multiple, identical images at bracketed exposures, above and below a median exposure.

By combining the multiple images into a single HDR image using software such as Photoshop or Photomatix Pro, a low dynamic range (8-bit or 16-bit) image can be created to reveal details in areas of shadow and highlight, even when contrast is excessive.

HDR imaging represents the next stage in digital photography development, and it will be interesting to see how future digital cameras cope with dynamic range in relation to how the naked eye copes with contrast.

NOTE

The term dynamic range has become synonymous with digital photography, referring to the ability of the sensor to record detail in highlight and shadow areas simultaneously. Dynamic range is also used to describe scene contrast (the variance between the brightest and darkest areas in a scene) and human vision (our ability to resolve detail in areas of highlight and shadow simultaneously).

1.23 & 1.24 *Using additional fill-in lighting, or a reflector, is a very effective way to lighten dark shadow areas, revealing detail and enhancing your picture.*

1.25 & 1.26 *Compare these images. The first, taken of a puffin on a cloudless day, has created a level of contrast too broad for the film to cope with, and the white feathers have washed out. The shot of the penguins, however, was taken on an overcast day. The diffused lighting has reduced the level of contrast to within the film's latitude, which means that the detail remains in both black and white feathers.*

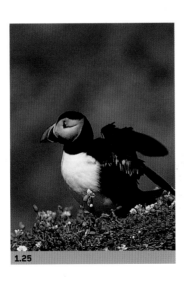

1.25

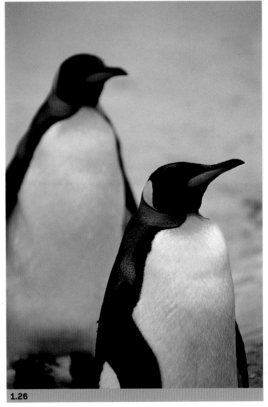

1.26

1.27

1.27 *The direction of your light source plays an important part in the rendering of texture and detail in your final image.*

DIRECTION OF LIGHT

The direction of the light source relative to your subject will also play a key part in how that subject is rendered in the final image. A light's direction will dictate, for instance, how surface detail appears: flat or textured, and how and where shadows fall, which will determine the sense of depth in your picture. You can also exploit the direction of light for artistic effect, creating silhouettes or beautiful golden "halos" that punctuate subject features and provide a frame of emphasis.

Typically, the direction of the light source will be either from the front, back, side, or above, and I explain how each affects the composition of your image, opposite. There are occasions when you may use lighting from below, usually in commercial fields where shadow-free images are required.

1.28 Front lighting.

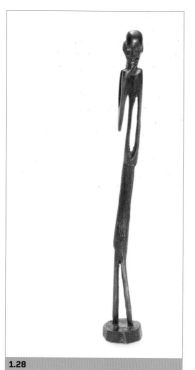

1.28

1.29 Side lighting.

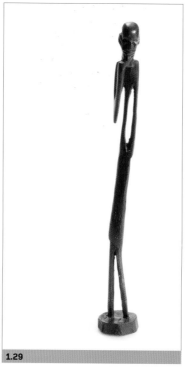

1.29

1.30 Backlighting.

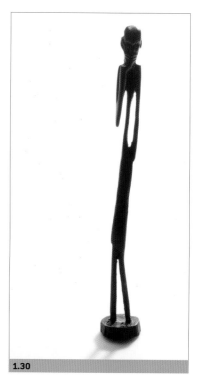

1.30

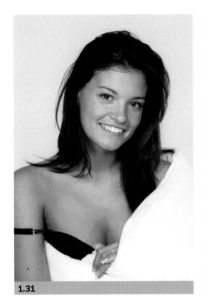

1.31 *The use of frontal lighting for this portrait gives it a much flatter appearance.*

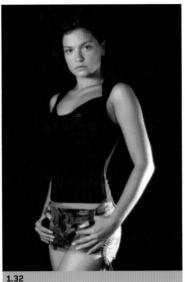

1.32 *The addition of side lighting on this portrait brings form to the image, accentuating the curves of the model's body.*

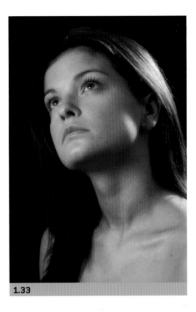

1.33 *The addition of a backlight has added highlights that create contrast and produce a more interesting portrait.*

Frontal lighting

You may have been given the age-old advice to always shoot with the sun behind you. This was based on the limitations of "point and shoot" cameras and was universally ignored by most experienced photographers because, while it ensured the greatest level of illumination (or intensity), thereby giving an accurate rendition of surface features, it also created flat, dull pictures. Frontal lighting generally eradicates shadow from a photograph, and shadows help to give an image depth. The lack of contrast from frontal lighting also flattens surface detail and is of no use when you are trying to emphasize texture in a photograph. If, however, you are simply trying to record features in a scene, then front lighting will provide you with adequate lighting conditions.

Overhead- and side-lighting

A good method for emphasizing texture or form is to use overhead- or side-lighting. Lighting coming from above or to the side of the subject creates shadow areas that punctuate, for example, the undulations in the bark of a tree, or distinguish between the sides of a three-dimensional object, such as a building.

Backlighting

Backlighting can be used to exploit the differences in reflectivity. For example, water, when backlit, appears wet and liquid, as you would expect. However, when lit by overhead- or side-lighting, it appears more solid. Creatively, backlighting can be used to produce the "golden halo" effect often seen in portraits. One thing to be aware of when using backlighting is the possibility of lens flare caused by light falling directly onto the lens. A lens hood will help to reduce these effects.

NOTE

THE KEY POINTS

The temperature of light affects the color balance in your photographs and can be controlled to some degree by optical filters, your choice of film or, with digital cameras, the White Balance setting.

The surface of the subject material determines how the light falling on it is reflected. Recognizing the reflective properties of your subject will help you visualize how it will appear in the final image.

Using artificial light, the bigger and closer the subject is to the light source, the greater the intensity of light, and the more flexibility you have in setting lens aperture and shutter speed. However, under natural light conditions, the intensity of light is only affected by atmospheric conditions.

Direct light (natural or artificial) creates hard-edged shadows and increases the level of contrast in a scene. Diffused light, on the other hand, lowers levels of contrast and produces soft-edged shadows.

Film and digital photo sensors can only record detail across narrow latitude dynamic range between featureless black and white. Therefore, in high-contrast scenes, you must either compensate for the shadows using fill-flash or reflectors, compensate for the highlights using neutral density filters, or choose between recording detail in the shadow areas or in the highlight areas.

Frontal lighting is the best option when an accurate rendition of surface features is required. To emphasize texture and form, overhead or side-lighting is a better option.

NOTE

COMMON ERRORS TO AVOID

Avoid conflicting shadows. Only one set of shadows should be visible and they should point in the same direction. Where it is impossible to avoid conflicting shadows, use the techniques described in this section to soften the edges of shadows.

When photographing portraits, try to light the background separately from the subject. This will avoid shadows on the backdrop that will detract from your composition.

Where shadows occur, include them in your composition. A large black area apparently disengaged from the subject will overpower the scene and detract from the overall picture design.

When using backlighting, use a lens hood to help minimize the effects of lens flare.

1.34

1.34 *When photographing portraits, light the background separately to avoid casting shadow on your subject that will detract from the composition.*

METERING AND EXPOSURE

32 How light is measured
 Types of light meter
 Incident light meters
 Reflected light meters

34 Multi-segment metering
 Center-weighted metering
 Spot metering
 Partial metering

36 How a light meter works

40 Applying exposure
 compensation
 The "sunny f/16" rule
 The "sunny f/22" rule
 ISO

42 Applying exposure settings
 Lens aperture
 Shutter speed

44 Bracketing
 Digital exposure
 The histogram
 Flash meters

Having got to grips with the physics of light, this chapter looks at the relationship between light and the camera. We know that when reflected light falls on light-sensitive material an image will form on it.

Unfortunately, photography is a little more complicated than that—the next step is determining exactly how much light you need to allow to fall on the film or photo sensor, and for how long.

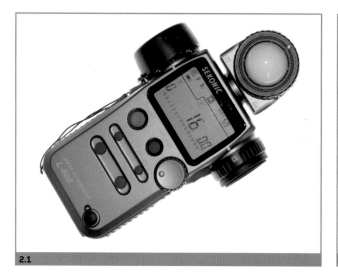

2.1

2.2

HOW LIGHT IS MEASURED

Light can be measured in one of two ways: by assessing the brightness of the scene (reflected light), or the amount of light falling on the scene (incident light). The light meter then calculates an exposure value, which in turn can be translated (either by the meter or by you) into a combination of lens aperture and shutter speed. The light reading will always be given in relation to the film speed or ISO equivalency you've set.

The basics are simple enough, but in practice there are some influencing factors that need to be taken into account if you are to calculate an accurate reading. The best place to start is by gaining an understanding of the different types of light meter and how each works.

There are two types of natural light meter: an incident light meter and a reflected light meter. A third type of light meter, a flash meter, used to calculate electronic flash exposure values, is often used in studio photography (see page 45).

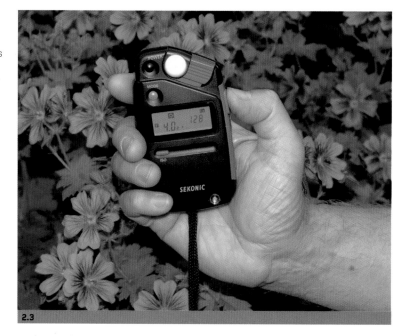

2.3

2.1 *Some hand-held meters double as both an incident meter and a spot meter, such as this model produced by Sekonic.*

2.2 *An incident light meter measures the quantity of light falling on a subject.*

2.3 *Incident meters are at their most effective when placed close to the subject.*

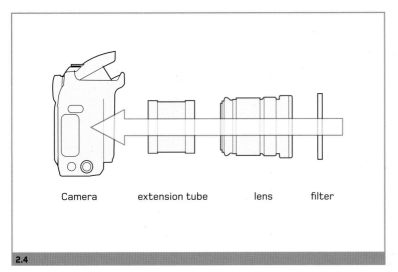

2.4 *Built into the camera, a TTL meter measures the amount of light entering the lens. Because it takes into account any attachments, such as filters, extenders and extension tubes, it is one of the most accurate forms of meter.*

Camera extension tube lens filter

2.4

TYPES OF LIGHT METER

Incident light meters
Incident light meters measure the amount of light falling on a subject. A white diffuser first averages the light and a cell beneath the diffuser reads this averaged light. For accurate results, the meter should be placed near to the subject in the same light and pointed toward the camera. The angle at which the meter is held can be critical and should always be pointed directly toward the lens along the same axis. When used in landscape photography, it is often impossible to place the meter close to the subject, which may be some miles off. An alternative method is to hold the meter above your head, facing away from the camera.

The advantage of an incident light meter is that it isn't influenced by highlight and shadow areas in a scene, as a reflected light meter is. On the other hand, because of this, neither can it produce selective exposure information, which proves to be this meter's main downfall, as it removes a layer of creative control.

Reflected light meters
Reflected light meters work in a different way, by assessing the level of light reflected from the subject. Often they are built into the camera and readings are given in the viewfinder. Most modern SLR (single-lens reflex) cameras come with a "through-the-lens" (TTL) meter that measures the amount of light actually entering the lens for greater accuracy.

Reflected light meters are generally more practical than incident light meters because, since they are measuring light reflecting from a subject, there is no need to be in the subject's direct vicinity. With TTL meters, the meter will automatically take into account any light-limiting accessories in use, such as filters or high-magnification lenses.

However, because the reflected light meter will be influenced by both highlights and shadows, as well as mid-toned subjects and everything in between, exposure calculations are often more complex.

In modern cameras, TTL meters provide systems to help overcome this limitation. In the past, basic reflected light meters simply gave a meter reading based on an average of the entire scene. As technology has developed, however, more sophisticated systems have been developed.

2.5

2.6

2.5 & 2.6 *Incident light meters should be pointed directly toward the lens at the same axis for an accurate reading, whereas the reflected light meter can be used at any angle in relation to the lens.*

2.7

Multi-segment metering

Multi-segment metering (MSM) is a metering system that can be highly accurate, even in the most complex lighting situations. An MSM system takes several independent readings from different areas of the frame and calculates a meter reading based on the findings. In some camera systems, these findings are first compared to a database of "real-life" findings to detect the closest match.

Although MSM has a significant level of sophistication, it works best when metering a scene with a tonal range within the latitude of the film or photo sensor being used, or when there is an even distribution of tones throughout the scene.

Center-weighted metering

Ideal for portrait photography, center-weighted metering (CWM) measures the light across the entire scene but weights the light reading towards the center portion only (usually around 75 percent of the reading is based on a center portion of the frame).

Spot metering

When set to spot metering (SM) mode, the TTL meter takes a reading from a tiny section of the scene—usually an area around just 3—5°. This enables precise metering of specific areas and provides the greatest level of creative control over your exposure settings. SM is an ideal solution when working in high-contrast conditions and where the intensity of light varies considerably throughout the frame.

It is possible to get hand-held reflected light meters that offer a 1° SM facility, which gives even greater accuracy when measuring light in variable conditions. Many landscape photographers prefer to work with a 1° spot meter for this reason.

Partial metering

Some Canon cameras have a metering facility called partial metering. Partial metering is a form of spot metering, but rather than taking light information from an area of the frame approximating to around 3 percent, the meter uses a wider area, typically at around 9 percent of the frame.

2.7 *Multi-segment meters are highly accurate and best used where the levels of contrast fall within the dynamic range of the film or photo sensor.*

2.8 *Center-weighted meters place the emphasis of measurement in a central portion of the frame and are ideal for portraits (whether animal or human).*

2.9 *Spot meters allow you to measure tiny portions of brightness in a scene. They are the most accurate meters for high-contrast scenes in which you want to measure just a small portion of the overall frame. They also give the greatest control over the picture-making process.*

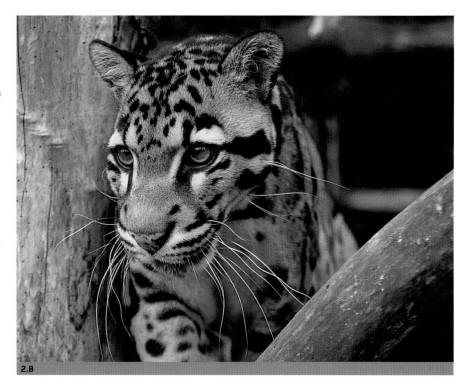

2.8

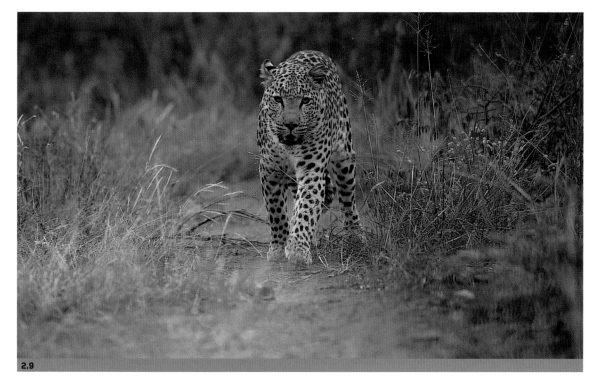

2.9

How a light meter works

All light meters are calibrated to give you an exposure value for a mid-toned subject—that is, a subject that reflects 18 percent of the light falling on it. Examples of mid-toned subjects are leaf green, a clear blue sky at around 11:00am on a summer's day, and London-bus red.

The 18 percent reflectance value is referred to as mid-tone or medium tone because it falls exactly halfway between film's ability to record pure white and pure black. For this reason, it is also referred to as medium gray or 18 percent gray.

Therefore, when you meter a subject, the light meter will give you a reading that will record the subject as mid-toned. This is fine if the subject

you're photographing is mid-toned, but what if it's not? To the meter it doesn't matter because it sees all things as mid-toned. But to you it matters enormously because, in most situations, you want to record tonality as it appears. So, having taken the meter reading you must ask yourself the question, "is the subject mid-toned, darker, or lighter?" If it is darker or lighter than mid-tone, you have to adjust the meter reading that the camera has given you.

Let me give you an example. Say you are photographing a snowman in your garden. You set your camera to auto-TTL metering and take a picture. But, once developed, the snowman looks gray and nothing like the brilliant white you remember. This is because the camera's meter saw it as gray—

18 percent gray to be exact. Now, assuming the snowman is still there take another picture, this time opening up your exposure (adding more light) by two stops. Now when you get your picture developed you will see that the snowman has come out looking exactly as you remembered it: bright, brilliant white. A camera will underexpose light subjects to make them darker and overexpose dark subjects to make them lighter—all the time trying to achieve a tone equal to 18 percent gray. In order to compensate for the camera's miscalculations you must tell the camera to do the opposite of what it has just done automatically. So, when photographing subjects lighter than mid-tone, where the camera has under exposed the image, you must tell it to overexpose by dialing

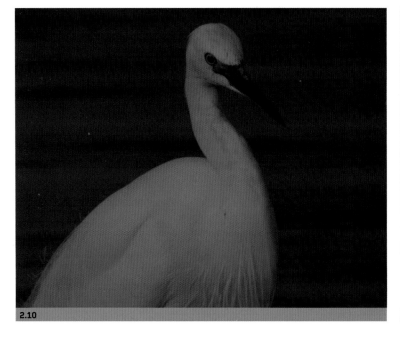

2.10

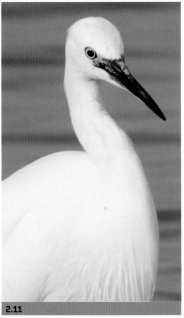

2.11

2.10 & 2.11 *Light meters always give a meter reading that will render your subject a mid-tone. So, when metering white subjects, the camera will underexpose, making your picture too dark. Opening up the suggested exposure setting will rectify this problem.*

in "plus" exposure compensation or by manually opening up the exposure settings. If you are photographing a subject darker than mid-tone, where the camera has overexposed the image, you must tell it to underexpose by dialing in "minus" exposure compensation or by closing down the exposure settings.

While exposure values are often referred to in terms of gray tones, the same rule applies for any color in the visible spectrum. For example, imagine you were photographing a blue sky in the early morning. A direct meter reading would give you an exposure value equivalent to medium blue—a tone of blue you would expect to see at noon. However, in the early morning the sky will appear much lighter. In order to record it at its true tone, you would need to add more light to your exposure than that indicated by the meter.

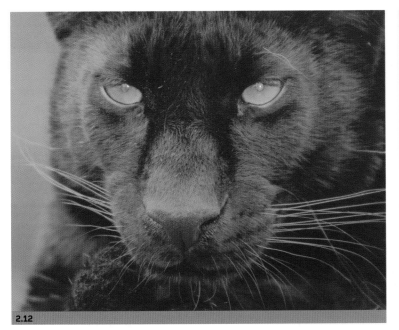

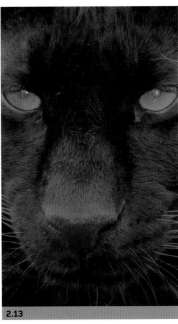

2.12 & 2.13 *The opposite effect occurs when shooting subjects that are black. When I photographed this black panther, the camera meter overexposed the original image to a mid-tone. Underexposing the camera's suggested setting by a fifth of a stop has achieved a more faithful exposure.*

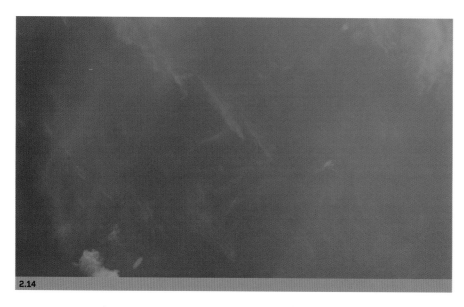

2.14

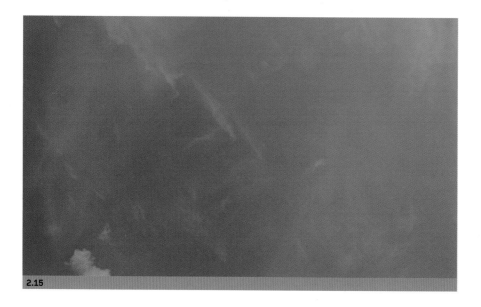

2.15

2.14 & 2.15 *While we talk about exposure in terms of gray tones, the same rule applies to color. This photograph taken early in the morning shows a mid-tone blue when taken on auto-exposure. A little compensation (+1 stop) helped to get the exact color that I saw with my eyes.*

2.16—2.18 *These three images illustrate exactly how a photographic light meter will turn everything mid-tone. Originally, 2.16 was white, and 2.18 was black. Only 2.17, an 18 percent gray card, has been reproduced accurately.*

2.19—2.21 *Applying the correct amount of exposure compensation has allowed the camera to reproduce all three tones accurately.*

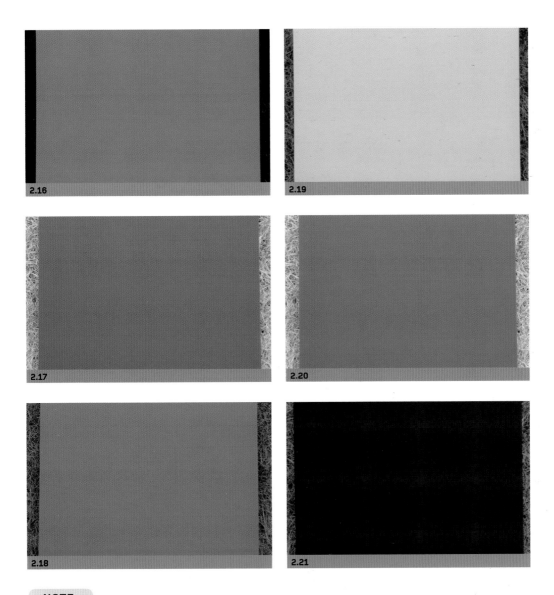

2.16

2.19

2.17

2.20

2.18

2.21

NOTE

TRY IT FOR YOURSELF

Try this simple test. On an overcast, dry day, place three pieces of card on the ground—one white, one black, and one medium gray. Set the camera's meter to auto-exposure and photograph each piece of card separately, ensuring they fill the entire frame. When you review the results you will see that each photograph appears the same in tone—medium gray.

Replicate the test, but this time add two stops of light to the indicated exposure when photographing the white card and take away two stops of light from the indicated reading when photographing the black card. Photograph the gray card at the indicated reading without altering the exposure. When you review this second set of pictures you will notice that each piece of card looks in the picture as it does in real life.

APPLYING EXPOSURE COMPENSATION

Because the camera, based on an unadjusted meter reading, will record a subject as a middle tone when the subject is actually lighter or darker than middle tone, the exposure will need to be adjusted. With the camera set to program AE or semi-automatic AE (i.e. aperture or shutter priority), exposure adjustments can be made using the exposure compensation function on the camera.

How much exposure compensation is required will depend on the tone of the subject being photographed. In general terms, light subjects require more light (plus [+] exposure compensation), while dark subjects require less light (minus [-] exposure compensation). If you consider light gray to be one stop brighter and white to be two stops brighter than medium tone, and dark grays one stop darker and black two stops darker than medium tone, this will bring you close to an exposure that records tone accurately.

For even greater accuracy, it is important you develop the ability to read tone in $^1/_2$ stop or $^1/_3$ stop gradations. To aid this process, the table (see 2.22) provides some real world examples of tonality relative to exposure compensation. Another useful tip is to carry a gray card with you, against which you can compare the tone of the subject you are photographing.

NOTE

Remember that the figures in 2.22 are based on my own tests and will vary depending on your camera's meter and the film or photo sensor you are using. It is always advisable to run some tests of your own for complete accuracy.

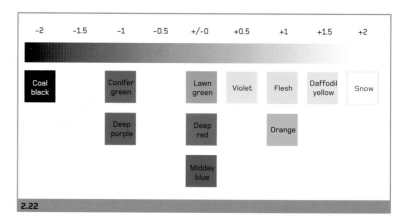

2.22

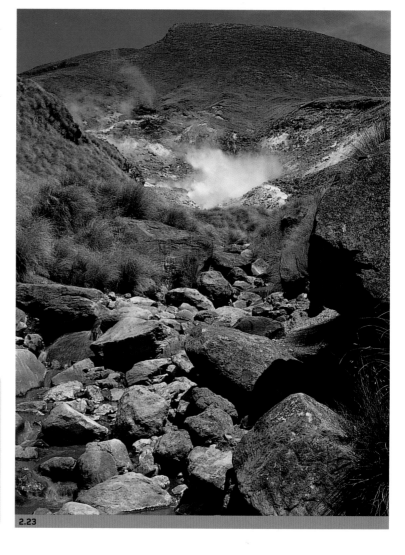

2.23

The "sunny f/16" rule

In high-contrast conditions such as those found on a bright, clear day, dark shadows and bright highlights can easily fool your camera's meter. One solution is to use the "sunny f/16" rule. This rule works by setting your lens aperture at f/16 and your shutter speed at the setting closest to that of the ISO rating of the film you're using (or ISO equivalency for digital cameras). For example, if you're using Fuji Velvia 100F, then your exposure setting using the "sunny f/16" rule would be f/16 at 1/100th (or 1/125th if your camera doesn't allow a third of a stop adjustments). Once you have this base setting you can then use any equivalent combination of settings. For instance, with the image facing opposite (2.23), you could also use 1/200th (1/250th) at f/11 or 1/50th (1/60th) at f/22. Sounds too simple to be true, but trust me—it works!

The "sunny f/22" rule

One time when the sunny f/16 rule doesn't work is when photographing white subjects under very bright conditions, when the subject fills a large portion of the picture frame. Under these circumstances, using the f/16 setting would result in detail being lost in the highlights—something that is best avoided. A variation of the "sunny f/16" rule is the "sunny f/22" rule. It works in exactly the same way, except your base lens aperture setting is f/22. Reducing the level of light reaching the film by half will darken the highlight areas of the image and add detail. As with the "sunny f/16" rule, once you have determined the correct shutter speed at f/22, you can use any equivalent combination of settings for your final exposure.

ISO

Meter readings are given in relation to the ISO of the film used, or the digital ISO rating that is set. In film terms, ISO relates to sensitivity. The higher the ISO rating the more sensitive the film is to light and the quicker it will react. High rated ISO films require less light to record a well-exposed image, and can be used in low light conditions. The downside of high ISO rated film is film grain. Film contains a layer of microscopic grains of silver halide crystals, which are the particles that react to light. These grains are made larger in fast films to the extent that, when they are enlarged to make a print, they become visible as film grain.

The term ISO is also used in digital photography, but the manner in which a digital camera changes its response to light is very different to that of film. In digital photography, when ISO is increased to a higher value the light signal recorded by the sensor is amplified, in much the same way you would increase the volume on a radio or television set by amplifying the sound. Because there are no silver halide crystals used in digital photography, the grain is non-existent. However, the downside of amplification is an increase in digital noise, shown as random speckles of colored, unrelated pixels that decrease the image quality. In both cases, unless used for artistic effect, it is advisable to keep the ISO rating at its lowest possible setting or value.

2.24

2.22 *Suggested exposure compensation values for lighter and darker than mid-toned subjects.*

2.23 *On a bright sunny day with the sun overhead, the "sunny f/16" rule will give accurate exposures each and every time.*

2.24 *When photographing white or highly reflective subjects under "sunny f/16" conditions, highlights can appear washed-out. Applying the "f/22" rule will produce a more truthful exposure.*

APPLYING EXPOSURE SETTINGS

Now that you know your exposure value, you must decide which combination of settings to use. The two main controls available to set exposure are lens aperture and shutter speed. How you apply them will have an effect on the way the subject appears in the final image. So, which of the two gets priority?

Lens aperture

Lens aperture is the hole in the diaphragm of the lens that passes light through to the camera. The size of the aperture is measured in f/stops, and ranges from very wide to very small. The smaller the f/stop the larger the hole, which appears confusing until you think of the f/stop numbers in terms of fractions. For example, 1/16th as a fraction is smaller than 1/8th, just as f/16 is smaller than f/8.

Aperture influences the extent of depth of field, i.e. how much of the scene in front of, and beyond, the point of focus appears sharp (also known as the zone of acceptable sharpness). The wider the aperture, the more depth of field is reduced, so setting a smaller aperture will increase the depth of field, and setting a wider aperture will decrease it.

This is important because depth of field determines which subjects in the scene will receive the most emphasis, and which will become hidden due to blurring. By controlling the extent of sharpness, and by default emphasis, it is possible to isolate subjects and dictate which objects in the photograph a viewer will look at, and the order in which they will look at them.

Shutter speed

Shutter speed relates to the length of time the sensor or film is exposed to light, i.e. the duration of the exposure. Compositionally, shutter speed controls how motion appears in the image. A fast shutter speed (relative to the subject) will freeze motion, emphasizing detail. At relatively slow shutter speeds, the subject motion will blur, creating a sense of movement.

For example, compare the two images of the waterfall (see 2.28 and 2.29). In the first image a fast shutter speed has been used to freeze the motion of the water cascading over the rock face. It is possible to show detail such as the tiny droplets of water splashing against the rock. In the second image, a slow shutter speed has been used to blur the motion of the water. Shutter speed may take precedence when holding the camera by hand in order to minimize the effects of camera shake.

2.25 *Shutter speed is the control we use to depict how motion appears in the final image. A fast shutter speed will freeze motion, such as a bird in flight.*

2.26 & 2.27 *Depth of field affects the emphasis placed on subjects within a picture. In the first image of an ostrich, the scene is sharp from foreground to background, helping to give the animal a sense of place. In the second picture of a Black-backed jackal, depth of field is kept to a minimum to focus attention on the animal.*

2.28 & 2.29 *Again, a fast shutter speed will freeze the action of water cascading down a waterfall. Slowing down the shutter speed will blur motion, as shown in 2.29.*

> **NOTE**
>
> Depth of field is also affected by focal length and distance to subject. In order to calculate the exact depth of field, given all three variations, you need to refer to depth of field charts, usually provided with the lens. Some cameras have depth of field preview that allows you to see exactly the available depth of field in any given scene. The Internet gives access to a number of online depth of field calculators. One of the best is www.dofmaster.com.

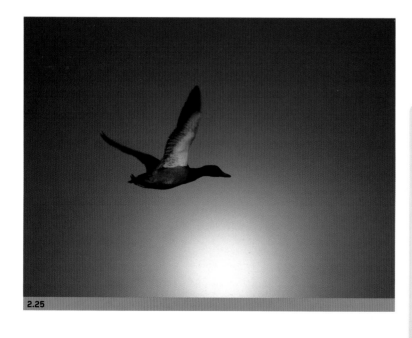
2.25

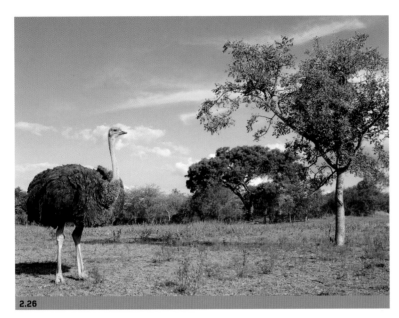

2.26

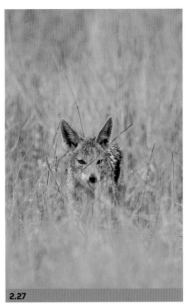

2.27

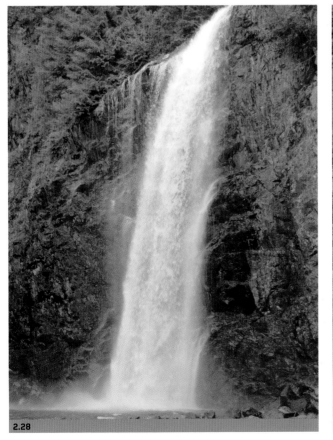

2.28

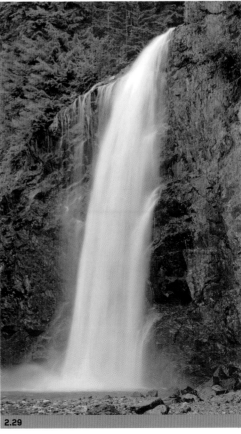

2.29

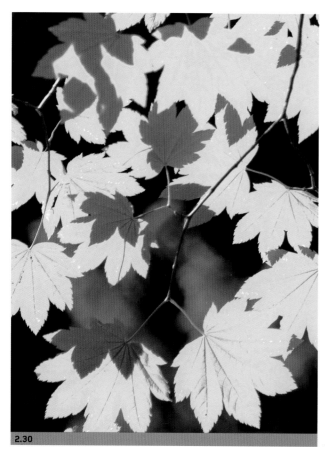

2.30

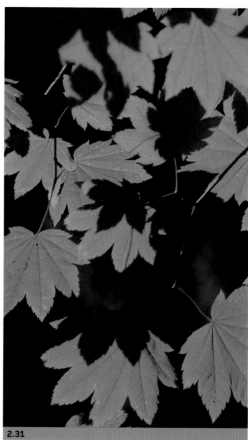

2.31

Bracketing

However hard you try, and however much care you give to calculating exposure, it is sometimes impossible to get it right. Many factors can influence an exposure, such as very bright sunlight reflecting off shiny surfaces (e.g. water, sand, and glass), constantly changing light conditions, such as those you will encounter on days where broken clouds fill the sky, and subtle variations in a subject's tonality. Something else to bear in mind, and something that is outside of your direct control, is that film manufacturers and processing laboratories operate to tolerance levels that could make a difference of up to a $1/2$ stop in your exposures.

Because of these factors, you may want to bracket your exposures. Bracketing involves taking more than one photograph of the same scene at varying exposure values above and/or below your initial exposure setting. Typically, the variance should be around a $1/3$—$1/2$ stop. On rare occasions, you may want to go as far as +/- 1 stop.

Digital exposure

Digital cameras record light very differently to film cameras. The sensor in a digital camera is a linear device, meaning the distribution of tones (referred to as levels) is heavily skewed to bright tones, with around 75 percent of all tonal information contained in the brightest pixels (whites and light grays). Therefore, when exposing with a digital camera, it is imperative to expose for the brightest area of the scene where detail is needed, also known as exposing to the right. Any degradation in shadow contrast can then be processed using image-processing software, without compromising the image quality.

Under-exposing a digital image, which is later "fixed" using image-processing software, is likely to result in digital banding (the appearance of distinct steps in changes between tones) and increased digital noise.

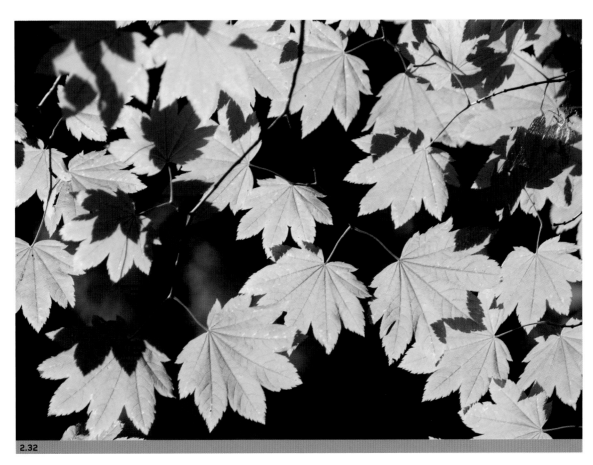

2.32

The histogram

Digital cameras have a function that provides a bar chart that identifies the distribution of tones across all tonal levels. This chart is known as the histogram. The horizontal axis of the histogram relates to the 256 tones of gray recorded in an 8-bit image. The vertical axis shows the quantity of pixels having a given tonal value. Put simply, the histogram enables the user to see exactly how the image was exposed. However, as the histogram relates only to a processed image, it must be used with caution. If the user is shooting in the RAW file mode the histogram may be widely inaccurate.

FLASH METERS

A flash meter works in much the same way as an incident light meter and measures the level of flash light to provide a required lens aperture setting. (In flash photography the shutter speed is usually dictated by the camera, because of the need for synchronization between flash duration and shutter speed.)

The meter is usually held facing toward the camera from the position of the subject. A test flash is then fired to enable the meter reading. Of course, this assumes that you

are able to fire a test flash, which often dictates that you are in a studio or using flash under controlled conditions. As with an incident light meter, a flash meter does not automatically take into account any external factors affecting exposure calculation, such as filters or high-magnification lenses.

2.30—2.32 Bracketing an image will help ensure you get an accurate result in difficult lighting conditions. Compare the three images shown here. The first and second images (2.30 and 2.31) show the same image one stop over and one under the original setting. In the final image (2.32), the exposure has faithfully reproduced the original scene.

USEFUL
EQUIPMENT

48	Supports
	Tripods
50	Cable releases
52	Beanbags
	Monopods
	Clamps
54	Filters
	81 series warm filters
56	80 and 82 series blue filters
	Creative use of white balance
	Neutral density filters
	Polarizing filters
	Using optical correction
	filters with digital cameras
58	Ultraviolet (UV) filters
60	Filters for black and white
	photography
	Digital filters
62	Lens hoods
	Reflectors
64	Positioning
	Surfaces and color
	Black reflectors
66	Sizes
	Handling reflectors
68	Diffusers

The ability to control and manipulate light for your own purposes is one of the main ingredients for a successful photograph. Of course, this is easier to achieve in a studio with artificial lighting, when you can alter the angle, direction, and size of the light source pretty much at will. Outdoors, it is a little harder to do that with the sun.

Wherever you are photographing, using various photographic accessories can help to persuade light to do what you want in relation to capturing the image you want. However, of the many and varied pieces of equipment out there, which are most useful, and how are they best utilized?

SUPPORTS

Tripods

Tripods are important for vibration-free photography, but particularly so for low-light and night photography, where there is an increased danger of camera shake due to the slow shutter speeds required.

There are some key factors to consider when buying a tripod. First, and most important, is rigidity. The sturdiness, of your tripod is determined by two factors: carrying capacity and center of gravity. All tripods are made to carry a certain weight, and they will prove effective up to this weight. Go beyond the recommendation by attaching a heavier camera, for example, and the tripod becomes less stable. The center of gravity is affected by two factors—the distance between the base and the top of the tripod stem, and the distance between the top of the tripod stem and the top of the camera plate. With both, the laws of physics rule: the lower, the better.

When using a tripod, try to spread its legs wide and even, and always avoid using the center column, if one is fitted. Raising the center column increases the center of gravity and can completely nullify the benefit of using the tripod. If you are using a long lens, attach the lens's tripod collar to the tripod, and not to the camera. An unbalanced camera on a tripod will cause camera movement and, again, reduce the tripod's ability to do its job.

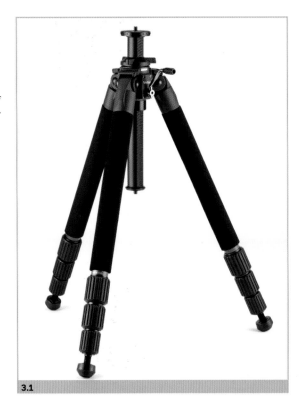

3.1

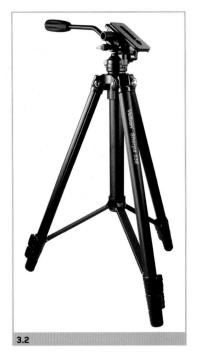

3.2

3.1: *A professional-level tripod is worth the investment. It needs to be strong enough to carry your heaviest camera/lens combination.*

3.2: *A tripod designed for indoor and studio use has base tension brackets for added support.*

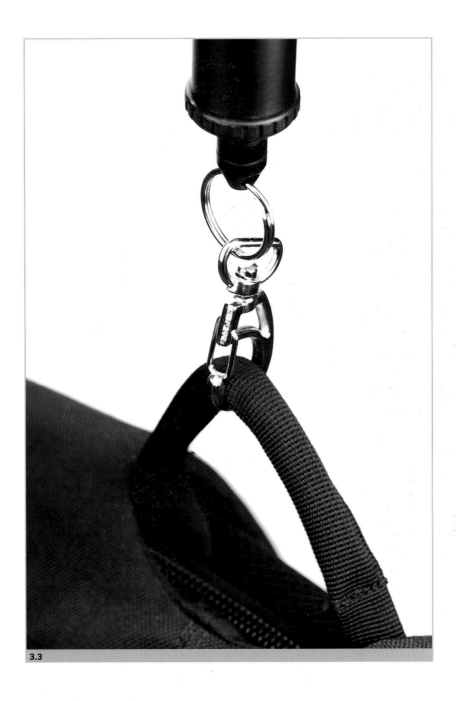

3.3

3.3: *A hook on the bottom of the tripod column doubles as a handy accessory holder but, more importantly, adds weight to the tripod creating added stability, particularly in windy conditions.*

3.4 *When attaching your camera to a tripod, make sure it is well-balanced, using the tripod collar on longer lenses, if necessary, for extra rigidity, and to reduce camera shake.*

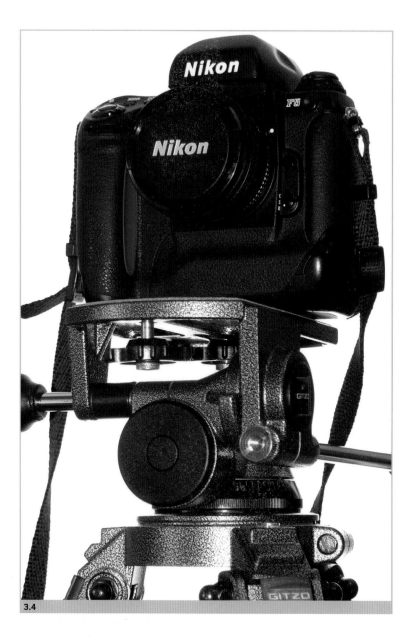

3.4

3.5 & 3.6 *I never recommend using the central column of a tripod. Raising it heightens the center of gravity and destabilizes the tripod, reducing its effectiveness.*

3.5

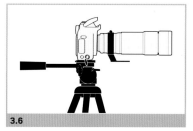

3.6

3.7

Cable releases

I mentioned the cable release earlier and recommend that they are always used in conjunction with a tripod. Modern cameras operate an electronic cable release, which effectively eradicates camera vibration from releasing the shutter. The older-style cable releases (which do actually use a cable) are almost as effective as long as you operate them properly, using a gentle motion on the push mechanism. An alternative solution if you don't have or can't use a cable release is to set your camera to self-timer and press the shutter manually via the main shutter release button, then stand back and let the camera fire the shutter.

3.8

3.7 *A tripod is one of the most important accessories in photography.*

3.8 *When using a tripod, fire the shutter using a remote release.*

3.9

Beanbags

I frequently use beanbags when photographing wildlife in low-light conditions. The advantage of the beanbag is that it is far easier to work with in cramped conditions, such as the front seat of a vehicle. When balanced properly, the camera remains quite steady and the beanbag often absorbs any vibrations. On the downside, beanbags do not offer the same degree of sturdiness that a tripod does.

Monopods

A monopod is better than having no support at all, and is helpful for some kinds of photography more than others, notably sport and wildlife photography. It is less helpful for low-light and night photography, when the exaggeration of movement caused by multi-second shutter speeds and fast apertures render them only slightly better than hand-holding the camera.

Clamps

Clamps can be very useful camera supports, acting in a similar way to a tripod. The key to how successful a clamp will be is what it is actually attached to. If attached to a solid object, such as a thick metal railing, then they will be relatively sturdy and movement-free. However, attached to something less rigid, such as the branch of a tree or a car window, they are weakened by the very thing that's supporting them.

3.10

3.9 *Monopods can be very useful if you are in the field and don't want to carry a tripod.*

3.10 *If you do not have a conventional support, use whatever solid object you can find.*

3.11

3.11 *If you do not have a tripod or monopod with you when out shooting pictures, find a solid support and use a sweater, or similar, to act like a beanbag.*

TIPS

There are some things you can do to minimize camera shake when hand-holding a camera.

First, use your body effectively. Keep your arms tight in to your body and spread your legs evenly. If possible, use a building, fence, or similar structure to support your weight. Make sure that your weight is evenly balanced on both feet. When you are ready to take the picture, take a deep breath and press the shutter release as you are breathing out, as this is when your body is at its most relaxed. Finally, keep breathing, if you can—holding it won't help you achieve a pin-sharp image.

Another option if you don't have a purpose-made camera support is to improvise. A thick woolly sweater on a wall or on your backpack can act just like a beanbag. Once, when photographing out of a kayak, I made a highly effective beanbag out of my life jacket, the foam seating cushion, and a bungee cord. It's amazing what you can find with a little imagination. Another alternative is to find a flat surface, such as the top of a wall, and simply rest your camera on that with the lens supported at the front.

3.12

3.13

3.14

FILTERS

There are two different types of filter: technical and creative. I am going to concentrate on specific technical filters that are essential to achieve the faithful reproduction of light. Technical filters are those filters that allow you to overcome the limitations of film and photo sensors in recording natural images, or that enhance some of the existing properties of light for artistic expression.

3.12 *The original image.*

3.13 *An 81 series filter can add a soft, warm glow to your image.*

3.14 *Don't overdo it—an 81D filter can make your image too orange.*

81 series warm filters

The 81 series of warm filters—so called because they add a subtle orange glow to photographs—are much prized by landscape photographers.

As I related in chapter two, during the day, light varies in color, from deep red to blue-white. All of us have seen photographs of the sunrise and sunset, and the reason for their appeal is their warmth, the so-called "golden hours" of photography.

The 81 series of filters can do one of two things. Firstly, they can help to accentuate the warmth of color at sunrise and sunset. Secondly, they can be used to nullify the blue color cast often visible on film on overcast days or at the height of the summer sun.

Be careful not to overdo things with these filters. Using too strong a tint (81D and above) can give your images an unnatural intensity. Bear in mind, too, that some scenes look better with a slight blue color cast, such as frost, snow, and the twilight hours.

3.15

3.16

3.15 & 3.16 *The original image (3.15) has a blue color cast because of the overcast conditions. The addition of an 81B filter (3.16) gives it a much warmer tone.*

80 and 82 series blue filters

At the other end of the scale, you may need to reduce the extent of warm color casts in your images. This is particularly true when photographing under tungsten lighting with daylight-balanced film, when your images will come out looking overly orange and quite unnatural.

The 80 and 82 series of blue filters absorb some of the red waves of light entering through the lens and, in so doing, allow more blue waves to reach and affect the film. The result is a much more natural-looking picture where orange and blue are balanced.

It is possible to use these filters for enhancing blue light in scenes, thereby creating cool, atmospheric images. Applied with skill and to an appropriate subject, this effect can look very dramatic but it takes a little practice.

Creative use of white balance

In technical terms, the aim of white balancing, whether controlled using optical filters or via the digital WB control, is to produce an image with no color cast, so that the color of light appears as we recognize it. However, there are occasions when

light will benefit from a color cast. For example, imagine a beautiful sunrise or sunset without the warm red glow—it just wouldn't be the same.

Optically, this effect is achieved by using a "warming" filter from the 81 series of filters. In digital terms, such optical filters can be replaced by using the WB control. For example, the cloudy and shade preset values have the effect of absorbing blue light waves and passing red waves, in many ways acting much like "warming" filters. To ensure that the red glow of sunrise or sunset appears in the image, setting either of these values will intensify the orange/red color cast.

Neutral density filters

Neutral density (ND) filters come in two sorts (solid and graduated), and various strengths (usually between 1 and 3 stops in $1/2$-stop increments). Solid ND filters are a means of reducing the level of light entering the entire lens. They are useful in very bright conditions when you need greater flexibility over shutter speed/lens aperture settings. For example, let's say you are trying to blur the motion of water over a waterfall, but the light is too bright to allow a slow enough shutter speed,

even at minimum aperture, to create the effect you want. Adding a neutral density filter will reduce the level of light reaching the film/photo sensor, meaning you will need to allow more time—a slower shutter speed—for the correct exposure.

Graduated neutral density filters achieve the same thing, except they only block a portion of light entering the lens, depending on where you position the filter. Typically, ND graduated filters are used in landscape photography where, for example, the sky is far brighter than the foreground. The resulting variation in tone is often too great for the film to handle.

3.17 & 3.18 *Adding a blue filter will change the atmosphere of your scene. Compare these two images and see how the different overtones affect your emotional response to the picture. Neither result is right or wrong—simply, different interpretations of a theme.*

3.18

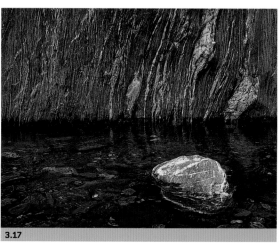

3.17

80 and 82 series blue filters | Creative use of white balance | Natural density
filters | Polarizing filters | Using optical corection filters with digital cameras

57

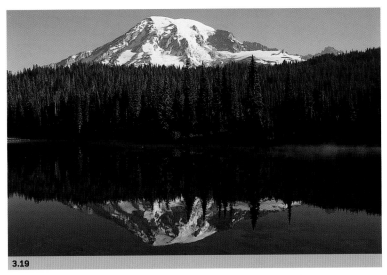

3.19

Polarizing filters polarize the light entering the lens, thus removing these reflections. Another effect is to darken blue skies and make white clouds more prominent. They can be used to good effect on foliage, too, which reflects a lot of non-polarized light, and to intensify the color of glossy objects, such as ceramic and plastics.

Do note that there are two types of polarizing filter: linear and circular. Both affect light in the same way but a linear polarizing filter will affect your camera's auto-exposure function. In order to use TTL-metering, therefore, you will need to use a circular polarizing filter.

Positioning an ND graduated filter, so that the dark section of the filter covers the brighter area of sky, will even out the difference in tones, allowing the contrast to fall within the dynamic range of the film/sensor, producing a photograph with an even balance of tones.

A word of warning when choosing ND filters. The term neutral implies that the filter has no effect on the color of light entering through them. In reality, some manufactured ND filters give a gray cast to light, which is not always pleasing to the eye, though it can enhance stormy skies. It is worth checking this out, if at all possible, before you buy.

Polarizing filters

Another essential for the landscape photographer is the polarizing filter.

Non-polarized light waves exist all around us, for example in light reflected off surfaces, such as water, and in light from blue sky at right angles to sunlight, although our eyes are unable to differentiate between polarized and non-polarized light. Photographic film and digital sensors, on the other hand, record this light causing, for example, reflections on windows, glass, and water.

Using optical correction filters with digital cameras

It is possible to use optical color correction filters, such as the 81, 80 and 82 series filters, with digital cameras. However, when doing so it is important to use a manual or preset white balance value. If WB is set to auto, the camera will aim to neutralize the effect of the filter. To match the results of correction filters used in digital with those of film, set WB to the same value as daylight-balanced film, i.e. around 5,200K. The daylight preset is close to this value (see below table).

3.19 A neutral density graduated filter will help to even the tones between light areas of a scene, such as skies, and darker areas, giving a contrast that falls within the latitude of the film or photo sensor being used.

Optical filter equivalents of WB settings

Pre-set setting	Standard K value	Optical filter equivalent
Daylight	5,200K	Unfiltered
Cloudy	6,000K	81-B (orange)
Shade	8,000K	81-C/D (orange)
Tungsten (Incandescent)	3,000K	80-A (blue)
Fluorescent	4,200K	80-D (blue)
Flash	5,400K	Unfiltered

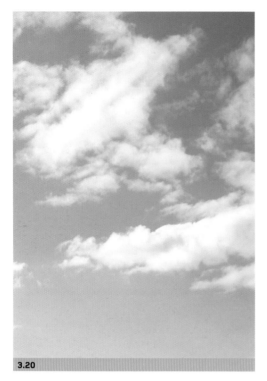

3.20

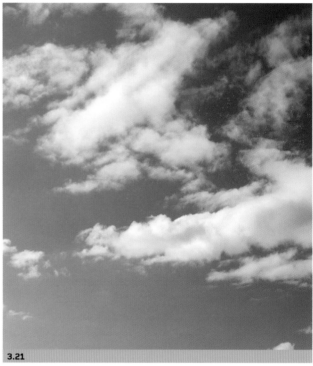

3.21

3.20 & 3.21 *Adding a polarizing filter can saturate colors, such as a blue sky, which, in this instance, helps to accentuate the clouds.*

USING POLARIZING FILTERS

1 Polarizing filters have the most effect when the camera is at 90°
to the sun.

2 Before taking the picture, rotate the filter through 360°
to observe what level of polarization gives the best results.

3 Circular polarizing filters work best with auto-focus, auto-exposure
system cameras.

4 If manually calculating exposure values use the following as a guide
to compensation values:

¹/₄ polarization	+ ¹/₂-stop
¹/₂ polarization	+ 1-stop
³/₄ polarization	+ 1¹/₂-stop
Full polarization	+ 2-stops

5 Use a polarizing filter for full-bodied colors, such as reds and blues.

6 Polarizing filters will remove unwanted surface reflections from water
and moisture, as well as the reflections from surfaces such as glass.

Ultraviolet (UV) filters

Ultraviolet light is invisible to the human eye but not to camera film. The effects of UV light on film can be an increase in blue color cast and haziness in the atmosphere. It is most apparent in shots taken at high altitude or close to the coast. A UV filter reduces UV light entering the lens, enabling images to appear on film as they do to the eye.

UV filters are often sold with camera lenses as standard, partly because they can be kept on at all times and double-up as protection for the front element of the lens. I use them only when necessary, because they are an extra barrier for light to travel through, which reduces the quality of light reaching the film.

A similar filter is the skylight filter. Skylight, or haze filters, do the same job as UV filters except that they have a pink tint that reduces the blue color cast.

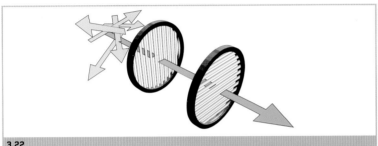

3.22

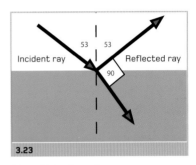

3.23

3.22 *Light is a form of electromagnetic radiation that vibrates in a plane at right angles to the direction of travel. A plane polarizer allows only light vibrating in one direction to pass through.*

3.23 *A polarizer has the strongest effect when angled at 53° to the vertical —known as the Brewster angle—and when the angle between the reflected and refracted beams is 90°.*

3.24 & 3.25 *Here, a polarizing filter removes some of the unwanted glare reflecting from the closed car window.*

3.24

3.25

Filters for black and white photography

Black and white film is more sensitive to blue light than the eye, so when photographing landscape scenes that contain a blue sky, on film the sky will appear much paler than it originally seemed. The effect is that the contrast between the deep blue sky and white clouds is diminished. To enhance the level of contrast you can apply a red filter. The red filter absorbs the blue light, darkening the sky and making white clouds stand out against a dark background. Red filters are most effective when there is a high proportion of blue light. The more white light visible in the scene the less effective the red filter becomes. In place of a red filter you could opt for orange—the effects are less extreme.

The situation changes when other colors are involved. Imagine that the sky you are photographing is part of a summer scene that contains trees rich with green leaves in the mid-ground. The red filter will not only darken the blue sky but the green leaves as well. Switching to a green filter, however, will lighten the leaves while still having a darkening affect on the sky. In black and white photography, you can also use a pale filter—yellow or yellow/green—usually referred to as a "correction filter". The effect of pale filters is to record colors in gray tone much closer to their visual brightness, as opposed to that recorded by black and white film. For most fields of photography the difference is minimal. However, pale filters can be essential for some fields of technical photography where accurate rendition of gray tone is necessary.

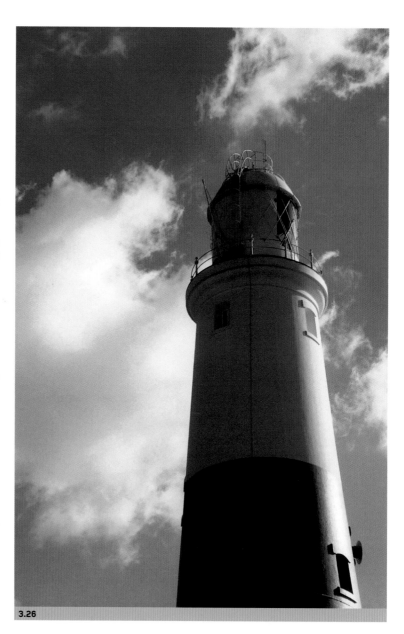

3.26

Digital filters

Digital filters can enhance and correct digital images. Photoshop provides a range of correction and effects filters under the Image/Adjustments menu. There are also specialist digital filter software packages such as the Tiffen Dfx Digital Filter Suite.

The idea behind digital filtering is exciting, providing an array of creative possibilities, but they are not the complete solution. For color correction and enhancement, digital filters are simpler to apply than trying to manage color using the selective tools in Photoshop, and if the camera has failed to capture the full dynamic range in the scene (whether in a single image or in multiple images) it is impossible to create these effects with computer processing.

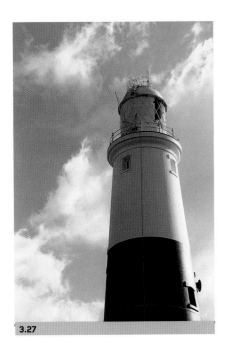

3.27

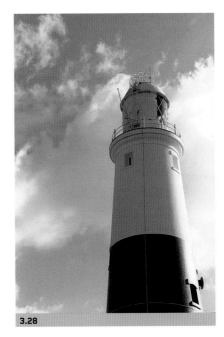

3.28

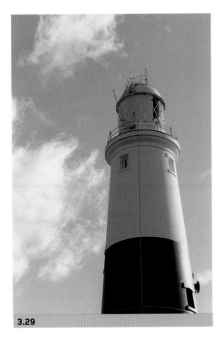

3.29

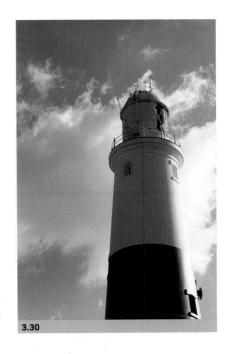

3.30

3.26 *Using different filters with black and white film enables you to achieve differing levels of contrast within your image. This is the original shot, taken without a filter.*

3.27—3.30 *From top left: 3.27 is shot with a yellow filter; 3.28 with a green filter; 3.29 with an orange filter; and 3.30 with a red filter. As you can see, the change of filter, from pale (yellow) to relatively dark (red), produces a gradual increase in contrast, and the effect can be varied depending on your desired result.*

LENS HOODS

Light enters the lens at different
angles, and the larger the diameter
of the lens the greater the angle of
entry. These stray angles of light
can cause lens flare—which you may
have seen on TV and on some of your
pictures—small, hexagonal marks
increasing in size from the light source.

In moving films, flare can add to the
atmospheric presence of a scene,
but in still photography they are
simply distracting. Using a lens hood
fitted to the front of your lens will
help keep lens flare to a minimum and
improve the quality of your pictures.

It is important to match the lens
hood with the lens, because some
lenses—particularly wide-angle
lenses—can cause vignetting.

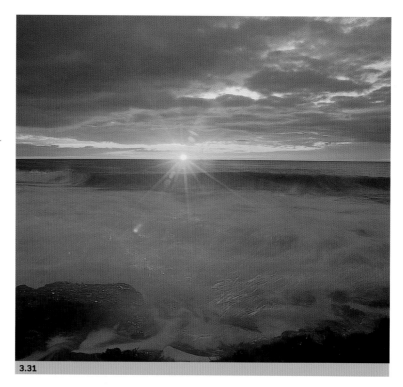

3.31

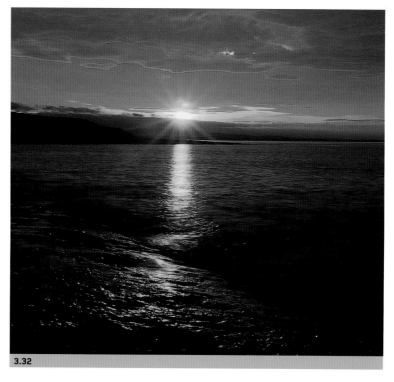

3.32

3.31 & 3.32 *When shooting
into the sun, stray light
can reflect off the various
elements in the lens and
cause lens flare (3.31).
Adding a lens hood will help
to solve the problem (3.32).*

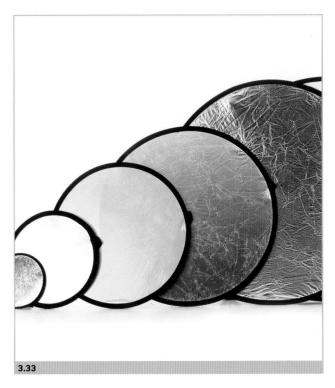

3.33

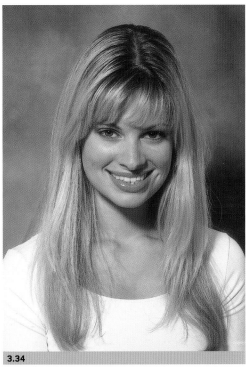

3.34

REFLECTORS

There are two types of reflector: panel and lighting attachments. In this section I am referring only to panel reflectors, how they work and when to use them.

The purpose of a reflector is to balance light and moderate the areas of shadow. In that way, they act very much like a fill-light, throwing light into parts of the scene unlit by the main light source. The beauty of the reflector is that it can never be brighter than the source light, which means a reflector will complement your lighting and not overpower it.

3.33—3.35 Panel reflectors throw light back into the subject's shadow areas, helping to balance and moderate tones. 3.34 shows a model shot without a reflector. Notice how the addition of a reflector in 3.35 changes the level of contrast between light and shade.

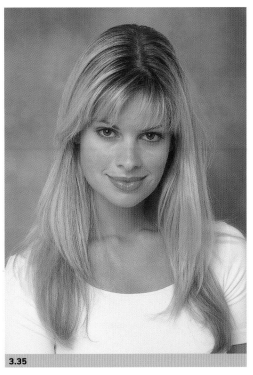

3.35

Positioning

The purpose of a panel reflector is to bounce light back into the shadow areas on the subject. As such, they are usually positioned directly opposite the main light source and close to the subject. The beauty of a panel reflector is that they can never be as bright as the primary light source and, therefore, they will retain some shadow, which maintains depth and definition.

Surfaces and color

While a reflector can be any color, they generally come in four colors—white, silver, gold, and blended. There is also a black reflector. The color of the reflector influences the color of the light reflected back onto the subject. Which color you decide to use depends on your desired effect.

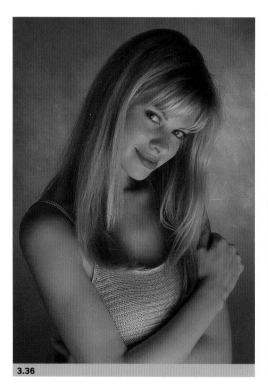

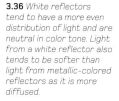

3.36

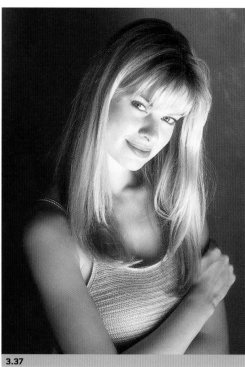

3.37

3.36 *White reflectors tend to have a more even distribution of light and are neutral in color tone. Light from a white reflector also tends to be softer than light from metallic-colored reflectors as it is more diffused.*

3.37 *If you look at a silver surface, you will notice that it is made up of light and dark areas. The smoother the surface the less pronounced the contrast. Silver reflectors make the reflected light more directional than the light obtained from a white reflector, with an accompanying increase in contrast.*

Black reflectors

The purpose of a black reflector is
not to reflect light but to absorb it.
In soft lighting conditions, such as an
overcast day or when using a soft
box in a studio, shadows are softened
with less well-defined edges. While
this can be a preference, there may
be occasions when you want hard,
contrasting shadows in your picture.
A black reflector will help to add
contrast into a picture by absorbing
the stray light that occurs with
diffused lighting conditions.

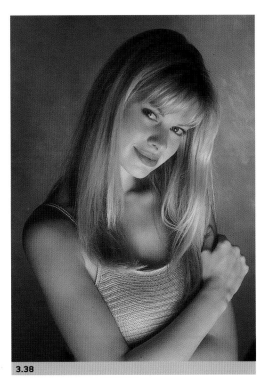

3.38

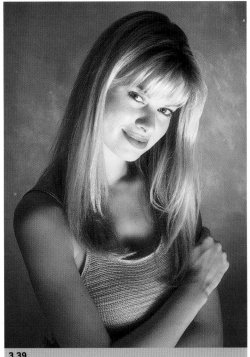

3.39

3.38 *The same effect
is achieved with a gold
reflector, though the
color balance is warmer
because of the yellow/
orange undertones. While
the warmth can be pleasing
in some situations, it can
be overbearing in others,
particularly indoor portraits.
For that reason, gold
reflectors are more likely
to be used outdoors.*

3.39 *A blended reflector is
made up of a combination
of gold and silver. The effect
is a cross between the two,
giving more natural-looking
warmth to portraits than
a straight gold reflector.
This makes them a better
alternative for indoor
portraits, where the subtler
color cast will complement
rather than overpower
the subject.*

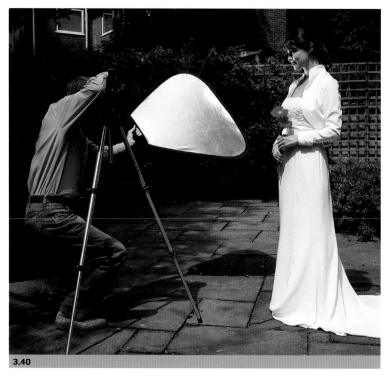

3.40

Sizes

Reflectors come in many different sizes, from the small ones that easily fit into an average gadget bag, to the very large that will just about fit into a studio. But, in photography lighting terms, the true size is the reflector's total area relative to the size of the subject. For example, place a small reflector (30cm/12in) next to a dragonfly and it becomes a large reflector. Similarly, place a large reflector (150cm/60in) next to a building, say, and it becomes a small reflector. So, when deciding on the size of reflector to use, you must first consider the size of the subject you are photographing.

Another issue to consider relating to size is portability, particularly when using a reflector outdoors. Many of the larger reflectors today come as fold-up packages, where the reflector can be folded down to a third of its normal size. This makes transportation much easier.

3.41

3.40 Some reflectors, such as this model produced by Lastolite, come with built-in handles for easy holding.

3.41 In the studio it is possible to get special brackets for positioning and holding reflectors.

TIP

Remember that a light-colored wall can be used as a reflector if the subject is positioned correctly.

Handling reflectors

The biggest challenge when using reflectors is holding and supporting them in the right place. (Of course, if you've got an assistant, this isn't an issue.)

In the studio, you can get purpose-built stands that have a clamp facility to hold the reflector in position. Outdoors is a bigger challenge. If you are photographing beyond arm's length from the subject, then find a suitable object to lean the reflector against, such as a wall. If you are within reach of the subject then you could just try holding the reflector by hand. Some reflectors now come with a built-in grip to make this easier. If you are going to hand-hold, I recommend using a cable release or remote shutter release for extra mobility.

The weather conditions play a part outdoors. In windy conditions, large reflectors have a tendency to take flight if not secured in some way. Carry some string or fishing line to attach the reflector to the support you're using.

That said, I can't emphasize how much better persuading a friend or family member to join you outdoors can be. You just need to find one crazy enough for the job!

NOTE

MAKING YOUR OWN REFLECTOR

You can make a reflector relatively easily or, indeed, improvise with material you can find around the home.

A reflector is simply a piece of highly reflective opaque material. White nylon is ideal and, if attached to a frame made from garden cane, or a piece of dowling, for example, will create a perfectly acceptable reflector. This also has the advantage that it will act as a diffuser if placed between the light source and the subject. A piece of white art board works equally well, as would a thick sheet of expanded polystyrene.

To make a metallic reflector, first take a piece of silver or gold aluminum foil, and crumple it up in your hands. Unfold the crumpled sheet and glue it over a piece of thick card or hardboard, sealing it at the back with some tape.

3.42

3.43

3.44

3.45

3.42—3.45
It's easy to make your own panel reflector.

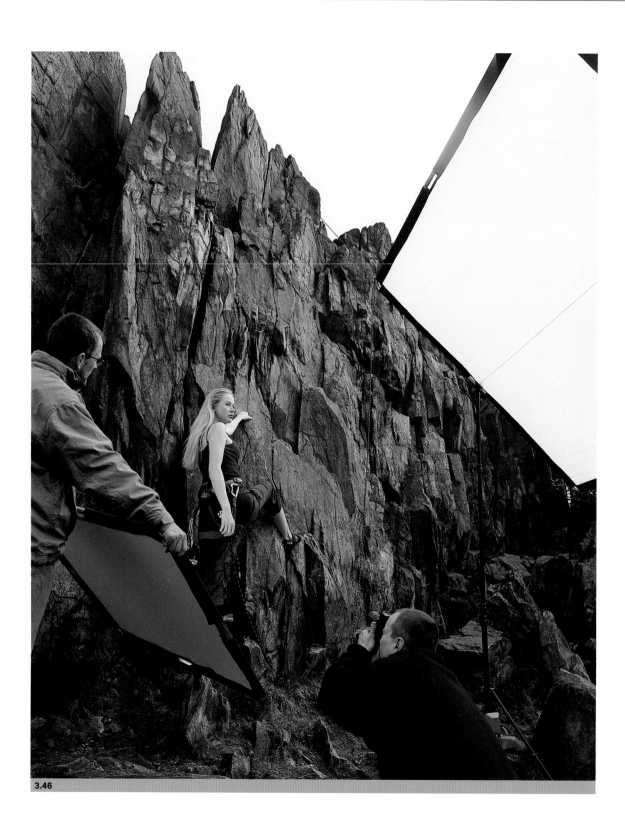

3.46

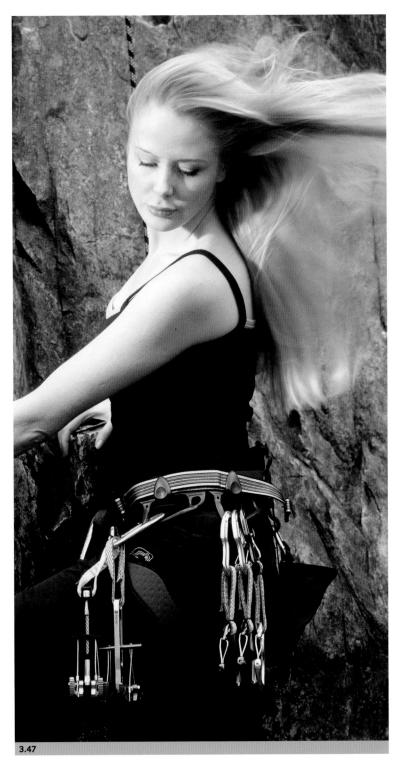

3.47

DIFFUSERS

If you are shooting in direct lighting conditions, you may want to diffuse the light source to soften the shadows and reduce contrast. A diffuser goes between the light source and the subject, and changes a point source to an omni-directional source by scattering the light. This is exactly the same as what happens when clouds obscure the light from the sun.

A diffuser is generally made from white nylon (although any transparent material will work). If the material is colored then the diffused light will also be colored. For best results, the material should allow around 50 percent of the light to pass through it.

There are other accessories that you can use to add to your creativity and effective use of light. Many of these, such as honeycomb grids, umbrellas, and barn doors are covered in the section on studio lighting (page 178). Of the others I may not have mentioned, my advice is simple: experiment. Most lighting techniques and effects are learned in this way, and you will understand lighting best when you see for yourself how small changes you make result in very different images.

3.46 & 3.47 A direct point light source can be diffused to create omni-directional lighting. Even outside in direct sunlight, a diffuser will help to reduce levels of contrast, which may not enhance the scene.

NATURAL LIGHT

72	Living with light
	From dawn to dusk:
	lighting through the day
74	Sunrise
	Early morning
76	Late morning
	Midday
78	Afternoon
	Sunset
80	Dawn and dusk
	From sun to storm:
	lighting and the weather
82	Clear blue skies
	and sunshine
84	Broken cloud
86	Overcast days
88	Stormy weather
90	Mist, fog, and haze

92	Photographing through
	the seasons
	Spring
	Summer
94	Fall
96	Winter
98	When to photograph what
100	Changing light
104	Direction of light
	Side lighting
106	Top lighting
108	Backlighting
110	Weather
	Clouds and contrast
112	Clouds as subjects

If you photograph in a studio with artificial light then you have complete control over the lighting conditions. Changing the angle of light, its direction relative to your subject, and even its color, is a relatively simple process. However, outdoors—or in a daylight studio—you lose much of this flexibility and you have to work with what nature provides.

For many photographers, natural light has an inner beauty that artificial light simply can't match. It is like a living being with a character and personality that it imposes on the landscape. And, like any living being, the mood of light changes depending on circumstance. Time of day, the changing seasons, and weather all play their part in the fickle nature of light, and directly impact on the emotional story of your photograph.

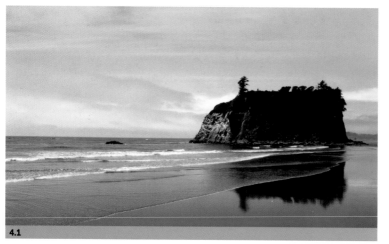

4.1

4.2

4.3

LIVING WITH LIGHT

To literally see light, and to interpret how subtle changes in the quality of light alter our perception of a scene, is one of the things that sets apart professional and non-professional photographers. Being able to use natural light effectively, altering your circumstances to suit the picture—rather than altering the lighting as you would in a studio—will determine your ability to gain maximum visual impact and heighten the viewer's emotional response to your images.

In order to achieve this, you must first understand how time and weather alters light. As you develop your instincts to interpret the fluctuations in the quality of light you will find that your ability to *predict* photographs, rather than *react* to happenstance, increases the compelling visual power of your images.

4.1—4.3 *As the angle of the sun changes, so does the color of light, from warm orange in the early morning (4.1), through yellow during mid-morning (4.2), and blue at the height of the day (4.3).*

4.4

FROM DAWN TO DUSK: LIGHTING THROUGH THE DAY

As the sun moves across the sky, two things occur that affect your photography. First, the angle of the sun in relation to your subject changes—from low angle at sunrise and sunset to high-angle at midday. The angle of the sun dictates the depth of shadows, which, in turn, emphasizes different components of the picture. A low angle produces long shadows that accentuate shape and texture, while a high angle minimizes shadows, reduces the illusion of depth, and gives flat lighting that emphasizes surface features.

As the angle of the sun increases, the temperature of the light changes, and with it the color of light. These changes influence the mood of the scene with the deep oranges of early morning and late evening. As the angle of the sun increases and, with it, the level of white light entering the scene, so the color temperature alters, giving a blue color cast that makes your images appear cooler. How strong this blue color cast becomes depends on determining factors, such as cloud cover.

So, under natural lighting conditions, how your subject is lit is dependent on the time of day you photograph it. Timing may well also determine the type of film or white balance settings you use, or whether you use accessories such as color correction filters or reflectors.

4.4 *As the angle of the sun relative to the earth's surface increases, so the color temperature of light increases. When the sun is at a low angle the color temperature is low. At the sun's peak, around midday, the color temperature is at its highest and light appears white.*

4.5

4.5 *In the early morning and in late afternoon when the angle of the sun is low, shadows are long. As the sun rises during the day the length of shadows decreases and is virtually non-existent when the sun is directly overhead.*

4.6

TIP

The color temperature at sunrise is around 3,000K. Daylight-balanced film is calibrated at 5,500K and, with no correction, the film will give an orange color cast, emphasizing the beauty of the warm light. This warm color can be enhanced further with the addition of an 81A warm filter—anything more will exaggerate the effect and give unnatural-looking results. If you want to compensate for the difference between the actual color temperature and the temperature daylight film is balanced to record in order to remove the color cast, then you can use an 80A (blue) filter.

If shooting with a digital camera then you can either set the White Balance to 3,000K (which is the equivalent of adding an 80A color-correction filter), leave the White Balance setting on 5,500K (equal to no adjustment on daylight-balanced film), or set the White Balance to "cloudy" (the same as adding an 81B warm filter).

Another option is to use a film that enhances warm colors—red, orange, and yellow—or a film that gives extra saturation to colors, making them deeper and more vibrant. For example, many landscape photographers use Fuji Velvia, because of its strong saturation properties, also much loved by publishers because it adds "punch" to the printed page.

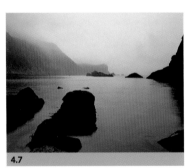

4.7

Sunrise

Many landscape photographers consider sunrise to be the ideal time of day for photography. This partiality to early morning light is not only because the light is often rich in warm colors and the shadows emphasize shape and texture, but also because morning light is cleaner and more crisp due to the lack of dust in the air, caused by the high levels of human activity during the course of the day.

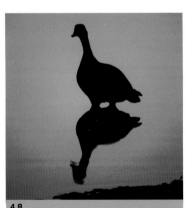

4.8

4.6 *Early sunrise over the rocks at Dunstanburgh, Northumberland, England.*

4.7 *The soft light of sunrise penetrates the early morning mist near Durdle Door in Dorset, England.*

4.8 *The lighting in this shot, taken at sunrise, shows the powerful, graphic effects you can achieve.*

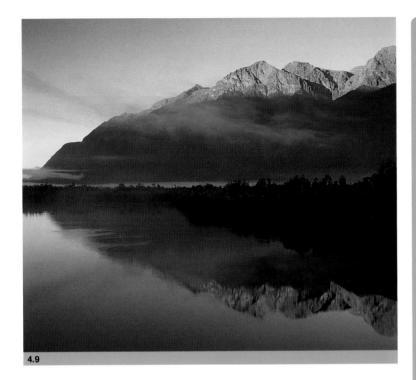

4.9

Early morning

As the sun rises, additional white light penetrates the earth's atmosphere and the deep red and orange of sunrise succumbs to a brighter, more yellow light. But, the long, form-filling shadows remain, making early morning a favorite time for landscape photographers.

4.11

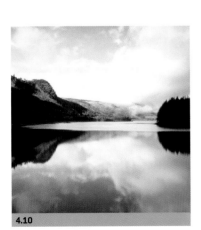

4.10

4.9 *Early morning is an ideal time to photograph still landscapes such as this scene of Mirror Lake in New Zealand.*

4.10 *This shot nicely captures the tranquillity of an early morning lake scene.*

4.11 *The Jurassic coast in Dorset, England. Early morning haze can add a surreal quality to landscapes.*

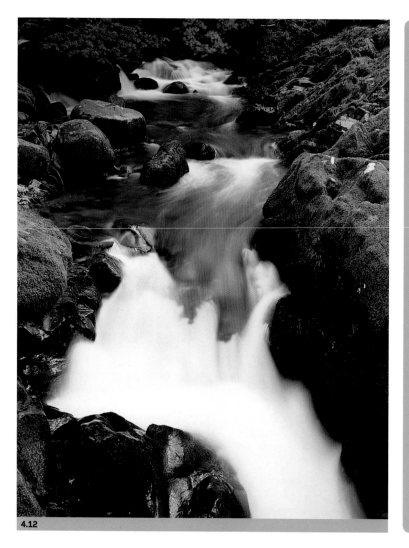

4.12

4.12 *Aira Force, Lake District, in England.*

Late morning

By late morning, most of the warm color is lost as a higher level of white light now penetrates the atmosphere. Shadows, too, begin to shorten, with the result that texture detail and form begins to fade. As shadow depletes so does contrast. The effect can be liberating (or not) depending on what you are trying to achieve with the picture. For example, contrast and shadow when the sun is at a low angle intensifies form, but that same lighting can also hide important detail.

4.13

4.14

4.13 *A coastal resort, Cornwall, England.*

4.14 *A stone church in Northumberland, England.*

Midday

At midday the sun is at its peak and at the highest angle to the ground. You will often hear the light at midday referred to as "flat", because the lack of shadows created by the high angle of the sun reduces the illusion of depth in a photograph. This lack of shadow, however, can be used to your advantage when photographing subjects where the main emphasis is placed on the features of that subject, such as record shots of buildings.

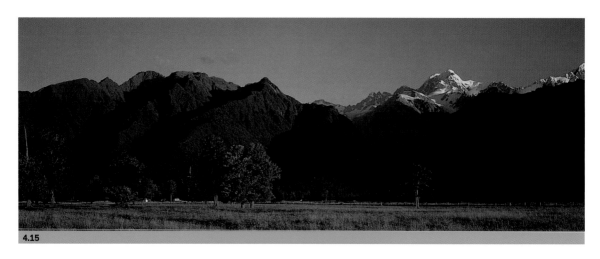

4.15

4.16

4.15 *The "southern Alps", South Island, New Zealand.*

4.16 *Urquhart Castle on Loch Ness, Scotland.*

Afternoon

Once the sun has reached its peak, it begins its descent toward sunset. The shooting conditions during the afternoon mirror that of the morning: the color temperature begins to reduce and a yellow glow replaces the harsh white light of noon. As the day draws on, the late afternoon light takes on a deeper golden glow and shadows begin to reappear, creating the illusion of depth and giving form and texture to subjects.

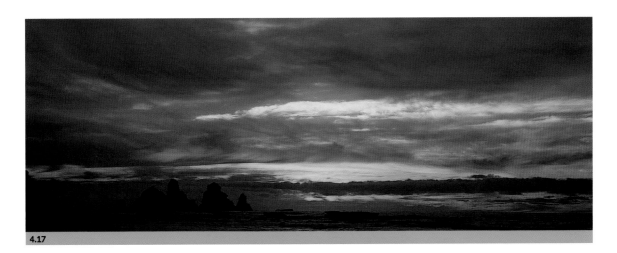

4.17

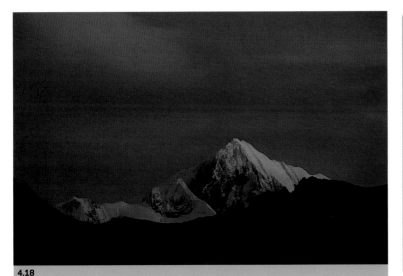

4.18

4.17 *Greymouth, South Island, New Zealand.*

4.18 *Lenticular cloud over Mount Tasman, South Island, New Zealand.*

Sunset

Sunsets are one of the most popular photographic subjects. Like sunrise, the light at sunset is full of deep, warm colors and the shadows cast by the low angle of the sun are soft and long. Shapes take on a three-dimensional form as the contrast between lit and unlit areas of the scene intensifies.

You often find that the oranges and reds of sunset are deeper than those of sunrise. This is not because the color temperature is any different but because of the level of dust in the air. At sunrise, the earth is settled from the night's relative inactivity. During the day, we create dust that lingers in the air which is constantly disturbed by activity. This dust affects the way light is reflected and helps to create the appearance of more intense colors.

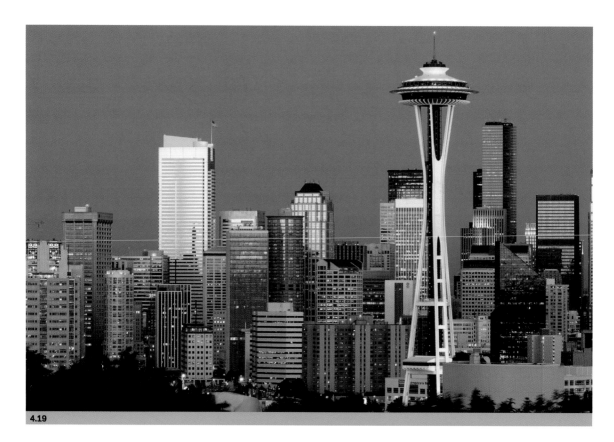

4.19

4.19 *Seattle skyline, Washington, USA.*

Dawn and dusk

Dawn and dusk are periods in between light; the time when day and night merge. It is the period when darkness fades and daylight threatens, and an ethereal atmosphere pervades. During this time, light doesn't last very long, but offers the photographer some of the most beautiful conditions in which to photograph, where the colors are warm yet subtle, and where the shadows have soft edges.

Photography at dawn and dusk also gives you the opportunity to mix natural and non-natural light. For example, in the image above (4.19), the darkening sky highlights the huge variety of artificial lights in the cityscape.

TIP

One of the things you'll notice most about low light is that it doesn't last very long, which means you must work quickly, ideally having pre-chosen your shooting position, or at least given yourself enough time to decide on your composition and set up your camera. You will also be shooting at long exposures and will need to consider the law of reciprocity failure.

4.20

4.21

4.22

FROM SUN TO STORM: LIGHTING AND THE WEATHER

Everything I have discussed thus far has assumed consistent weather conditions. Of course weather changes, and with it the lighting conditions in which you photograph. For example, the intensity of light on a cloudless day is much greater than it is when storm clouds fill the sky. Depending on the weather, the sun can change from a point source—like a spotlight—to an omni-directional source where the lighting is spread around more evenly, similar to a photographic light box. And, a misty morning can give light an almost ethereal character.

Thus, in much as the same way as the time of day changes the angle of light and the color temperature of light, the weather also affects the temperature and the size of the light source. And, as the time of day affects the mood of your photographs, so too will the weather conditions.

4.20—4.22 The weather conditions will affect both the size of the light source and the mood of your pictures. Compare these three images and see how the different conditions create different emotional responses.

4.23 *On cloudless days, when the sun is directly overhead, images can appear flat and lacking in form. In this image it is hard to determine the depth of the scene, as the foreground appears to merge into the background, even though the distance between foreground and background stretched is around one mile.*

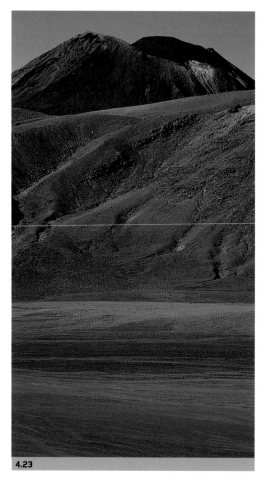

4.23

Clear blue skies and sunshine

Most people, when they talk about "good weather", are referring to the sort of weather we see on bright, sunny, cloudless days; the sort of weather we all want to experience on vacation.

Photographers, however, are different. For us, bright cloudless days are some of the worst days for photography: featureless skies, harsh shadows, and high contrast produce dull scenes and thorny technical problems.

The key to making the most of direct sunlight is to combine it with the most sympathetic time of day and turn some of its limitations to your advantage. For example, direct sunlight often causes high levels of contrast. Turning this contrast to your favor and shooting when the sun is at a low angle in the sky can produce some very effective silhouettes. Altering the exposure settings and exposing for the shadows will completely alter the effect and produce "rim" lighting, lending your subject a beautiful "halo".

So, by combining direct sunlight with a low angle and shooting into the light, you can create stunning, evocative images full of visual energy and powerful personal expression.

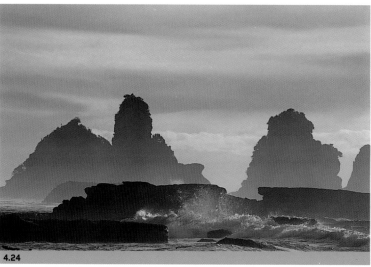

4.24

4.24 *The rays of light in this image create a soft, dreamy atmosphere.*

4.25—4.27 *Waiting until later in the day means you can use the point source of light from the sun to create more artistic and appealing effects, such as silhouettes, and rim lighting.*

4.25

4.26

TIPS

Try to avoid vast expanses of blue featureless sky by dropping the angle of the camera and raising the position of the horizon, or by including tall structures, such as buildings or trees, to break up the skyline and add interest.

Use the high levels of contrast to your advantage by shooting into the light early in the morning or later in the afternoon, creating silhouettes and golden halos around your subject.

When shooting into the light, be careful not to look directly at the sun, and use a lens hood to help avoid lens flare.

Avoid high, overhead direct lighting when photographing portraits outside.

4.27

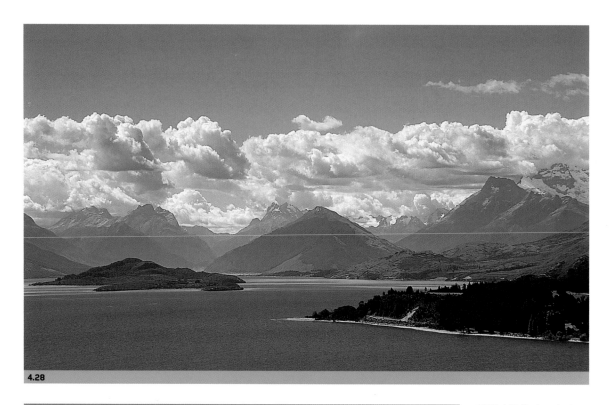

4.28

4.29

4.28 & 4.29 *Broken cloud helps to bring interest to otherwise featureless skies.*

4.30 *Ever-changing lighting conditions, which can be caused by broken cloud passing in front of the sun at irregular intervals, can make setting exposures a complicated affair.*

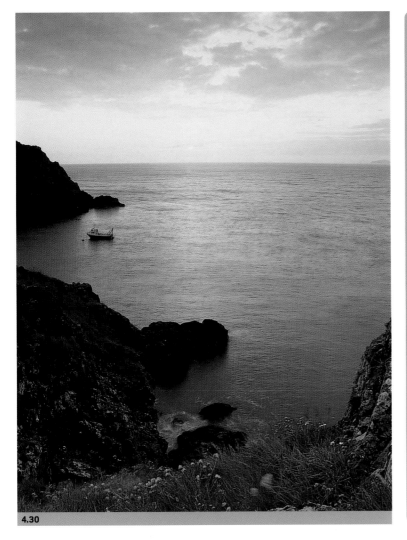

4.30

Broken cloud

Sunny days do not always have clear blue skies, but are often accompanied by large, white fluffy clouds. Broken cloud offers the photographer two advantages. Firstly, it helps to break up featureless blue skies, adding interest to landscape pictures. Cloud formations are often a prerequisite if selling images to postcard publishers, for example. Secondly, when a cloud drifts in front of the sun, it acts as a large diffuser, turning direct sunlight from a point source to an omni-directional source of uniform light.

This even spread of lighting softens shadows and reduces contrast, giving a much less harsh feel to the scene, and producing sympathetic lighting for outdoor portraits. However, one of the problems of broken cloud is that because the intensity of light is always changing, metering for exposure becomes a continuous activity throughout your shooting time.

4.31

Overcast days

On overcast days, the cloud cover acts as a giant diffuser throwing a completely uniform level of light on the scene below. It is the same effect as attaching a diffuser box to the front of a flash unit. This uniformity softens shadows and reduces contrast to a greater degree than broken cloud conditions and is ideal for photographing subjects that suffer under these conditions, such as portraits and waterfalls. Similarly, intensity of light fluctuates far less, making calculating exposure a simpler task.

A downside to overcast days is that, like clear blue skies, overcast skies lack any real interest for the landscape photographer. Even their color, white or gray, is uninteresting. So, when photographing on overcast days, it is just as important to reduce the area of sky visible in the picture by changing the angle of the camera or using tall structures, such as trees, to add interest.

4.31 & 4.32 *Overcast conditions, where the clouds turn the direct sunlight to an omni-directional light source, can be ideal for photographing scenes such as waterfalls, forest streams, and leafy glades, which demand subtlety.*

4.32

4.34

4.33 *The light in this image is diffused by the shade of the trees, but, combined with the overcast light, it makes for an atmospheric shot of this glade.*

4.34 *When photographing high-contrast scenes, such as this Brown bear fishing for salmon at the waterfall along Brooks River, direct sunlight can make a well-balanced exposure impossible. Waiting until the sky is overcast will reduce levels of contrast and give more even tonality.*

4.35 *The problem with overcast days is the lack of any subject interest in the sky, which can be a problem for landscape photographers.*

4.33

TIPS

SHOOTING ON OVERCAST DAYS

Use the reduced level of contrast and soft shadows to photograph subjects that are suited to these conditions, such as people, flowers, woodlands, and waterfalls.

Restrict the area of sky visible in the picture by changing the angle of the camera, using a longer focal length lens to narrow the angle of view, or by using features to add interest.

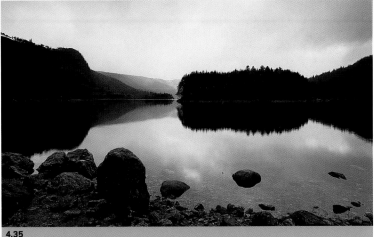

4.35

Stormy weather

While the thought of racing out into a storm with all your electronic equipment and instrumentation is daunting, if not a little foolish, stormy weather can be the inspiration for highly evocative, characterful images that transform an average scene into one of high photographic impact—the "wow" factor, again.

Storm conditions can provide some of the most dramatic lighting effects in outdoor photography. From landscapes where dark, ominous skies are counteracted by brightly lit foregrounds, to shafts of light cutting through breaks in the clouds, through to one of everyone's favorite natural phenomena: rainbows.

The difficulty of photographing in stormy weather—aside from the practical problems—is due to variations in the intensity of light across the scene. While these variations create interesting and strong compositions they need to be metered for carefully, and minute adjustments made to compensate for the variations. Sometimes, these adjustments can only be made in the darkroom or on the computer at the processing stage. However, post-camera processing can be minimized by effective use of compensating filters, such as neutral density graduated filters that help to equalize variations in tone.

4.36—4.39 *Venturing out in stormy weather may not be your idea of fun. But, for the dedicated photographer, stormy conditions can produce some of the most compelling lighting conditions imaginable— from rainbows to multiple lighting effects.*

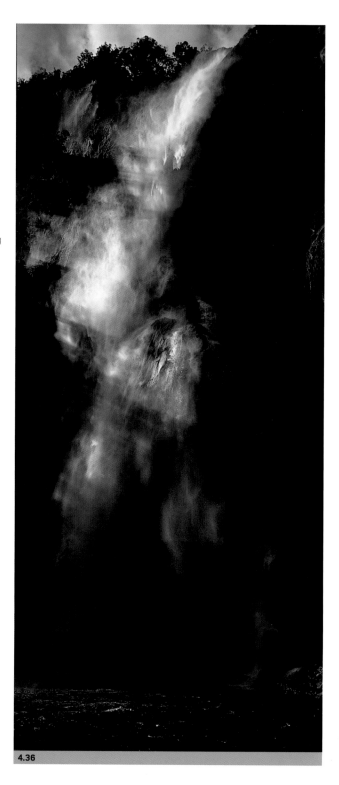

4.36

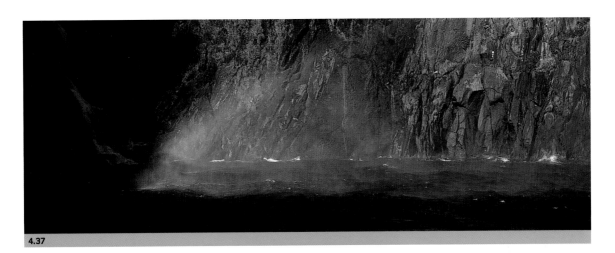

4.37

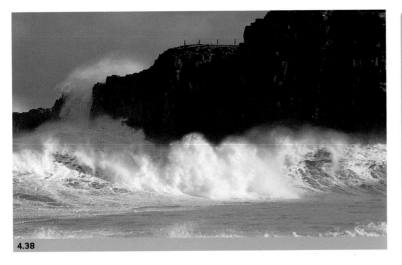

4.38

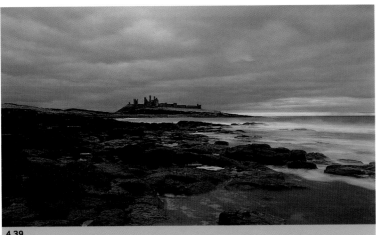

4.39

TIPS

Keep your camera protected from the elements.

When confronted with variations in light intensity, make a decision on which part of the scene is the most critical to your composition and meter for that spot.

Use graduated neutral density filters to help equalize the tones between dark skies and brightly lit foregrounds.

Adjusting your camera position can increase the intensity of color in rainbows.

Use the differences in light intensity to add to the dramatic atmosphere of the scene.

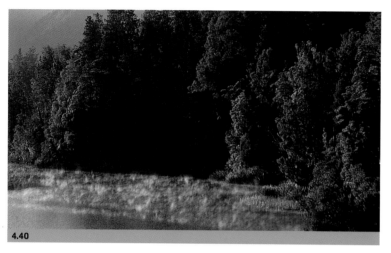

4.40

Mist, fog, and haze

Mist or fog, particularly early in the morning, can create some wonderfully atmospheric photographs. The effect of mist and fog on light is much the same as the effect caused by clouds in that they act as natural diffusers of a point light source. However, being less dense than clouds, more light passes through, and so mist can appear brighter. These weather conditions also have less effect on the color temperature of light so that, while clouds can often block the orange rays of sunrise, mist and fog allow some of that orange light to pass through, keeping the overall warm tone of the scene. This effect is heightened when photographed with the camera pointing toward the sun and the subject is backlit.

Mist or fog can also help to add interest to otherwise dull areas of a scene and can be used as an important element of the overall composition. Be careful, however, that it doesn't obscure too much of the scene and detract from the image you're trying to make.

Haze is another matter. Haze is caused by dust and salt particles in the air (as opposed to water particles that cause fog and mist). As such, haze is "dirtier" than fog or mist, which is not often very helpful to photographers. However, haze does have some endearing features. I have mentioned that the warm glow of sunset tends to be richer than that of sunrise. The intensity is caused by haze, with the same particles that dirty the air during the day, which helps to create the sunset's depth of color.

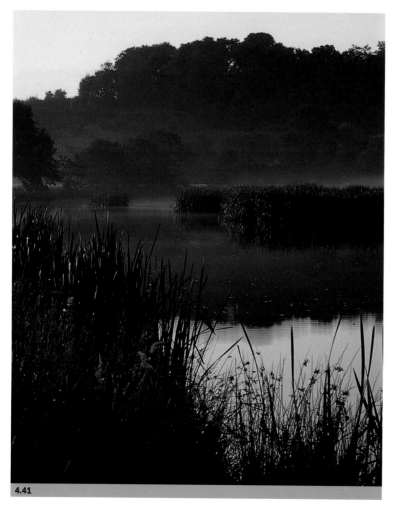

4.41

4.42

4.43

TIPS

In the morning use an 81 series warm filter to enhance the warm glow of the light.

Using an 81 series warm filter on a very hazy evening (sunset) may overdo the effect and produce unnatural-looking pictures.

Backlighting helps enhance the effect of morning mist, producing ghostly images.

Keep an eye open for mist and fog obscuring too much of the scene you're photographing.

4.40—4.43 *Mist or fog, like clouds, cause the sun to become an omni-directional, diffused light source reducing levels of contrast. When combined with warm, early morning light, the effect can be very ethereal.*

PHOTOGRAPHING THROUGH THE SEASONS

Spring

Spring begins the year for nature photographers. The short days lengthen, and nature begins to waken. Enthusiasts reach for their cameras and head out into the field. And understandably so, with such a rich variety of subjects to photograph: spring flowers blooming, new shoots on old trees, newborn animals venturing into an unknown world. Opportunities abound.

Spring brings with it better weather and longer shooting hours. The sunrise is earlier than in winter, and the sun is above the horizon until much later in the afternoon. The lower angle of the sun means that the shadows remain prominent, adding texture and form to subjects. Spring showers can help to saturate the colors in flora, which will be further enhanced by using a polarizing filter.

4.44 *Mount Rainier National Park, Washington, USA. The shorter days of winter begin to extend in spring, enabling photographers to get out early and capture shots, such as this.*

4.45 *Unfurling fern tendril. This close-up shot is an ideal way to record the flora and fauna of spring.*

4.46 *Haze is prevalent during the summer months. The effects can be used to advantage by strong compositional forms.*

4.47 *Summer lighting can accentuate the features of a scene, such as this view taken in the Lake District, England.*

4.48 *Dunstanburgh, Northumberland, England. On clear summer days, sunrise is a time of great photographic lighting.*

4.44

4.45

TIPS

On wet spring days, use a polarizing filter to remove surface reflections from leaves and to saturate colors.

On overcast days, attach a macro lens to photograph the new spring flowers.

Enhance the warm colors of sunrise with an 81A or 81B filter, or by setting an equivalent WB setting on your digital camera.

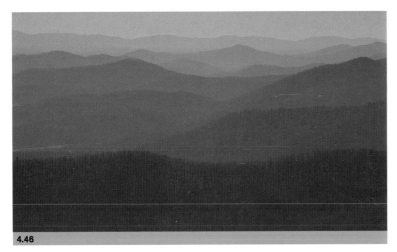

4.46

4.47

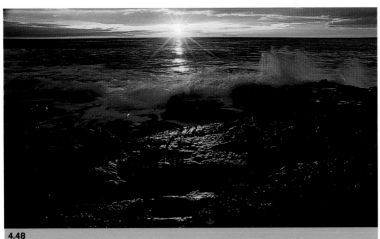

4.48

Summer

Arguably the worst season for outdoor photography, summer is the season when most photographs are taken. In summer, shooting begins in the early hours. On clear days, sunrise can produce stunning light, full of intensity and warmth, making for great landscape photographs. Later in the day, blue skies can provide the sort of lighting beloved by postcard publishers; lighting that accentuates the features of a scene and gives a picture a sense of place.

Care should be taken, however, as harsh shadows and flat lighting, usually seen at the height of the day, can produce less pleasing effects that can ruin the aesthetics of your composition. Summer is also a time of haze, with added dust in the air, reducing the clarity of light. Later in the day, however, this same dust will fuel the deep red colors of the dying sun.

TIPS

Avoid photographing during the middle of the day when the high angle of the sun casts harsh shadows and produces flat lighting.

The best times of day for summer photography are sunrise and early morning, late afternoon and sunset.

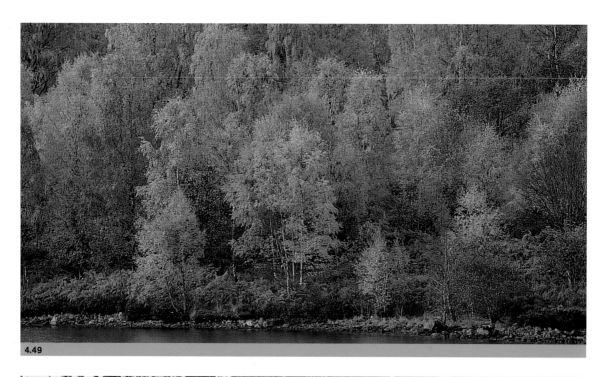

4.49

4.50

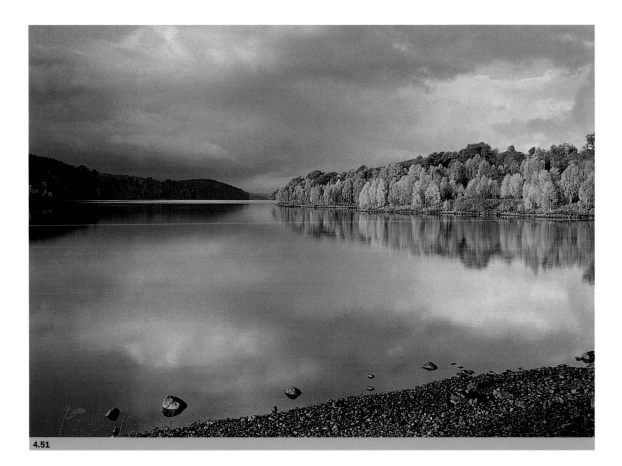

4.51

4.49—4.51 *Fall is a time of beautiful rich, warm colors, which can be exploited by the outdoor photographer.*

Fall

Fall is the season of color, and these colors can be used in your compositions to beautiful effect. It is a powerful communicator, and mixing the reds of dying leaves with the greens of mosses and evergreen trees will give your pictures a special visual energy. To bring out the texture and detail in fall foliage, the best time of the day for photography is mid-morning and mid-afternoon. Like springtime, sunrise is later in the morning and sunset earlier in the day. And, like springtime, the sun doesn't rise fully overhead, which is ideal for landscape photography.

TIPS

Photograph leaves and foliage during mid-morning or late afternoon in order to catch the best light for emphasizing texture.

Fall colors can be given added saturation by using a polarizing filter.

Use directional light to emphasize the rich colors of fall and try compositions that match complementary colors, such as red and green, to give your pictures visual energy.

4.52

4.53

4.54

Winter

Winter is one of my favorite seasons for photography. The low angle of the sun, the extra clarity of the light, and the lack of foliage all move toward emphasizing the elements of design— line, pattern, shape, and texture— that are the cornerstone of making photographs.

Winter days are short and sunsets are early. However, it is possible to do some good shooting throughout the day due to the low angle of the sun, with its accompanying long, form-filling shadows.

In winter, colors tend to be muted— pastel shades are more prominent than the deep, saturated colors of summer and fall. This effect can be pleasing, giving your images a subtle ambience, but if extra saturation is required, then using a polarizing filter will help to bring out existing color.

4.52 *In winter, the angle of the sun often remains low throughout the day, providing great opportunities for special lighting effects, such as the backlighting on these ice crystals.*

4.53 *Winter is a wonderful season for photography where graphic elements of design, such as line and pattern can be exploited for strong photographic compositions.*

4.54 *The low angle of the sun also produces strong shadows, which help to accentuate form and give pictures a three dimensional feel.*

TIPS

Use a polarizing filter to bring out colors that are muted over the winter period.

Make the most of the low angle of the sun by shooting throughout the day.

Use the lack of dense foliage to emphasize the graphic elements of your composition.

WHEN TO PHOTOGRAPH WHAT

The following is a guide to the best conditions for photographing particular subjects. That is not to say that these are the *only* times at which to take pictures of those subjects, but simply ideas, or prompts, for those times and conditions that are proven to work for your photoraphy. For example, if I suggest photographing cityscapes in winter, it doesn't mean they can't be photographed at any other time of the year.

One tip I give to students at my workshops is to experiment. Never be afraid to try ideas "outside the box". For example, when photographing moving subjects, rather than using a fast shutter speed to freeze motion, try shooting at 1/4sec, say, and see what happens. By way of another example: many advise never to shoot portraits outdoors at noon on a clear summer day because of the unflattering shadows created by direct midday lighting. Yet Edward Weston, one of photography's greatest exponents, once shot a

whole portfolio of portraits in this way with great success. So, experiment with your own ideas. How you see and interpret different lighting conditions is all part of developing your own photographic signature. And, after all, the only person who will see any unsuccessful results is you. In the meantime, here are some ideas for you to play with.

Subject	Time of day	Weather	Season	Comment
Tree silhouettes	Sunset	Clear	Winter	The lack of leaves on trees in winter adds to the design element of the picture, emphasizing line, which is further enhanced by the strong graphic statement made by silhouettes.
Portraits	Early morning or late afternoon	Overcast	Any	Overcast lighting will soften the shadows and reduce contrast. Use a reflector to lighten the shadow side of the subject.
Wildlife	Early morning or late afternoon	Clear	Spring/ summer	Wildlife activity is greater in spring and summer. The warm glow of early morning and late afternoon sun will add to your composition.
Coast	Sunrise	Clear	Any	Warm light at sunrise can often be complemented by sea mists, lending pictures a beautiful radiance.
Postcard scenes	Late morning or early afternoon	Broken cloud	Summer	Postcard publishers prefer pictures to have bright, fluffy clouds and sunny weather.
Woodland/forest	Early-to-late morning and late afternoon	Overcast	Fall	The fall colors of woodlands and forests are one of photography's highlights. Overcast weather will help to reduce contrast, while low-angled sunlight brings out the texture in leaves. For added color saturation, use a polarizing filter.
Waterfalls	Morning or afternoon	Overcast	Winter/ spring	Waterfalls are notoriously high in contrast subjects and are best photographed in overcast conditions, which reduce contrast. Higher rainfall in winter and spring adds to the level of water flow. Some waterfalls can dry up in summer and fall.

Subject	Time of day	Weather	Season	Comment
Flowers (close up)	Early morning or late afternoon	Hazy	Spring/ summer	Use the low angle of early morning or late afternoon sun to bring out the texture in petals. Overcast conditions reduce contrast but you may want to add a polarizing filter to saturate the colors.
Flowers (expanses)	Late morning or early afternoon	Clear, broken cloud, overcast	Spring/ summer	Large expanses of flowers often look best when set off against a clear blue sky.
Mountains	Sunrise and early morning, late afternoon to sunset	Clear or broken cloud	Any	Mountains look good at all times of year, often blanketed in snow during winter and a backdrop to flowering meadows in summer. Low-angled light will help to give them a three-dimensional form.
Hills and valleys	Early morning or late afternoon	Clear	Any	The low angle of light in early morning and late afternoon helps to give hills and valleys form.
Lakes	Early morning	Clear (and still)	Spring/ summer	On very still sunny days, the surface of a lake can produce mirror-like reflections.
Rivers	Sunrise and early morning, late afternoon, sunset	Clear or broken clouds	Any	Silhouetting the bends in the river against a colorful sunrise or sunset can produce a distinctive graphic statement.
Cityscapes	Dusk or night	Any	Winter	Reduced levels of dust in winter gives a clarity to the scene that can be obscured by smog or haze in summer. Waiting until dusk or nightfall will bring the city to life with a mix of natural and artificial light.
Still life	Early morning or late afternoon	Overcast	Any	Shadows formed by low-angled sunlight will give form to still-life subjects, while reduced contrast from overcast weather will make faithful exposures easier.
Snow	Early morning or late afternoon	Clear	Winter	Backlighting on a clear winter's day will bring out the best in snow and ice crystals.
Record shots	Midday	Overcast	Any	The midday sunlight will reduce shadows and emphasize the features of your subject.
Insects	Early morning	Hazy	Spring/ summer	Insects are best photographed when it's cooler, since low temperatures make them inactive. Clear mornings are always cooler because cloud cover works as an insulator, retaining heat at the earth's surface.
Pets	Early-to-late morning and late afternoon	Overcast	Any	The slightly brighter light of late morning and early afternoon will enable you to select faster shutter speeds to freeze movement. Overcast conditions will help to soften shadows and reduce contrast.
Fast-moving action	Late morning and early afternoon	Clear or overcast	Spring/ summer	Fast-moving action often requires the use of fast shutter speeds. Brighter weather conditions will allow you greater flexibility in your exposure settings.

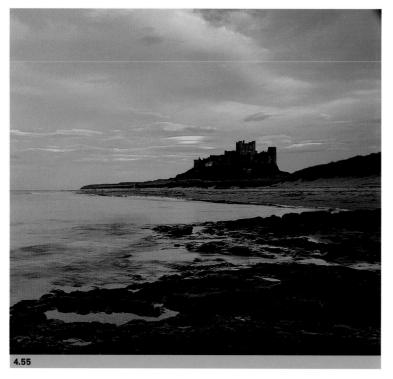

4.55

CHANGING LIGHT

Sometimes, even waiting just a single hour can make all the difference to the type of light illuminating the landscape. Study the pairs of photographs, here and overleaf, and see how changing light has completely altered the mood of the images.

The first image of Bamburgh Castle, in Northumberland, England, (4.55), was taken at around 5pm on a fall day. The sky is still blue, which, combined with the dark rocky foreground, gives the picture a cool, mysterious feel. The low angle of the sun creates shadows on the castle walls, giving the castle a three-dimensional form. In the second picture, (4.56), taken about an hour later at around 6pm, the mood has completely changed. The setting sun bathes the scene in a warm pink glow. A slow shutter speed has given the incoming sea a ghostly effect, which, together with the pastel coloring, makes for a calming picture. Notice how, with the sun below the horizon, the dark shadows on the castle walls, evident in 4.55, have become much softer and have almost disappeared completely, giving the castle a flatter appearance.

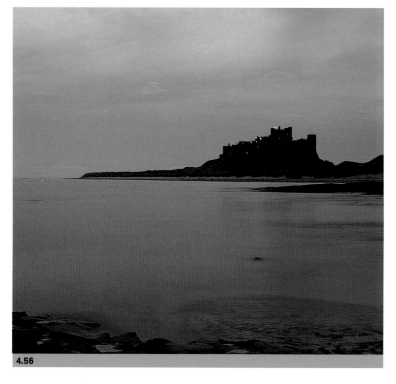

4.56

4.55 & 4.56 *Bamburgh Castle, Northumberland, England.*

A similar effect occurs with these images taken in the Okefenokee National Wildlife Refuge in Georgia, USA. The first and fourth images (4.57 and 4.60), taken at around 4:45pm as the sun begins to set, still have an overall blue cast, giving the scene a much cooler atmosphere. In the second and third images (4.58 and 4.59), taken 30 minutes later, the sun has set and the pictures come alive with deep shades of yellow, orange, and pink. Notice, however, how the images are less calm than the sunset scene taken at Bamburgh Castle, where the pastel colors soften the overall image.

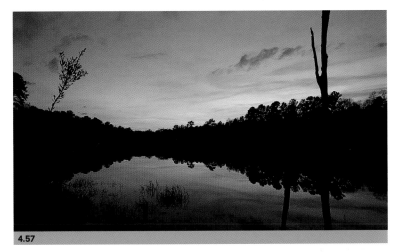

4.57

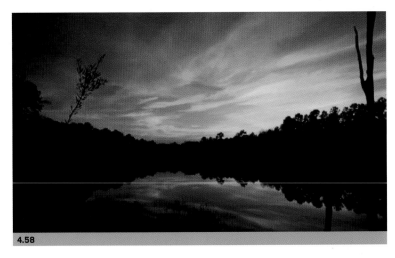

4.58

4.59

4.60

4.57—4.60 *Okefenokee National Wildlife Refuge, Georgia, USA.*

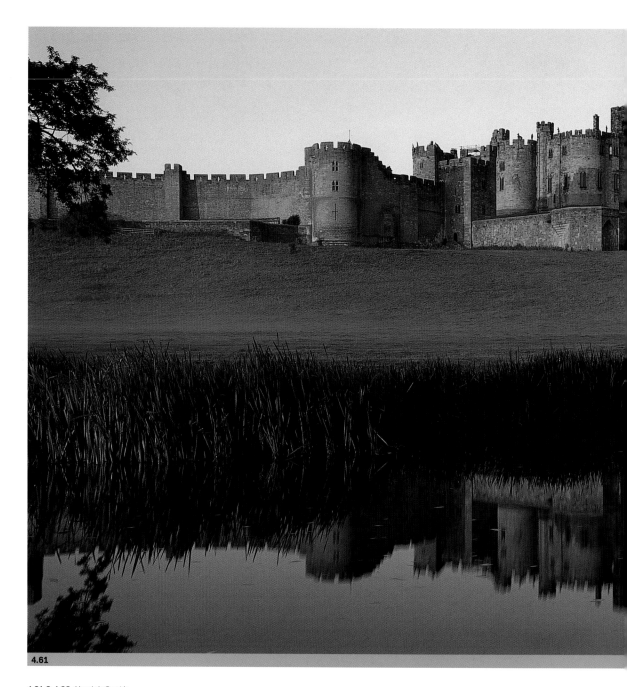

4.61

4.61 & 4.62 *Alnwick Castle, England. Light affects the way a photograph is perceived, and should be a major consideration when thinking about composition.*

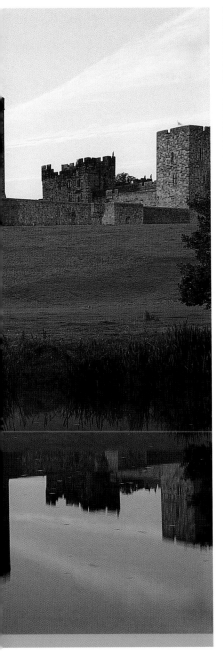

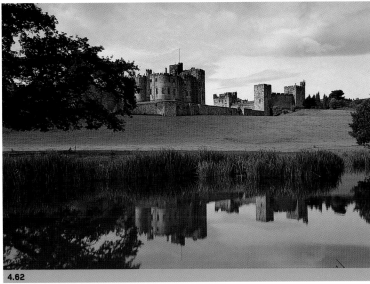

4.62

The same change in mood and color temperature can be seen in the early hours of the morning. In these images of Alnwick Castle in Northumberland, England, the difference in appearance of the castle between the first shot, taken at 8am (4.61), and the second shot (4.62), taken just an hour later, is a stark one. Sunrise was late in the morning as these pictures were taken in late fall. The color temperature in the first image is very orange, giving the picture, and the castle walls in particular, a beautiful warm glow. In the second picture, at around 9am, the warmth has subsided considerably and a much cooler image is created. Notice, too, how the low angle of the sun in the first picture adds a high level of contrast to the bank of reeds at the edge of the river, giving them form and depth. An hour later, those same reeds appear much less interesting, as the contrast is lost.

4.64

DIRECTION OF LIGHT

Changing the direction of light in relation to your subject will alter the level of texture and detail in the picture. Again, study the pairs of images over this, and the next few pages, to see how the direction of light affects the final image.

Side lighting

In both these images, the early morning sun, at a low angle to the subject, has cast shadows—in 4.63 to reveal the undulating surfaces of the snow, and, in 4.64, along the length of the reed. These shadows have given both of the subjects form and a three-dimensional image on a two-dimensional surface—the film. If taken much later in the day, both images would have appeared flat and uninteresting, and it would have been impossible to see the texture in either.

4.63 *Frans Joseph Glacier, South Island, New Zealand.*

4.64 *Lake Matheson, South Island, New Zealand.*

4.65

Top lighting

Top lighting, such as that found around midday when the sun is overhead, produces very flat images, lacking in shadow and, therefore, contrast. In the image of the Grand Canyon in Arizona, USA (4.65), this works well as it helps to detail the sedimentary layers in the rock face. However, the picture lacks depth and it is difficult to distinguish between one wall of rock and another. Some depth is given by including the cacti in the foreground. Notice the difference, however, between the appearance of the rocks in the left of the image and those in the top right of the picture, where shadow has formed—the rock takes on a much more three-dimensional look.

In the second image, of Monterey in California, USA (4.66), again, there is a complete lack of depth in the picture due to the absence of shadow. It is difficult to tell how far apart the boulders in the foreground are from the central rock and, in turn, from the boats in the background. However, it is easy to pick out features throughout the picture, which provides the kind of subject information that is often sought by postcard and calendar publishers.

4.65 *Grand Canyon, Arizona, USA.*

4.66 *Monterey, California, USA.*

Backlighting

Backlighting can be used to great creative effect, producing silhouettes and rim-lighting and helping to isolate and emphasize some of the elements of design fundamental to making good pictures.

In the first image, (4.67), backlighting has been used to create a contrast between the warm fall colors of the leaves and the multi-directional line of the tree branches. Neither side-lighting nor top lighting would have created this highly graphic effect.

The second image, (4.68), is less graphic, and places more emphasis on mood. Taken in Yosemite National Park in California, USA, backlighting has been used to emphasize the cloud creeping into the picture in the top right corner of the image. If this picture had been taken from the opposite direction, it would have produced a very flat image with little or no interest for the viewer. The effect is to create a picture with a slight sense of foreboding.

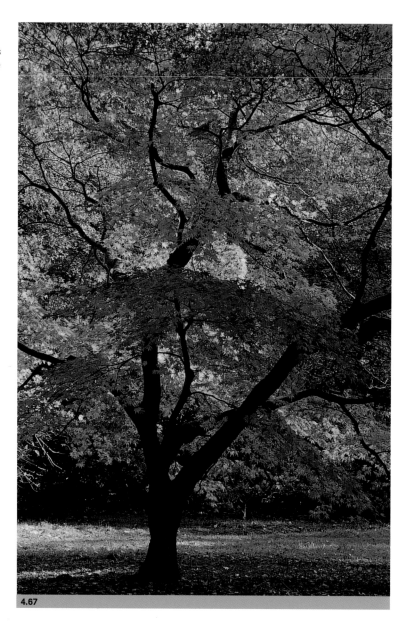

4.67

4.67 Westonbirt Arboretum, Gloucestershire, England.

4.68 Yosemite National Park, California, USA.

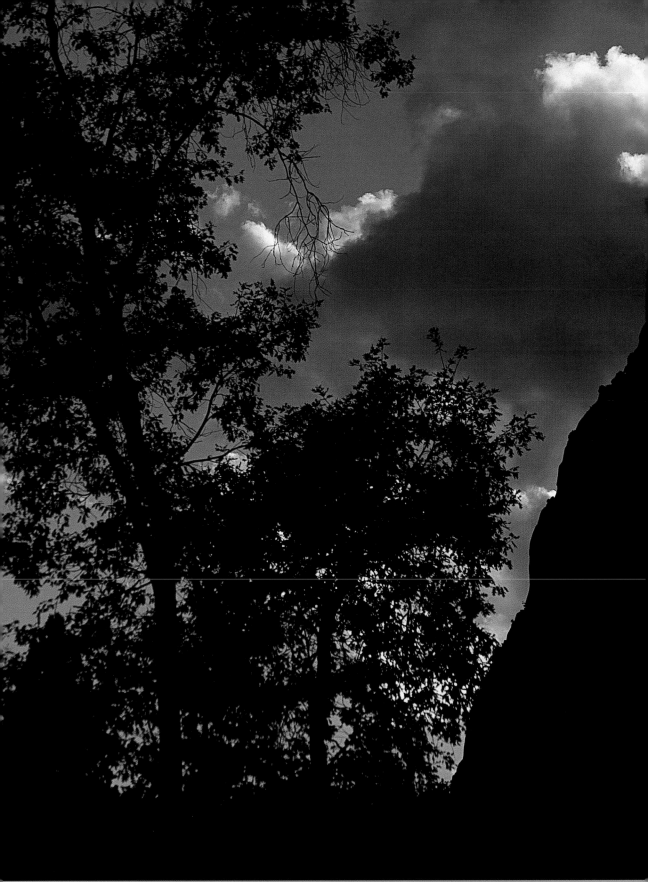

WEATHER

The weather has much to do with
the level of contrast in a scene. On
bright sunny days, with direct light
falling on the scene, shadows tend
to be hard and contrast increases.
On overcast days when the light is
omni-directional, having been scattered
by the clouds, shadows will appear
soft and contrast reduced. Compare
these four images to see the effects
of changes in weather.

Clouds and contrast

Weather patterns are notoriously
unpredictable in glacial regions.
These two pictures were taken just
moments apart. In the first image,
(4.69), there was very little cloud
covering the sky, and the sunlight
was direct, producing dark, hard-
edged shadows. The level of contrast
between the highlight and the shadow
is quite clear, to the extent that little
or no detail appears in some areas
of snow. In the second image, (4.70),
taken when the cloud cover had fully
formed and the sunlight was omni-
directional, see how much softer the
shadow appears. Contrast is reduced
and there is detail in both the shadow
areas and the highlight areas.

4.69

4.70

4.69 & 4.70 *Frans Joseph
Glacier, South Island,
New Zealand.*

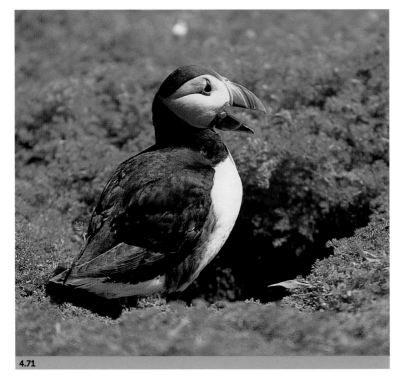

4.71

Both 4.71 and 4.72 were taken on the same day, just three hours apart—but in completely different weather conditions.

The picture of the puffin, (4.71), one of Skomer Island's main tourist attractions, was taken around noon with no clouds in the sky. As you can see, there is very little shadow, but the intensity of light falling on the white and black areas of the bird creates a high level of contrast. Under these conditions, it was impossible to retain detail in white and black areas. Having metered for the black feathers, some of the white feathers on the bird's breast have lost all definition.

Around 3pm, when the sky clouded over, I came across a guillemot, (4.72). Because the light was now omnidirectional, the level of contrast had dropped significantly and there is detail in both the dark and light areas of the bird.

4.72

4.71 *Puffin, Skomer Island, Pembrokeshire, Wales.*

4.72 *Guillemot.*

4.73

4.73 *Mount Cook and Mount Tasman, South Island, New Zealand.*

4.74 *Yosemite National Park, California, USA.*

4.75 *Tongariro National Park, North Island, New Zealand.*

4.74

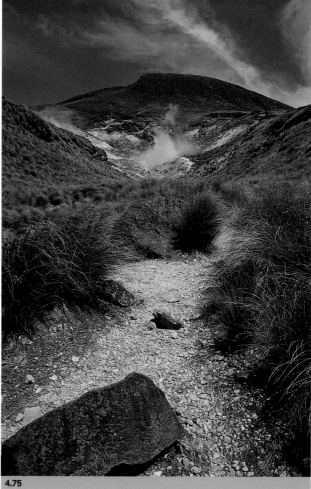

4.75

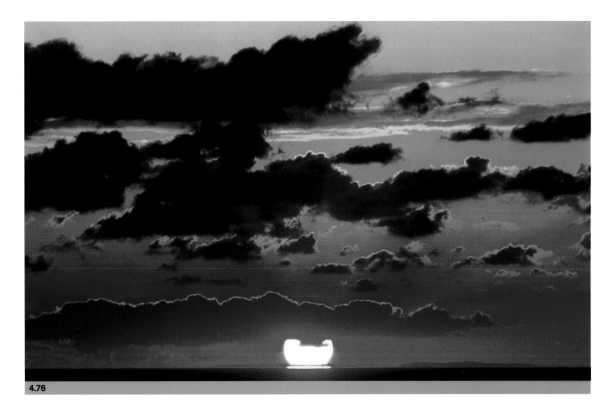

4.76

Clouds as subjects

A problem with cloudless skies is that plain blue can look a bit dull, and lacking in substance. Clouds add interest to your composition.

In the image taken at Yosemite National Park, California (4.74), the sky is completely clear and, while it doesn't overwhelm the picture, neither does it add any real interest.

Another image, (4.75), photographed in the volcanic mountains in Tongariro National Park in New Zealand is far more interesting. The wisps of clouds creeping into the picture space in the top right corner of the frame add interest and a sense of depth.

Sometimes, clouds can be the subjects themselves. The images of Greymouth in New Zealand, (4.76 and 4.77), were taken late in the day. The contrast in color, which creates layers in the image from top to bottom,

gives a sense of depth, and the altering shape of the clouds creates a visual energy. It is also an illustration of how the density of cloud cover affects the level of light passing through the cloud.

4.76 & 4.77 *Greymouth,
South Island, New Zealand.*

4.77

LOW–LIGHT AND NIGHT PHOTOGRAPHY

116 Getting started with low-light and night photography
Essential gear
Cameras

118 Lenses

120 Avoiding camera shake
Conventional methods
Hand-holding

122 Focus
Auto-focus
Focus screens

124 Flash and meters
Flash unit
Hand-held exposure meter

126 Film and film sensitivity
Digital sensors and amplification
Exposure
Measuring low light exposures

128 High-contrast scenes

130 Long exposures and the laws of reciprocity

132 Long exposures and digital noise

Many photographers head indoors when the sun goes down, but those who do are missing out. Low-light and night photography offer the photographer great opportunities for creative image-making. From the sky at night to the landscape at dusk and dawn, from cityscapes to wildlife—the scope for your camera is huge. What puts many off is having to learn new techniques, but the fundamental principles of photography at night are the same as those during the day. The rules of composition are the same, and light is still the essence of the captured image. So, what are these "fearsome" new techniques that make us prisoners to daylight? This chapter will help you find out.

GETTING STARTED WITH LOW-LIGHT AND NIGHT PHOTOGRAPHY

The basic fundamentals of photography are no different in low-light and night photography, but there are some techniques that are more prevalent, which are worth mastering. Principally, you will be working with slow shutter speeds and fast apertures, making blur from camera shake and vibration a real enemy. Calculating exposure will be more difficult to ascertain, and focusing can become a major challenge.

As well as some of the specifics mentioned below, it is sensible to make sure you are fully aware of how your camera operates—the position of the relevant controls, the direction of turn on dials for setting shutter speed and aperture, etc.—before you venture out. While I advise this for all types of photography, it is especially useful in the dark, since you won't have the same visual reference as that available during the day. Knowing how to operate your camera "blind" can save a lot of time, and sometimes will make the difference between getting the shot or not.

ESSENTIAL GEAR

The belief that low-light and night photography requires lots of new, expensive equipment is unfounded. Yes, you will require some additional kit, but none of it is particularly expensive and you may have some of it already.

Cameras

The main requirement of a camera in low-light conditions is that the shutter can be left open for long periods of time. At the very least this means that your camera must have a shutter-speed setting referred to as the "Bulb" setting. When set to "Bulb" the shutter will remain open for as long as the shutter release remains depressed, which can be for seconds, minutes, hours—and even days! Many modern SLR cameras have shutter-speed settings up to several seconds in regular increments (1, 2, 4, 8, 16, 30) and this can make long exposures slightly more accurate. Though, to be honest, the difference of a second or two during a 30-second exposure is minimal.

Another useful, though non-essential, tool built into some cameras is a facility for altering your film speed setting manually. This allows you to "push" your films—to make them work at a faster ISO rating than they are calibrated for. With digital cameras, this facility is replaced by the ISO equivalency setting, which allows you to alter the level of amplification for each shot.

A very useful tool when using SLR cameras is the mirror lock-up facility. Most of the vibration incurred when releasing the shutter is caused by the action of the mirror flipping up out of the way of the shutter curtain, allowing the light to pass through to the film/photo sensor. By locking-up the mirror prior to firing the shutter, the vibration is eradicated. This facility tends to come with only the more expensive SLR cameras. Some mid-range digital cameras offer the same facility.

With film cameras, the mirror is locked-up manually before the shutter is released. This has the advantage of removing all vibration caused by the mirror flipping out of the way of the shutter curtain, but does mean that you lose vision through the viewfinder and you also lose auto-focus and auto-exposure capabilities. This may be less of a problem in very low light where neither function operates effectively anyway. With digital cameras, the mirror is electronically locked-up after the shutter is depressed, but before the shutter curtain is opened. This allows you a constant view through the viewfinder and continued operation of auto-focus and auto-exposure up to the point of release. However, there is then a delay in the shutter curtain opening, which may cause you to miss the shot, for instance, if your subject is moving. It may also mean that you get some vibration. As with most things in photography, it's a bit of a compromise!

The last thing your camera must have is either a cable-release socket and/or a self-timer. When shooting in low light, it is important to minimize camera vibration. This can be diminished if a cable release or self-timer function is operated.

5.1 *To capture a scene in fading light at the end of the day, you will need a tripod, and remote cable release for best results.*

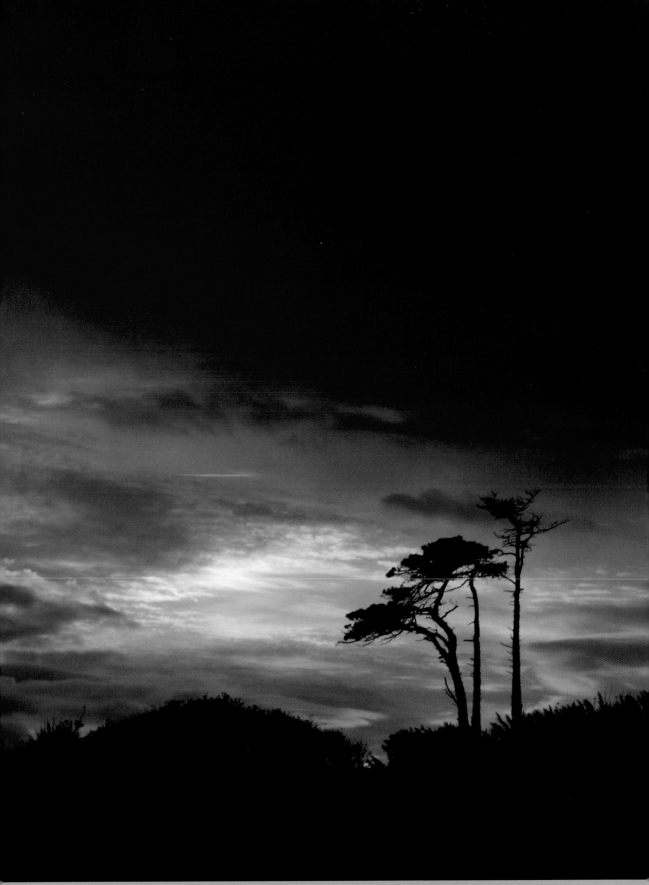

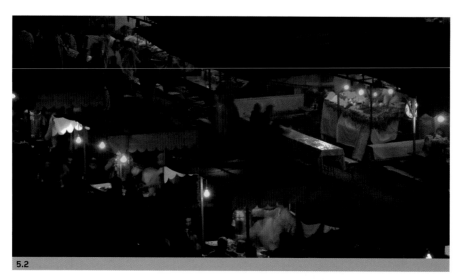

5.2

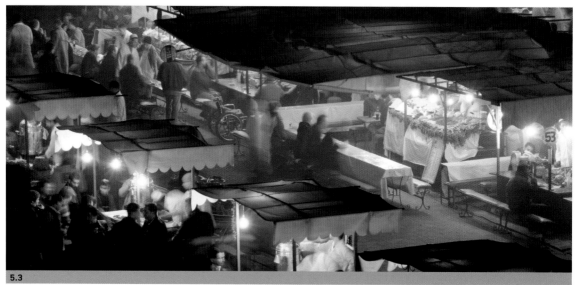

5.3

5.2 & 5.3 *With SLR cameras the speed of the lens will determine the brightness of the image in the viewfinder. When a lens is attached to a TTL camera it automatically opens up to its widest aperture, irrespective of the actual setting used in any given shot. Therefore, a lens with a fast (wide) aperture will allow in more light making the scene brighter than a lens with a slower aperture.*

Lenses

The lenses used for daylight photography are also suitable for low-light conditions. What is important to consider is the speed of the lens. A fast lens, such as a lens with an aperture of f/2.8 or faster, has two advantages over a slower lens (f4 or slower). Firstly, it allows you extra stops of light. For example, a lens with a maximum aperture of f/2.8 is two stops quicker than a lens with a maximum aperture of f/5.6—allowing four times as much light to reach the film/photo sensor at the same shutter speed. This has the advantage of letting you use faster shutter speeds, even when light levels are low. The second main advantage is the brightness of the viewfinder (for an SLR camera) and the ease with which you can see your composition and set your focus distance. A lens with a maximum aperture of f/2.8 allows additional light through the lens, making it is easier to see what you are doing in the viewfinder. This is not an issue with rangefinder cameras, and it is worth checking the level of brightness of the viewfinder if you are using this type of camera.

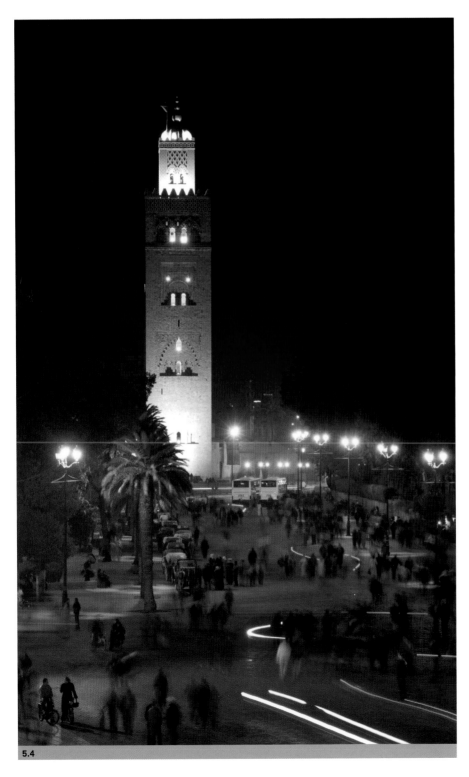

5.4 *To capture this night time image, I required a lens with a fast (wide) aperture.*

5.4

AVOIDING CAMERA SHAKE

Conventional methods

In the chapter "Useful equipment" (see page 46), we looked at the range of supports that are essential to achieving pin-sharp photography. The best option, of course, is to use a tripod. If you invest in a tripod, which I recommend, do make sure to buy a good-quality, sturdy tripod by a respected brand. If you don't have a tripod to hand, use some kind of solid support, such as a monopod, or a beanbag resting on a solid surface. If there is no option but to hand-hold your camera to achieve a shot, there are techniques for making sure you get the best, if not guaranteed results.

Hand-holding

The following techniques will help to keep the camera steady if it is necessary to hold the camera by hand. I will begin with a warning: the human body is in constant motion—blood is rushing through your veins; your heart and pulse are beating; your eyes are making often imperceptible movements and, of course, you're breathing. It is impossible to remain completely still and, while many photographers claim to be able to hand-hold a camera at slower shutter speeds than anyone else, what they really mean is that they've never examined their pictures with the eye of a professional picture editor.

There is a rule of thumb for hand-holding a camera, which says that for shake-free images, simply set your shutter speed relative to the focal length of the lens you're using. In my experience, this "rule" has to be taken with a precautionary pinch of salt. There are so many external factors that can influence your ability to hold a camera steady that, at best, this technique only works under ideal conditions. And, just to give you an example, consider the difference in size and weight between a 300mm lens with a maximum aperture of f/5.6 and one with a maximum aperture of f/2.8.

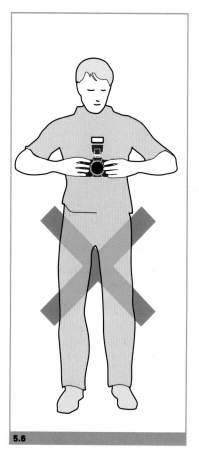

5.6

5.7

5.6 & 5.7 *When hand-holding the camera, keep your arms close to your body for extra support.*

5.8

5.9

5.8 *Hand-holding the camera in low light can add to the problem of camera shake, which will be seen as blur in your pictures.*

5.9 *Attaching the camera to a tripod will help resolve the problem of hand-holding in low light, giving you pin-sharp pictures.*

NOTE

With minimal levels of light to work with, photography in low-light conditions often dictates the use of shutter speeds measured in seconds, or even minutes. This is frequently true even when using fast films and fast ISO equivalency ratings. At such slow shutter speeds the possibility of blur from camera shake and vibration is greatly increased and necessitates the use of a camera support. Several options for camera support are available to you and some are more effective than others.

5.10

5.11

FOCUS

Focusing can become a problem when there is little natural light, simply because it's difficult to see anything through the viewfinder. And switching to auto-focus doesn't necessarily offer the best solution.

Auto-focus

Auto-focus tends to operate in one of two ways, either by infrared distance-detection or by contrast-detection. Infrared distance-detection will work in low-light conditions but, with the minimal levels of contrast often found in low-light conditions, contrast-detection systems will usually fail. For the same reason, manual focusing without infrared distance-detection can be tricky, as it is not always possible to see clearly what you're doing. The focusing problem is further compounded by the fact that you are most likely shooting with the lens aperture wide open, therefore depth of field will be minimal, making accurate focus more critical.

There are two techniques you can use to aid focusing when light is low. First, try to find a light in the scene, such as a streetlight or a lit window that is the same distance away from the camera as your subject. Focus on the bright point and then re-frame to your original composition. If there is no bright point in the picture, or at the appropriate position, then use a torch with a strong beam to illuminate

5.10 & 5.11 *With contrast-based AF (auto-focus) systems, the lack of visible detail at night can lead to AF-failure (see 5.10). Try to focus on an area with enough light to avoid this, as shown in 5.11.*

065660

your subject and focus manually using the light of the torch. (Remember to turn it off once you've set your focus.)

Without those options, your only recourse is to guesswork. Estimate the camera-to-subject distance (or, if the subject is close enough and hand-measuring is practical, measure the distance with a tape measure), and then use the distance indicators on the lens barrel to set your focus.

Focus screens
Some of the more sophisticated cameras give you the ability to change the focus screen. Where this is the case, it is worth talking with your local camera dealer, or check the manufacturer's website about the availability of focus screens made specifically for night photography. These give a much brighter image in the viewfinder.

5.12 *If there is too little contrast in the area of the AF sensor, look for a bright area of the scene with which to focus, such as a street lamp or light from a window, remembering to recompose your picture before shooting.*

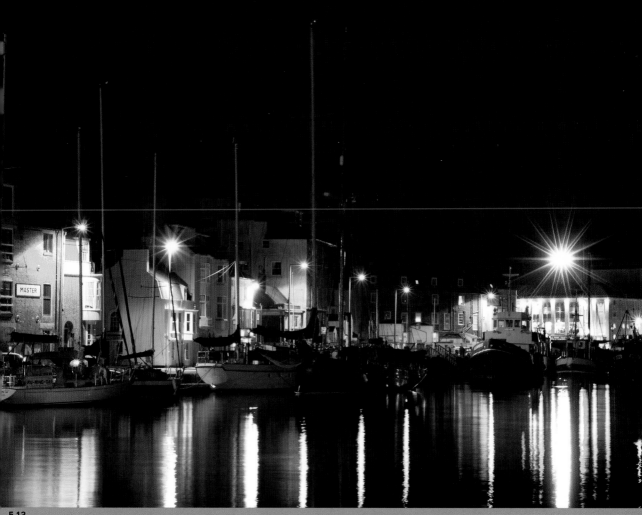

5.13

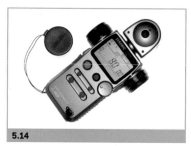

5.14

5.15

FLASH AND METERS

Flash units

If you are shooting at night and in low light, you may well want to use flash as the primary light source for fill lighting. The type of flash unit you need is dependent on what you are shooting, but your major consideration should be the guide number, which determines the power output of the flashlight.

5.13 *Portable flash unit.*

5.14 *By removing the cone from the incident light meter, this hand held meter can be used as a reflected light spot meter.*

5.15 *Combination reflected light meter and incident light meter.*

Hand-held exposure meter

While your camera may have a built-in flash meter, such as a TTL meter, it may be limited in low-light conditions. Firstly, it may not operate at the levels of light you're working in, when exposure values may be outside the range of your meter. Secondly, the lighting conditions may be quite complex, requiring you to make minute measurements of individual areas to calculate an accurate exposure. In these cases, your camera will need a spot meter and, if it comes without one, invest in a hand-held meter.

In very low-light conditions, hand-held incident light meters (or combination incident/reflected light meters) have an added advantage if the white dome (invercone) is removable. The white dome on an incident light meter averages the light falling on it to give an 18 percent mid-tone value. It does

this by allowing only 18 percent of the light falling on it to reach the metering cell below. If you remove the invercone, all the light falling on the cell will be read. Effectively, this makes the cell five times more sensitive to light, giving a light reading in conditions that would be impossible with the cone attached. Of course, you'll need to make the necessary adjustment to the reading given; multiply by 18 percent—or 20 percent to make life a little easier—to obtain the correct exposure value, or reading.

As technology has developed, more sophisticated light meters have become available, some of which are designed for use in very low light. An example is the Gossen Sixtomat Digital meter, which has a measurement range of −2.5 to +18 EV with a high sensitivity for night scenes.

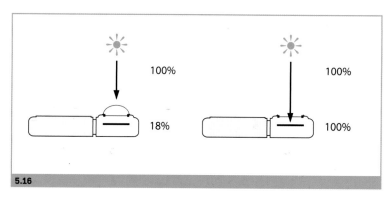

5.16

5.16 *The invercone, or simply, cone, on an incident light meter absorbs 82 percent of light falling on it to give a mid-tone reading. Taking it off allows 100 percent of light to fall on the meter, which can be useful for calculating exposure in low-light photography.*

5.17 Images of star trails are created by setting a long time exposure of several hours via the bulb shutter speed setting in manual or shutter-priority AE exposure modes.

5.17

FILM AND FILM SENSITIVITY

All films have an industry standard rating known as ISO (previously ASA). The lower the ISO rating the less sensitive the film is to light, and the more light it needs to create a useable exposure. For low light conditions, fast films with high ISO ratings (e.g. 400, 800 ISO) are available.

The manner in which the ISO rating for film works is based on the way it is manufactured. Film is formed of several layers, one of which consists of tiny crystals of silver halide. It is these crystals that react to light. In slow films, the crystals are particularly small, and will remain invisible to the naked eye when the image is enlarged to print size. To make film more sensitive to light (i.e. faster) the crystals used are bigger and react more quickly, meaning less light is needed to create an exposure. The downside to fast film is film grain. Because the crystals are bigger, when an image is enlarged to print size they become visible. In some instances, film grain can artistically add to composition, but more often than not, will negatively affect the image quality. Therefore, a balance must be found when using faster films in low light conditions.

Film speed can be related back to f/stop units of measurement. So, doubling or halving film speed equates to doubling or halving exposure. For example, a film with an ISO rating of 100 is one stop faster than a film rated at ISO 50, and thus requires half as much light to record the same exposure. Conversely, an ISO 100 film is one stop slower than an ISO 200 film and would require double the amount of light to record the same exposure.

Digital sensors and amplification

When it comes to ISO, digital cameras operate very differently to film. In film photography, the same ISO terminology is used to describe the speed at which the sensor reacts to light. However in digital, ISO relates not to sensitivity, but to amplification.

In effect, the camera amplifies the light signal to make it stronger, meaning less light is needed at higher levels of amplification to record the same exposure.

The downside to amplification that low-light photography users face is digital noise. Several aspects of the digital photography process create noise, one of which is long exposures. When the sensor is active for long periods it heats up, and this generates noise. At high ISO ratings, the reduction in light signal reduces it to noise ratio, which is important as it relates to image quality. So, take a relatively large amount of noise compared to a signal caused by a high ISO rating, add in additional noise generated by excessive sensor heat, and then amplify it. The result is a high level of visible noise, which unlike film grain has no artistic qualities.

EXPOSURE

Exposure is one of the more complex aspects of low-light and night photography. In general, you will face three main challenges when calculating exposure times:

1) The reduced level of light may be too low for your exposure meter to operate effectively.

2) Where you are mixing artificial and natural lighting, the level of contrast between bright artificial light and very dark natural light will be way beyond the dynamic range of your film/photo sensor.

3) With long exposure times (above one second), you will need to consider the laws of reciprocity failure.

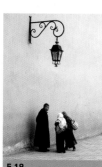

5.18

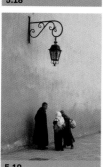

5.19

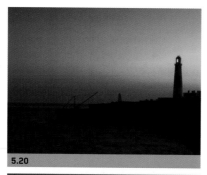

5.20

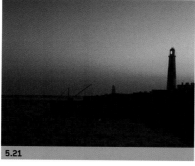

5.21

5.18 *Film grain at ISO 100.*

5.19 *Film grain at ISO 800.*

5.20 *Noise at ISO 100.*

5.21 *Noise at ISO 800.*

Measuring low light exposures

Many film cameras enable the ISO value, used in conjunction with the camera's meter, to be set manually (although this may require covering the bar coding on the film canister) and at a variance with the ISO of the film. Typically, this allows pushing and pulling of the film. Manual override of the ISO value may permit meter readings to be assessed, even in dark lighting. By temporarily setting the highest ISO value on the camera, the meter will assume this value when calculating exposure. Once you have the exposure value, you simply need to work backwards to get the required exposure for the actual ISO rating of the film.

For example, say you are using an ISO 400 rated film, and at that ISO setting the light is too low for the camera to calculate an exposure. If you change the ISO setting on the camera to its highest value (e.g. on the Nikon F6 this is 6400), this may be sufficient for the camera to be able to calculate the exposure. Now, using the f/stop unit system, simply work back to your actual ISO (as described in the table below).

You can apply the same technique with a digital camera by increasing the ISO rating to take the meter reading and reducing it again to make the exposure, remembering to calculate the actual exposure value based on the working ISO rating.

If the light is still too low for this technique to work, then try removing the cone/invercone when using a hand-held incident light meter. This achieves an increase in light levels, since the cone/invercone gives an 18 percent mid-tone reading, absorbing 4/5ths of the light falling on it, with only 1/5th reaching the metering cell below. Remove the cone/invercone and all the light is then measured by the cell. Having taken a reading in this way, you will need to adjust backwards to calculate your mid-tone meter reading by multiplying the given reading by 1/5th. Combine this with the technique described, and you have even greater sensitivity to work with.

For example, say that your incident light meter gives you no reading with the cone/invercone attached. (On light meters with a digital read-out, it will probably show a message saying "LO".) Remove the cone/invercone and take a new reading. Now, say that reading is ten seconds at f/2.8. In order to get your mid-tone reading, you must reduce that exposure calculation by 80 percent. Therefore, your actual exposure would be 50 seconds at f/2.8.

If you find all this too complicated in the field, the other option is to experiment and learn by experience. By taking several photographs of different subjects at different exposure settings, noting each setting as you go along, you can pretty quickly build up a "light chart" of your own to work from. Overleaf, I have compiled one based on my own experiments. By no means is it exhaustive, but it's a useful guide, and I always think it is worth going through this process yourself to see what works best for you.

The digital camera's ability to record and retain shooting data, combined with its instant playback and review functions, has made experimentation far easier. However, a note of caution—if you shoot digital in RAW mode, the playback image and histogram may be widely inaccurate, as they are based on a processed file; the camera having corrected any under or over exposure before relaying the information in the LCD monitor.

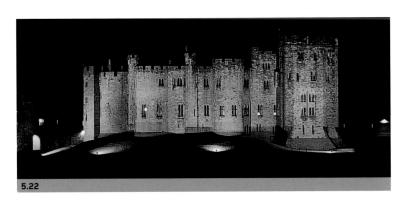

5.22

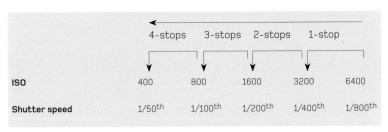

	4-stops	3-stops	2-stops	1-stop	
ISO	400	800	1600	3200	6400
Shutter speed	1/50th	1/100th	1/200th	1/400th	1/800th

5.22 *In order to retain greater control over lens aperture in low-light conditions—for example, to increase depth of field —you can push film to respond more quickly to light, or alter the ISO-equivalency to achieve the same result.*

High-contrast scenes

It is quite feasible that you will be photographing scenes where low levels of natural light are complemented by bright artificial light. A typical example is a cityscape at night where the black sky and dark streets are enlivened by the glow of lights left on overnight, floodlit buildings, street lamps, and car headlights. In such a complex scene as this, exposure calculation becomes difficult because of the varying levels of illumination and the stark contrast between an almost black sky and the brilliance of the lights.

Given this type of situation, you must decide what effect you are trying to achieve with your photograph and expose accordingly. That is, exposing for the highlights or for the shadows. In this example, if you exposed for the highlights, then the shadows would be severely underexposed with the result that they'd appear black in the photograph. On the other hand, if you exposed for the shadows, then the highlights would be grossly overexposed and would appear washed out.

Under normal levels of brightness, it is generally considered preferable to retain detail in highlight areas. However in night photography it is acceptable to burn or clip the highlights in the center of a streetlight, for example, so as to not compromise image quality in the mid- to dark tones.

Subject	Recommended aperture/ shutter speed at ISO (ISO equivalency) 400	Compensation for reciprocity failure: 400 ISO slide film
Floodlit buildings at night – front on to camera	1/4 sec @ f/4	None
Floodlit buildings at night— angled to camera	1 sec @ f/8	+ 1/3 stop
Funfairs (to freeze motion)	1/125th @ f/2.8	None
Funfairs (to blur motion)	1/15th @ f/8	None
Fireworks	Up to 1 min @ f/8 or f/11	None
Lightning	Up to several min @ f/8 or f/11	None
Star motion	4—8 hours @ f/8	None
Moon (clear night)	1/250th @ f/16	None
Floodlit sports events (to freeze motion)	1/125th @ f/5.6	None
Floodlit sports events (to blur motion)	1/30th @ f/11	None
Car-light streaks (busy road)	10—20 sec @ f/22	None
Landscapes (under full moon)	4 min @ f/11	+ 1.5 stop
Landscapes (under partial moon)	8 min @ f/11	+ 1.5 stop
Street scenes (with sidewalk lights)	1/4 sec @ f/8	None
Cityscapes (close up)	2 sec @ f/11	+ 1 stop
Cityscapes (wide-angle)	8 sec @ f/11	+ 1 stop

5.23 *St Catherine's, Dorset, England.*

5.24 *Bourbon Street, New Orleans, USA.*

5.25 *Night scene, Tokyo, Japan.*

5.26 *The Great Clock housing "Big Ben", Westminster, London, England.*

5.23

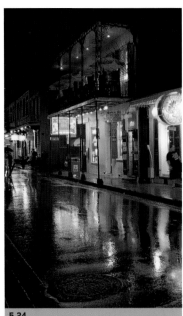

5.24

5.25

5.26

5.27

Long exposures and the laws of reciprocity

I have alluded to the laws of reciprocity failure. The principle behind it relates to film's sensitivity to light. Under usual photographic operating conditions (i.e. shutter speeds measured in fractions of seconds), the laws of physics determine that a change in one exposure control (lens aperture or shutter speed) can be compensated for by an equal and opposite change (a reciprocal change) in the other. That is, an exposure setting of 125th sec at f/11, for example, allows exactly the same amount of light to reach the film/photo sensor as an exposure setting of 1/250th sec at f/8; 1/500th sec at f/5.6; 1/1000th sec at f/4, and so on. Of course, the rule also applies in reverse. For example, 1/60th sec at f/16; 1/30th sec at f/22, etc. This balance works without fail until you enter the realms of long-time exposures, which are generally considered to be greater than one second. When exposing film for long periods, film's sensitivity to light suffers some fall-off, and this causes the laws of reciprocity (equal and opposite changes) to fail. In effect, the longer film is exposed to light, the less sensitive to light it becomes. Thus, when photographing at long exposures, you need to add some additional light, to make up the balance. The question, of course, is exactly how much compensation is required? Unfortunately, there is no simple answer to that question. While, in theory, the laws of reciprocity failure are an exact science, in practical terms they are not. The level of compensation needed will depend on not only the length of time the film is exposed to the light, but also on the emulsion used. Different film types (e.g. transparency film, negative film, black and white film) react in different ways, and different makes of film within the same grouping (e.g. Fuji Velvia, Fuji Provia, Kodak Ektachrome, Kodachrome) also react in contrasting ways.

In digital photography, the laws of reciprocity apply to all shutter speeds, and no exposure compensation is required.

5.27 *At night, when shutter speeds are measured in seconds, rather than fractions of seconds, you need to allow for reciprocity law failure. Here, I added an additional stop of light to my calculated exposure in order to get a faithful reproduction of the scene.*

FUJI	1sec.	4sec.	16sec.	64sec.
Fuji Velvia (RVP)	None	+ 1/3rd stop	+ 2/3rd stop	Not advised
Fuji Provia 100F (RDP III)	None	None	None	None
Fuji Astia 100 (RAP)	None	None	None	+ 1/3rd stop
Fuji Provia 400F (RHP III)	None	None	None	+ 2/3rd stop
Fuji Sensia 100 (RA)	None	None	none	+ 2/3rd stop
Fuji Sensia 200 (RM)	None	None	None	+ 2/3rd stop

KODAK	1sec.	10sec.	100sec.
Ektachrome E100VS (Pro)	None	None	None
Ektachrome E100SW (pro)	None	None	Not advised
Kodachrome 64	Not advised	Not advised	Not advised
Kodachrome 200	+ 1/2 stop	Not advised	Not advised
ELITE chrome 400 (EL)	1/3rd— 1/2 stop	1/2 stop	Not advised
PORTRA (Pro) 160NC/ 160VC/400NC/ 400VC/400UC	None	None	Not advised
SUPRA (Pro) 100/ 400/800	Not advised	Not advised	Not advised

The table, above, gives some indication of the compensation required for some films on the market today, as recommended by the manufacturer. As with all things photographic, I suggest you use these figures as guidelines only and run your own tests to evaluate the effects of reciprocity failure for your own photography.

NOTE

A TEST FOR RECIPROCITY FAILURE

1 Find an even-toned scene or subject to photograph.

2 Set up your camera on a tripod in low-light conditions.

3 Calculate your exposure in the usual way, and apply an exposure setting where the shutter speed is 1/2sec, with the lens aperture as close to fully open as possible. (If this isn't possible, wait until the level of light has decreased.)

4 Take a photograph at this setting. This is your base picture against which you can compare the following set of images.

5 Now take several more pictures, lengthening the shutter speed each time (e.g. 1sec, 2sec, 4sec, 8sec, 16sec, and so on) and making the reciprocal change in lens aperture.

For example, if your base setting is 1/2sec at f/4, your following exposures should be 1sec at f/5.6, 2sec at f/8, 4sec at f/11, 8sec at f/16, 16sec at f/22, etc.)

6 Bracket each shot +1/3rd stop, +2/3rd stop and +1 stop.

7 Have the film processed and review the results. You should see an increasing level of underexposure as the shutter speeds reduce on the non-bracketed images. Now review the bracketed images and decide what level of compensation gives the best results at the given shutter speed for the film used. If you use different film types, you will need to test each individually.

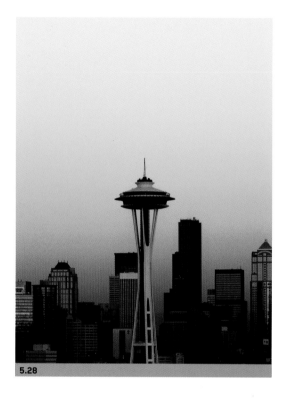

5.28

Long exposures and digital noise

When a digital sensor is exposed to light, that light reaches the capacitors on the sensor as a signal, which is simply a measurement of an amount of light. Inaccuracies in the signal, which occur on a random basis, lead to what we refer to as noise, and are shown as unrelated speckles. Another way to think of this is to imagine a radio tuned in to a particular station. On the whole, the sound waves reach the receiver without error and a clear signal is heard as uninterrupted sound. Occasionally, something will interfere with the signal and the sound is interspersed with static and crackle. This is radio's equivalent of the noise found in digital photography.

The most relevant factor relating to digital noise is the signal-to-noise ratio (SNR). SNR refers to the quantity of noise present in a pixel, relative to the amount of signal. In effect, a pixel can contain lots of noise, but as long as it has a significantly higher signal content, the errors will form a lower percentage of the overall content and become lost in the detail.

A major factor influencing the occurrence of visible noise is shutter speed. During exposure, when the sensor is active it heats up. This heat is transferred to the electrons, causing them to become free of their molecules. These free electrons merge with electrons freed by the

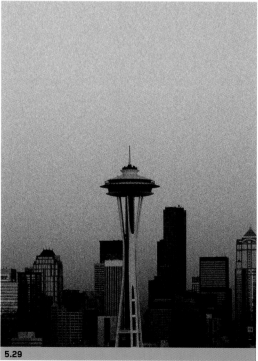

5.29

5.30

5.28—5.30 *Digital photo sensors do not show grain in the way film does but, instead, is affected by digital "noise", which looks much like grain. These images show the effect of digital "noise" before noise reduction is applied and after.*

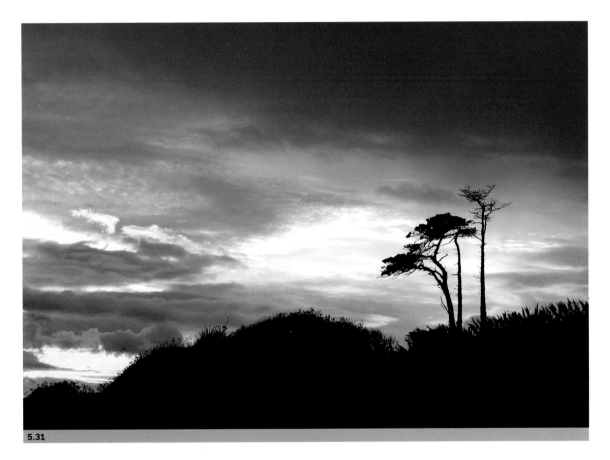

5.31

5.31 *Shooting into the fading light of day on a very slow shutter speed, and using a tripod, produces this stunning silhouette.*

photons, resulting in dark-current noise. At faster shutter speeds (typically anything faster than a few seconds), the level of dark-current noise is minimal and largely invisible. However, the longer the sensor is active, the hotter it gets and the greater the likelihood of visible dark-current noise occurring. This can make low light and night photography with long-time exposures problematic, and image quality is liable to suffer.

TIPS

NIGHT AND LOW-LIGHT PHOTOGRAPHY

1 The essential gear for night and low-light photography are a tripod and remote shutter release.

2 When calculating exposure for film photography, remember to compensate for reciprocity law failure.

3 Fast ISO-rated films react more quickly to light but increase the proportion of grain.

4 High digital ISO ratings increase amplification of the light signal, but may result in an increase in visible noise

5 Take time before shooting to allow your eyes to get accustomed to the dark.

6 Hand-held light meters are often more sensitive to light, and thus work better in low-light conditions.

7 Because of the limitations of auto-focus systems, it is often easier to focus the scene manually.

8 On a practical note, take care when out alone at night, and, preferably, take someone along to accompany you.

CLOSE-UP AND MACRO LIGHTING

136	Exploiting artificial light
	Working with a single flash
138	Moving in
	Positioning the flash unit
	Macroflash units and
	twin-flash set-ups
	Common problems
	Black backgrounds
140	Highly reflective surfaces
	Twin highlights
	Continuous source lighting
	Using natural light

One of the main advantages of macrophotography is its ability to reveal detail in subjects that are often too small for the human eye to see clearly. Sure, we can see a bumblebee drinking nectar from a flower, or a dragonfly hovering over a pond or stream, but, it is not until you get very close that you can begin to pick out the intricate detail.

Good lighting plays a significant part in creating truly outstanding photographs in close-up situations. The challenges, however, are numerous, not least of which is finding a light source large enough and close enough to give maximum depth of field, while minimizing hard shadows and light fall-off.

6.1

EXPLOITING ARTIFICIAL LIGHT

While natural daylight can be used in close-up and macrophotography, it is a specialty that lends itself ideally to artificial light. Some photographers are critical of this, citing unnatural overtones, hard shadows, and black, featureless backgrounds as evidence. And, while all of these factors can occur, each can be overcome by careful selection of flash position and subject-to-background separation.

Working with a single flash

While most photographers using flash seek out the most powerful unit available to them, the close-up and macrophotographer has another perspective. For them, a small, low-powered flash unit, close to the subject becomes a broad, large source of light similar to daylight on an overcast day or a large studio flash bounced off an umbrella.

It is true that flash photography in close-up and macro work takes some experimentation, particularly if you are working with a non-TTL flash unit. When photographing with a manual unit, you will need to try some test shots, moving the flash unit around to ascertain the best position for your particular brand and model. However, once you have identified the most suitable position, then this set-up will produce consistent results for most subjects. The exceptions will be when photographing very bright or very dark subjects, when you will need to make some minor adjustments. (Minus 1-stop or so for white or highly reflective subjects, and plus between $1/2$—1-stop for dark subjects.)

With auto-TTL flash, the process is far simpler as the flash unit will, in theory, modify the output of the flash to suit the situation. In practice, however, I would still recommend running some tests, since the likelihood is that the auto-system will slightly overexpose the scene. This is mainly due to the fact that while the control chip will respond in billionths of a second, the flash cannot turn itself on and off quickly enough, and some excess light will spill onto the scene.

6.2

6.1 & 6.2 *Black backgrounds occur because of the rapid fall-off of light from smaller flash units. They can be visually striking, as shown here, but are not to every photographer's taste.*

6.3

6.4

Moving in

When using a higher magnification to increase the reproduction ratio by moving the lens closer to the subject, you increase the distance between subject and film plane, which will cause light fall-off and, theoretically, alter your exposure. However, since you are also moving the flash closer to the subject, the two will cancel themselves out, as per the inverse square law, and your exposure should remain roughly the same.

Positioning the flash unit

With the flash unit at around 45° to the subject, the light will fall on the surface at an acute angle, causing tiny shadows to form. These shadows will accentuate detail and texture, and add to the overall impression of sharpness.

Macroflash units and twin-flash set-ups

Macroflash units are specially designed for close-up and macro photography and consist of two flash tubes attached to either side of the lens. In more sophisticated units, the power output from each tube can be adjusted to give even lighting all round or to make one tube the key light and the other a secondary, or fill light.

On older models that don't allow separate settings for individual tubes, you can achieve the same result by placing a neutral density filter over one of the tubes.

The advantage of the macroflash is that it produces even lighting that retains some direction to bring out form. Twin-flash set ups effectively achieve the same thing as macroflash and consist of two flash units attached to the camera via a bracket at an angle of around 45° to the subject. When fired together, they produce uniform lighting across the scene. The disadvantage is that there is a possibility of double shadows, which appear ugly in any picture. To overcome this, you can set the power output of each flash separately, making one unit the main light and the second unit a fill light. Alternatively, you can achieve the same effect by moving one unit further away from the subject. As a guide, doubling the flash-to-subject distance will reduce the level of illumination by around two stops.

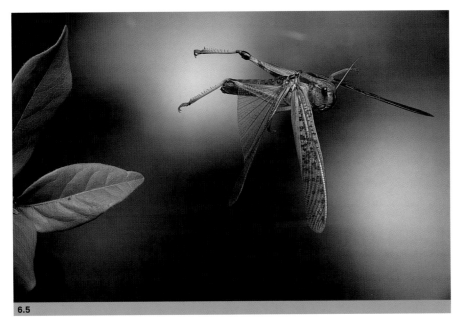

6.3 *This macro shot brings out the color and texture of the plant beautifully.*

6.4 *Twin-flash set up for macrophotography*

6.5 *Using special techniques, you can avoid backgrounds turning black. Use artificial colored or patterned backgrounds to combat this effect.*

6.6 *Black backgrounds are often caused by the fall-off of light when using a small flash for macrophotography.*

6.5

6.6

COMMON PROBLEMS

I mentioned earlier that some photographers argue against the use of flash in close-up and macrophotography because of some of the pitfalls that occur. The following pointers will help you around some of the potential problems.

Black backgrounds

Some people like black backgrounds for the dramatic effect. Others dislike them because they seem unnatural. Whatever your point of view—and there is no right or wrong—you can avoid using them. Black backgrounds occur because of the rapid fall-off of light from smaller flash units. One solution is to place an artificial background, such as a piece of green card or an old brown t-shirt, behind the subject—closer to the camera so that a percentage of the flash light will illuminate it, but not enough that it becomes overpowering.

6.7

Highly reflective surfaces

Surfaces with a high reflectance can produce hot spots when photographed with flash. To prevent these hot spots from overpowering your composition, use a diffuser over the flash head(s). This will soften the quality of light and mute any overly bright areas of the image.

Twin highlights

When using a twin-flash set up, and sometimes when mixing natural and artificial light, it's common to record twin highlights in the eyes of insects and other creatures. These look unnatural because we are used to a single highlight (the earth having only one sun). There is not much you can do to avoid this effect, other than a single flash unit when appropriate.

6.8

6.7 & 6.8 *Highly reflective surfaces can produce hot spots when photographed with flash.*

6.9 *Twin highlights in the eyes of insects and animals can be difficult to overcome when using a twin flash.*

Continuous source lighting

So far I have talked mainly about flash lighting, but continuous source lighting, such as tungsten and fluorescent lighting, is another possibility for you to consider. One of the main advantages of continuous source lighting is that you can see the effect of the lighting on your composition before you make the photograph. This enables you to identify hot spots or hard shadows and adjust your lighting accordingly.

One potentially major disadvantage with tungsten lighting for close-up work is the heat tungsten lamps give off. Because tungsten light is relatively low-powered, it needs to be placed close to the subject for the best results. However, get too close for any length of time and the tiny creature you are taking care of will fry.

USING NATURAL LIGHT

When shooting close up outdoors, natural light may be your preferred option. The quality, direction, and color of natural daylight will all impact your pictures and either enhance or detract from the overall effect.

For most close-up subjects, hazy, diffused light is ideal with the lower levels of contrast, helping to retain detail in highlights and shadows. Mid-morning, when the sun is at an angle of around 45°, the direction of the light will help to create shadows on textured surfaces that will add form to your composition. However, if the light is too direct then you may find the shadows too harsh and it would be better to wait until the sun disappears behind a cloud.

If the natural light conditions prove far from perfect (and let's face it, this is photography we're talking about so we know that's going to happen), then carrying a small reflector with you may help to save the day. In close-up and macrophotography, reflectors (even small ones), can play a vital role. Placed close to the subject, they can soften shadows and alter the direction of the light falling on your subject. On bright sunny days, you can use them as a shield to diffuse the light falling on your subject.

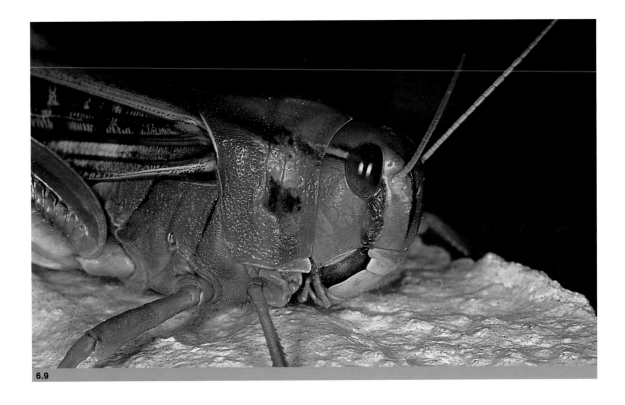

6.9

THE DAYLIGHT STUDIO

144 Setting up a daylight studio
Choosing a room to work in
Rooms as props
Making up the room
for photography
Source of light

146 Size of lighting

148 Direction of light
Color of light
Other daylight
studio locations

150 Fill-in flash

When you think of studio photography, you tend to think of intricate, artificial lighting systems. Often, of course, this is the case but there are times when you can use natural daylight to great effect in the studio.

The advantage of using natural light for indoor photography is that the light, having been reflected off multiple surfaces, is usually soft, subtle, and muted, making it ideal for portraits with a gentle or romantic atmosphere. Shadows are very low key, and contrast is minimal. As usual, there is a downside. Often, the level of light will be very low, necessitating slower shutter speeds and faster apertures, increasing the likelihood of motion blur and reducing depth of field.

We all accept, however, that the art of photography is about meeting constant challenges, and the daylight studio is a great place to begin learning the fundamental techniques of studio photography.

SETTING UP A DAYLIGHT STUDIO

Choosing a room to work in

This may sound like an obvious statement to make, but anyone who has ever commandeered the family bathroom for a darkroom will know where I'm coming from: before you plunge headfirst into setting up a daylight studio at home, first consult anyone else with access to the room to gauge how long you'll have it to yourself. This is particularly important if you're working with a model, since constant interruptions will soon disrupt the flow of your photography.

The next thing to do is to select a room that is large enough to work in (look for high ceilings and open floor space), with plenty of sources of natural light. This could mean having two, or more, windows on different walls, or a window and outside door. Multiple light sources are not essential but will give you added flexibility when posing or setting your subject. If you have only a single light source to work with, such as a single window, try to use a room with a large window to give you more options.

Rooms as props

For some styles of photography, you may prefer to work with some props. These help give your pictures a sense of place and will dictate the room you work in. For example, if photographing mothers with babies, you may use a nursery as the setting. In glamor photography, a bathroom or bedroom may be a suitable location to set up, or to depict a craftsman at work, a workshop is an appropriate venue.

Making up the room for photography

Once you have decided on the room, you will need to make sure it's a practical location for photography. Try to keep the floor space clear of clutter and make sure there is a natural walkway around immovable objects. Using the source of light as your guide, select the areas you will set, or pose your model and then imagine photographing her/him there. Look through your viewfinder and check to see what the background looks like. Are there any obtrusive elements that will detract from your photograph? If so, move them. Unless they are part of your pre-visualized plan, remove pictures from the walls and make sure that any nails or holes that are left won't appear in the picture. Anything that doesn't add to the composition of the picture should be taken away and kept out of sight.

7.1

7.1 *Having more than one light source, preferably from large, south-facing windows, will enable you to light your subject more effectively.*

Setting up a daylight studio | Choosing a room to work in
Rooms as props | Making up the room for photography | Sources of light

145

Sources of light

Obviously, the most important element of your daylight studio is your light source. Usually, this source will come from one or more of three different areas: windows, doorways, or skylights. Doorways and windows will generally give you side lighting, which is ideal for rendering form and texture, and is typically more pleasing to the eye.

Windows are often better placed than doorways and provide more usable light, though this isn't always the case. For instance, patio doors can provide a large amount of light.

Skylights are ideal for replicating the lighting found during the middle of the day. On a cloudy day, much like a small window or narrow doorway, they can turn an omni-directional source of light into a point source. They are also ideal when mixing natural light with fill-in flash, since the flash is less noticeable, giving you more natural-looking effects.

I assume that you are unable to change the position of the light source, and so this will dictate how you set or pose your model. You can, however, change some aspects of the source, such as its size (and quality), direction in relation to the subject, and its color.

7.2

7.3

7.2 Skylights will enable you to light your photography from above.

7.3 Doorways and windows are ideal sources for side lighting.

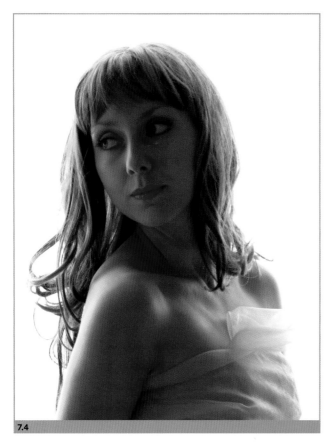

7.4

Size of lighting

Let's say you are using a single window as your light source, and that the window is a fairly standard size—around 150 x 120cm (59 x 47in). You can increase the effective size of the window (light source) by putting a diffuser over the glass, which will further scatter the light entering from outside.

Alternatively, you can decrease the effective size of the window (light source) by blacking out a section of it, creating a more direct point source. And, just as with daylight outdoors or in an artificially lit studio, the size of the light source will affect the quality of light, either soft and low in contrast, or hard and high in contrast.

7.5

7.4 *A small window will act as a direct, point light source.*

7.5 *Most of the time, you may only have a single light source, a window, to light your daylight studio, so it is worth finding ways to enhance the effects.*

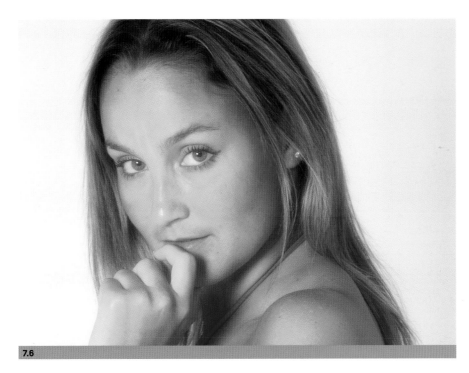

7.6 Here, a diffuser was made to fit over the glass to "scatter" the light, creating a large, omni-directional light source.

7.7 "Scatter" your light by introducing a diffuser to enhance the lighting on your subject.

Direction of light

In a daylight studio, the direction of the source light is fixed by the position of the opening (window, door or skylight). However, by simply adjusting the model's position in relation to the light source, you are able to change the direction of light with the same level of control as when using a flash unit. So, for front lighting, place the model facing the light source; for side lighting turn them 90 degrees; and for back lighting turn them a further 90 degrees.

Color of light

When light enters the daylight studio via an unobscured opening, its color is determined by the prevailing conditions. It is possible to alter the color of the light by placing a diffuser over the opening, through which the light must pass. In this way, the diffuser acts much like a color gel used in flash photography. For example, placing a diffuser made from a transparent red material will create red light, giving a warm color cast. A blue diffuser will have the opposite effect, creating a cool color cast. When choosing a material for the diffuser, remember that an opaque material will change the light source from a directional (hard) source to a soft (omni-directional) source, which in turn, will alter the level of contrast in the scene. A transparent material will have no effect on the quality of light.

Other daylight studio locations

While the obvious place to start when setting up a daylight studio is your home, there are other locations that may be utilized. For example, barns make excellent natural light studios, and can also be used to create effective scenes, such as those used in glamour photography. When utilizing buildings that aren't private, take steps to ensure that your shoot, and the model's privacy, is not compromised. If your budget stretches to it, it is also possible to hire professionally equipped daylight studios.

7.8 *When setting up your lights around your subject, consider the direction of the light to suit the portrait, and whether you want to use a diffuser to add some soft color to the shot.*

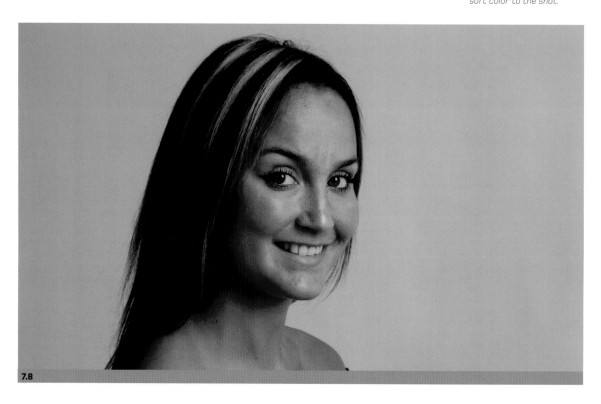

7.8

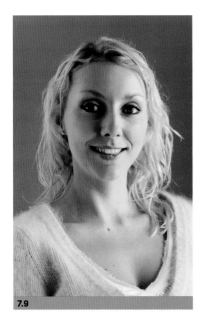

7.9—7.11 *This sequence of images demonstrate the ways in which your subject can be lit naturally, with the help of simple accessories, such as a color diffuser, to create different effects.*

7.9

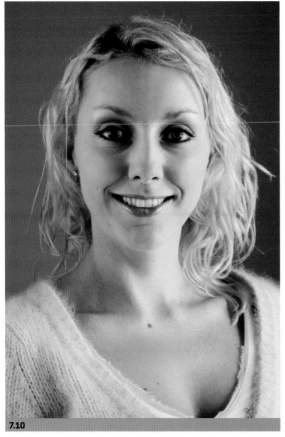

7.10

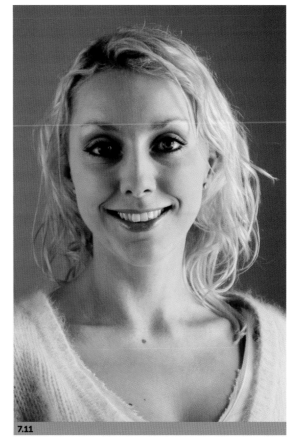

7.11

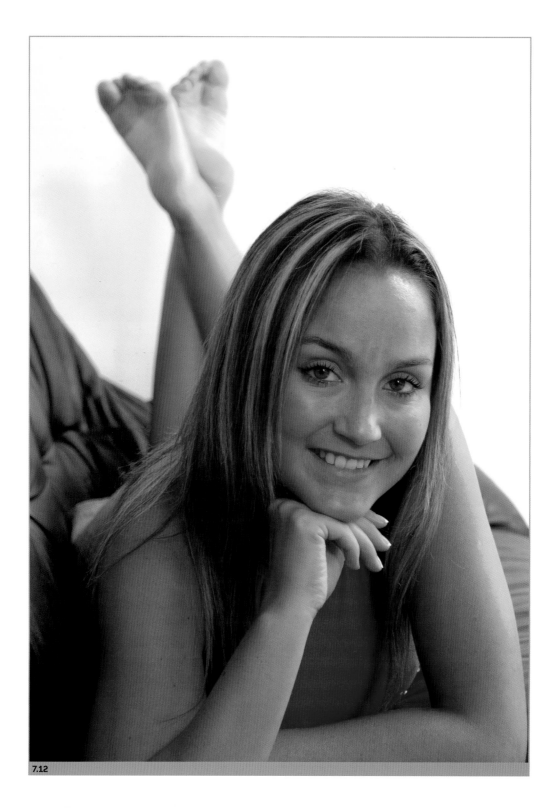

7.12

Fill-in flash

Mixing natural light and artificial light is not unusual, whether photographing indoors or outdoors. The purpose of fill-in flash is much the same as the purpose of using a reflector. Fill-in flash adds illumination into shadow areas of the scene and helps to reduce contrast.

When using fill-in flash, it is important that you get the exposure right. One of the advantages of flash over a reflector is that, generally, it is a more powerful source of light. However, this can also prove to be a major disadvantage if you intend to use the available natural light as your primary light source. If the fill-flash is too powerful, greater than the primary source, it will overwhelm the subject and spoil your image.

This problem is less of an issue with modern electronic flash, which tends to feature TTL-metering specifically for fill-in flash situations. However, whether you are using an automatic system or a manual one, it is useful to know the metering technique you should employ.

First, take a meter reading of the area lit by the natural light and note the exposure setting. Then, take a flash meter reading of the area lit by the fill-in flash. Since the aim is for the natural light to dominate, this second reading should be no more than the first. If it is, then you need to reduce the flash output until it is either the same as, or less than, your initial reading. Setting the level of fill-in flash to the same level as the natural light will produce a flat image, so it is better to set the light level from the flash at about one-stop less than the level of natural light. This will help to keep some shadow detail and give your subject dimensional form.

When using fill-in flash, it is better to keep the flash unit off-camera and at an angle to your subject. When photographing people, this will help stop red-eye—caused by the light from the flash reflecting back directly from the retina of the eye.

TIPS

SPECIAL TECHNIQUES

One of the effects you often see created in the daylight studio is a model posed in the striking rays of direct sunlight streaming through a window. Usually, the picture is composed so that some of the surrounding area is included in the shot to create a sense of place. While this effect is a little clichéd now, it is still a highly effective use of natural light in the studio and well worth attempting at some point.

The key is to pose your model so that he/she is directly in the line of the sun's rays. Expose for the rays themselves (best done with a spot meter) and the surrounding area will come out underexposed (darker), giving the impression that the subject is caught in the light, much like a spotlight on a theater stage.

It is not a simple image to capture and may take some experimenting. It is worth bracketing your exposures to ensure at least one of them is exposed as you intended.

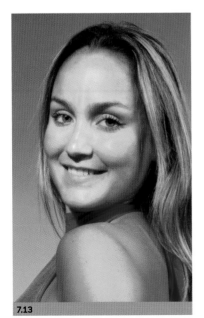

7.13

7.12 *Fill-in flash is invaluable for lightening the subject's dark shadow areas.*

7.13 *With fill-in flash, keep the angle of the flash to one side to avoid red-eye.*

ARTIFICIAL LIGHT

154 Understanding
 portable flash
 Types of portable flash unit
 Built-in camera flash

156 Hot-shoe flash
 Hammerhead flash
 Multiple wireless flash
 systems
 Ring flash

158 Tilting and rotating heads
 Slave flash

160 Diffusers
 Direct-attached
 reflector cards
 Choosing a flash unit
 Power

162 Coverage
 Recycling time
 Automation
 Dedicated flash

164 Basic techniques
 On-camera or off-camera?

166 Red-eye reduction
 Bounced flash

168 Using fill-in flash in daylight
 Portable flash exposure

170 The role of the shutter
 The role of the lens aperture
 Flash-to-subject distance
 Depth of field

172 The role of the flash unit
 Manual flash exposure

174 Calculating flash exposure
 with bounced flash
 Calculating flash exposure
 with diffusers
 Calculating exposure
 for fill-in flash

176 Advanced techniques
 Slow-sync flash
 Rear-curtain sync

Ever since the invention of photography, photographers have sought ways to prolong their image-making after the sun has gone down. In the early days, this invention was driven more out of necessity than creative drive. As cameras became more sophisticated and film more advanced, flash took on a whole new life and photographers began creating highly imaginative images with careful and clever use of controlled, artificial light.

Today, the options are boundless. We can have light wherever we go, and lots of it. But, in many ways, learning to photograph with artificial light is far more complex than understanding the nuances of natural light, because there is at least one extra component to consider. It's a little like photographing captive animals, in that people believe it is easier simply because you can control the environment.

What is often overlooked is the difficulty of making an artificial environment look natural. This is a skill that takes time to master and which provides a whole new avenue of creative possibilities.

UNDERSTANDING PORTABLE FLASH

The first experience many photographers have with artificial light is the portable flash unit. For many, this is as far as they ever get, perhaps put off by the harsh and unflattering results that inexperienced use of portable flash may produce, or by what appears on the face of it to be a highly technical, complex field of photography. While poor use of flash may produce inferior images, the necessary skills can be mastered with a little practice, and may open up a whole range of new picture making opportunities.

Types of portable flash unit

Look through the camera bag of any professional photographer, in any field of photography, and you will find some kind of flash unit. And, chances are, you won't find two of the same. There are lots of different flash units out there, and you must ask yourself, which is the best one for me?

One way to answer this question is to think about the flash unit in much the same way that you think about your camera. By now you have learned that no single camera can do everything. You may own different camera bodies for different areas of photography, and the same applies to flash units, so it makes sense to look through all the options available in order to make an informed decision.

Built-in camera flash

Many modern cameras, in particular 35mm SLRs, come with a flash unit that's usually built into the prism finder. For more serious photographic applications, these units are very handy for quick bursts of fill-in flash, but they suffer from two major problems. Firstly, they are in a fixed position—and not a very good position at that. Being a direct, front-on light source, they give very flat, hard lighting and, when photographing people or animals, will produce the effect known as red- or green-eye. Secondly, they are not particularly powerful and have a very limited range.

8.1 A built-in flash unit in a modern SLR camera.

8.2 Flash from a built-in unit can cause unsightly results such as "green-eye".

8.3 Used well, small flash units can add subtle, attractive lights to the subject's eyes.

8.1

8.2

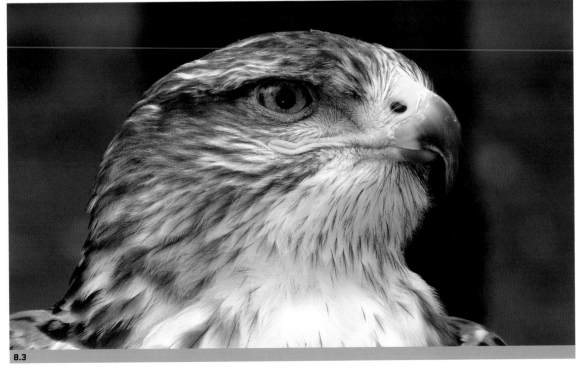

8.3

8.4

8.4 *A portable
on-camera flash.*

8.5 *Hammerhead flash.*

Hot-shoe flash

The vast majority of modern flash units are designed to complement the camera via the hot-shoe (sometimes referred to as the accessory-shoe), which is usually found on top of the finder. The hot-shoe provides the electronic link between the flash and the camera, allowing for accurate discharge at the right moment. In some older cameras, the hot-shoe is just an attachment mechanism (an accessory shoe) without this contact point, and the flash is synchronized with the camera via a PC lead. The advantage of this type of flash unit is the additional power and range it provides over the built-in version. However, when attached directly to the camera, it suffers the same directional shortcomings as the built-in unit, producing only front-on lighting.

Some of the more advanced units enable bounce-flash, which goes some way in overcoming this problem, although not without some compromise. It is also possible to attach these units off-camera with a specially designed bracket. Synchronization with the camera is then achieved via a PC lead, although some manufacturers make brackets that have the same functions as the on-camera hot-shoe.

Hammerhead flash

From the name alone you begin to get a feel for this type of flash unit. The hammerhead flash is designed to work off-camera and consists of a large flash head mounted on a stem that acts as a handle. The most compelling feature of this type of flash unit, as its name suggests, is power and range. However, they also boast fast recycling times and a wider choice of accessories, which greatly increase the possibilities for practical application.

Hammerhead flash units are far less portable than the more compact hot-shoe mounted alternatives. But their additional benefits make them the preferred choice of many professional photographers, particularly working in the fields of press, PR, forensics, and wedding photography.

Multiple wireless flash systems

Wireless technology is the latest offering from the major photography manufacturers, and enables multiple wireless flash systems to be activated by a transmitter unit on the camera. Put simply, this means several flash units can be positioned around a subject without the need for cables, and exposure can be calculated manually or automatically via the TTL-metering system in the camera. Wireless technology is highly intuitive and relatively easy to use, giving the user a level of sophistication in portable flash photography that has previously only been possible in a studio set up.

8.5

Ring flash

Ring flash is a specialized type of flash that produces very distinctive all-round, near shadowless lighting. It is commonly used in close-up and macrophotography and attaches to the camera via the front of the lens, which then pokes through a hole in the middle of the flash unit. Synchronization is via a PC cord and adaptor that fits into the hot-shoe. Larger versions are available and are often used by fashion photographers.

8.6

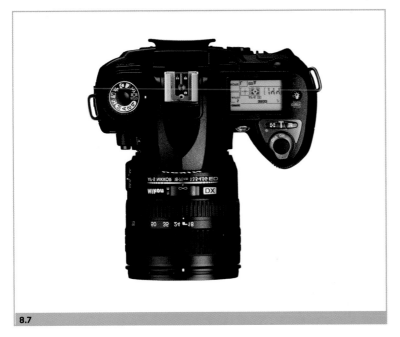

8.7

8.6 *A modern ring-flash unit, primarily used in macrophotography.*

8.7 *A hot-shoe on the prism finder of an SLR camera, to mount portable flash units.*

8.8

Tilting and rotating heads

Most modern external flash units feature a tilting/rotating head, which enables the use of bounced flash. The advantage of bounced flash is that it softens the quality of the light from the flash unit, turning it from a point source to an omni-directional source (by increasing its size), which will reduce contrast and shadow definition. This is achieved by directing the flash output (by tilting or rotating the head) at a reflective surface, such as a light colored wall or reflector, so that the light will bounce off the surface and reflect onto the subject. The downside to this technique is that flash output becomes less intense and it may be necessary to reduce flash-to-subject distance in order to achieve an acceptable level of exposure.

8.8 *A tilt-and-swivel flash head in the swivel position.*

8.9 *A tilt-and-swivel flash head in the tilt position.*

8.9

Slave flash

Slave flash units are so called because they work off a main flash unit—most likely your main camera flash. Small and very limited in power, they are generally used to provide fill-flash to the main flash unit, or to create specific lighting effects. They work through a built-in sensor that detects the flash of the main unit and then sets off the flash of the slave. They are very useful accessories and can help to overcome some of the limitations of portable flash units, particularly helping to fill in dark shadow areas caused by the point source of the principal unit. However, they have no direct influence over exposure control so you must calculate exposure manually.

8.10

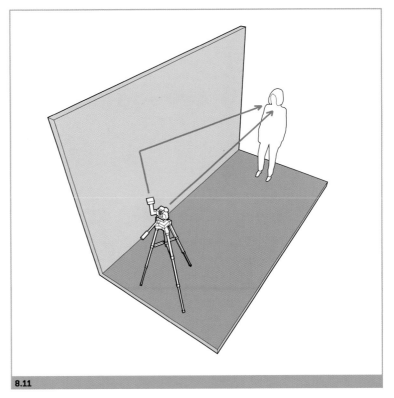

8.11

8.10 *A slave flash sensor, used to trigger flash when not attached to the camera.*

8.11 *Tilt the flash toward a light-colored wall to reflect light on to the subject to reduce contrast and produce a softer effect.*

Diffusers

Another way to increase the relative size of the light source from a portable flash unit is to attach a diffuser. This may be in the form of a simple, translucent plastic cover that fits directly over the flash head. You can also get larger, more sophisticated versions that resemble scaled-down versions of studio soft boxes, or simply make one yourself using a suitable framework and some white material, such as nylon.

With a diffuser, there is no need to angle the flash and it remains pointed directly at the subject. The diffused light will be of a softer quality than the non-diffused flash, although probably less soft than bounced flash. Another advantage of this is that diffusers can be used with fixed-head flash units. Calculating exposure may or may not be a problem, depending on the flash unit being used.

Direct-attached reflector cards

An alternative to reflecting flashlight off a wall or ceiling is to bounce it off a reflector card. Reflector cards attach directly to the flash head and can be bought commercially or made with relative ease. They consist of a piece of card (usually white but they can also be silver or gold), which varies in shape and size; the larger the card the softer the quality of light reflecting from it. The card is attached to the back of the flash head with sticky tape or Velcro, and the flash head is tilted up so that it fires onto the reflector card.

The advantage of using a reflector card over bouncing flash off a wall or ceiling is that the distance the light travels between the flash head and the reflective surface is usually less and so flash power is maintained. The level of diffusion, however, will generally be less since the reflective surface of the card is much smaller in area than that of a wall or ceiling.

CHOOSING A FLASH UNIT

When choosing a flash unit you must first consider what you are going to be using it for. For example, the typical portable flash set-up for macrophotography is quite different to the one you would use for reportage. Flash units are much like cameras—no one size fits all and when deciding what is best suited to your style of photography you need to consider some of the fundamental features of all flash units. These include power and coverage, recycling times, and levels of automation and dedication to your camera body.

Power

The power of the flashgun is one of the first things you are likely to consider and, as a general rule, the more powerful the flash unit, the more flexibility you have when using it. Power is measured by the flash unit's guide number, which varies depending on the ISO rating (equivalency) of the film or photo sensor being used. In a nutshell, the bigger the guide number, the more powerful the flash and the greater its range. This increases your flexibility in exposure settings. For example, let's say that you are trying to photograph an athlete running in a stadium. Because you can only get so close, you are unable to influence exposure settings by moving closer to the subject. So, with a less-powerful flash unit, you will probably be shooting at a wide-open aperture and relatively slow shutter speeds, which are not the ideal settings for fast-action photography. However, increase the power (guide number) of the flash unit and you are able to use faster shutter speeds without needing to get closer to the action. The other element of power to consider is that you can always reduce the power of the flash unit down from its maximum, but you cannot increase its power above its maximum. It's better to have more than you need than not enough.

What power buys you then is flexibility. The downsides tend to come in two forms: price and portability. Power costs money and, typically, the higher the guide number, the more expensive the unit. Power also means extra size and weight, and more powerful units tend to be bigger and heavier in size than their smaller cousins. So, once again it becomes a question of balance and compromise. As a rule, go for the biggest gun you can afford.

NOTE

I mentioned that the guide number (GN) of a flash unit varies, depending on the ISO rating of the film (equivalency of the sensor) used. Be aware of this when manufacturers and salespeople quote you guide numbers. For example, a flash unit with a GN of 120 for ISO 400 film is less powerful than a flash unit with a GN of 40 for ISO 25 film. This is a common technique used in sales to make less powerful flash units appear more powerful than they actually are.

8.12

8.13

8.12 & 8.13 *A diffuser attached to the front of a portable flash unit softens the quality of light from the flash.*

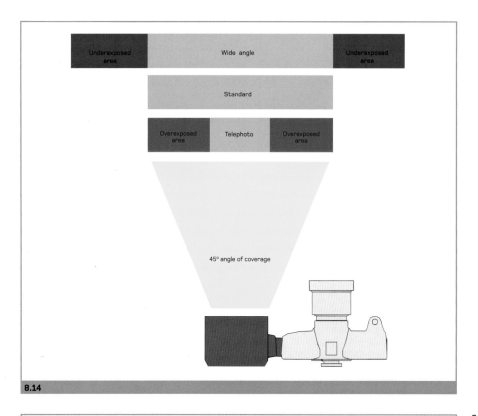

Underexposed area | Wide angle | Underexposed area

Standard

Overexposed area | Telephoto | Overexposed area

45° angle of coverage

8.14

8.15

8.14 *Flash units with fixed coverage are designed to work with a single focal length lens (typically 50mm). Using wider or longer focal length lenses will result in under- or over-exposure, respectively. The same problems will occur when using lenses with a focal length beyond the range supported by a flash unit with variable (zoom) coverage.*

8.15 *A built-in flash unit will offer you adequate light for most everyday photography, but for more wide-ranging photography, a dedicated flash will prove more useful.*

Coverage

When designing photographic equipment, manufacturers have to draw a line in the sand and, with flash, that line dictates that the coverage of the flash (how far it spreads out from the point source), is roughly equivalent to the field of view of the human eye (or a 50mm lens in 35mm photography). If, however, you are using a wide-angle lens with a greater field of view, or a telephoto lens with a narrower field of view, then anomalies will occur. For example, with wide-angle lenses, the flash won't reach all parts of the scene and some vignetting (darkening of the corners of the frame) will occur. With a telephoto lens, some of the light from the flash will be lost, which can throw out your exposures or light areas of the scene that were not part of your composition.

There are a couple of ways to overcome these issues. Some flash units come with a built-in diffuser that widens the angle of coverage of the flash. A better solution, however, is to buy a flash unit with a zoom head. The zoom, which works by way of a fresnel lens in front of the light tube, can be set so that its angle of coverage matches the lens in use. There are limitations, though, and the coverage usually ranges between 28mm—105mm focal lengths. In some more sophisticated (and expensive) models, the zoom function is automatic and changes when you swap lenses or focal lengths. Other systems may operate on a manual basis.

Recycling time

The recycling time of a flash unit measures how quickly the flash tube recharges after it has been fully discharged. You may recall the days when flash units fully discharged with every shot, and then had to wait several seconds for the little red indicator light to come back on, telling you that it was ready to take another flash picture. Things have changed since then, and most flash units only discharge the exact amount of light needed to give a technically correct exposure for the scene, allowing for more continuous shooting. However, recycling time is still an important factor in some specialized fields of photography, particularly when you want to take several shots in quick succession, such as with wildlife, motor sports, and press photography.

Automation

Something that often used to put people off flash was the need to calculate exposures manually based on a table or set of tables that came with your flash unit. Not only was this complicated but very unproductive. Modern flash units have taken much of that complication out of flash exposure and have made life far simpler for the photographer.

An automatic flash unit relies on you telling it the film speed (ISO equivalency) you're shooting at and, in return, it tells you the aperture to use, given your distance from the subject, which it learns from your focus setting. More sophisticated models even give you a range of apertures, together with the range of the flash with each, giving you a little added flexibility.

This system works fine so long as you stick to the indicated settings. If you change anything without consulting the flash unit, however, the flash will carry on regardless and you will end up with technically inaccurate exposures.

DEDICATED FLASH

And so we come to the most evolved of modern day flash units—the dedicated flash. Dedicated flash units communicate directly with your camera and take the information they need to calculate the relevant settings directly, without any need for input from you. With all this information to hand, the flash unit will set shutter speed and adjust output levels depending on your preferred aperture.

In order to work, dedicated flash units need to be used with cameras that have been designed to work with them. So, for example, a Nikon dedicated flash unit will not work on a Canon camera, and vice versa.

BASIC TECHNIQUES

On-camera or off-camera?

With very few exceptions, I would always advise using portable flash off-camera. With lighting coming from directly in front of the subject, particularly hard flash lighting, your images will tend to be flat and lifeless. When photographing people with on-camera flash you will also need to deal with red-eye. Many animals, too, also suffer from something I refer to as "demonic eye"—a phenomenon similar to red-eye but where the eyes turn a shade of bright green. Using the flash unit off-camera, both on a bracket or even hand-held, gives you far more flexibility and will produce much better lighting. Because the light is coming from the side, it will help to give your subject a three-dimensional appeal and form. If you have no option but to use the flash on-camera, then I would advise using it in combination with a diffuser or a reflector card to help soften the quality of the light.

8.17

8.17 *Direct, front-on lighting does not flatter the subject in portrait photography, creating flat images and dark, hard shadows.*

8.18

8.18 *Side lighting helps give form to three-dimensional subjects, improving the composition, but in this case, the hard quality of the light makes for a very contrast-rich image.*

8.19

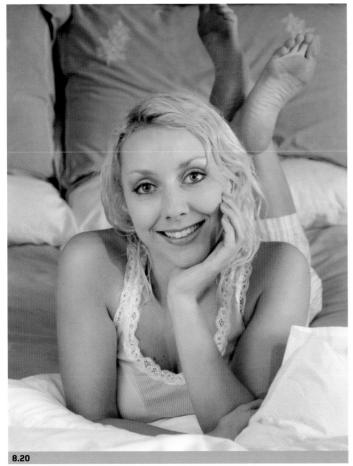

8.20

8.19 & 8.20 *Using on-camera flash with a reflector (8.19) or a diffuser (8.20), however, will help to soften the quality of light and give a more pleasing effect than direct light from a point source.*

Red-eye reduction

Red-eye is a symptom of on-camera flash caused by the light reflecting directly back from the retina of the eye. Some cameras now have a function known as red-eye reduction. This works by emitting a series of high-speed, low-power flashes before the main flash is fired. It is based on the theory that red-eye is reduced when the pupils are contracted, and exposing them to a bright light prior to the picture being taken will make them contract. Does it work? At times, but in my experience it rarely solves the problem completely.

A better option is to use a diffuser or bounced flash to soften the light and create an omni-directional source, or to keep the flash off-camera and angle the light from the side. This will prevent the light from reflecting off the retina.

8.21

8.21 & 8.22
Red-eye is an unsightly result of using direct, front-on flash in low light (8.21). Red-eye reduction can help to overcome this problem (8.22), although it is by no means foolproof. Using an off-camera flash or bounced flash can also help reduce red-eye.

8.22

Bounced flash

I have already discussed the advantages of bounced flash and this technique will give your flash pictures a much-enhanced quality, so long as there are sufficient levels of light. In order to bounce flash, you need to have a flash unit that has a tilting and/or rotating head. You also need a bright surface—preferably white—to bounce the flash off.

Bright surfaces are important because they reflect a greater percentage of the light falling on them. Avoid colored surfaces, as they will change the color of light reflecting back on the subject.

Ceilings are preferable to walls, since the reflected light is far closer to the light we expect to see from the sun, i.e. overhead and above the eye line.

Be aware of the extra distance that bounced flash has to travel. Because flash exposure is so dependent on flash-to-subject distance, when calculating exposure or when checking the maximum range of your automatic/auto-TTL flash unit you must calculate the flash-to-subject distance to include both the flash-to-reflector distance and the reflector-to-subject distance.

For example, if the distance between the flash head and, say, a nearby wall, is one meter (3.2ft), and the distance between the wall and the subject is a further three meters (9.6ft), then your total flash-to-subject distance is four meters (12.8ft), as shown below (8.25).

Something else to be aware of when bouncing flash is the law of physics, which states that the angle of reflectance is equal to the angle of incidence. What that means in English is that light will reflect at the same angle it hits a surface. For example, if you point the flash head directly up toward the ceiling, then the light will reflect straight back down again. The importance of this in your flash photography is that, when bouncing flash, you need to make sure the angle of the flash will direct light back onto or just in front of the subject for best results. Light falling too far either side of the subject is likely to render the subject in shadow.

8.23 *Direct light from a point source creates hard shadows.*

8.24 *Bouncing the flash off a nearby wall helps to soften the quality of light and reduce the harsh nature of the shadows.*

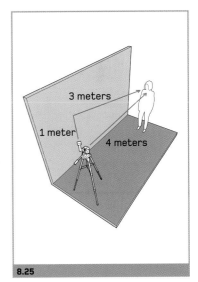

8.25 *When bouncing flash you need to be aware that the flash-to-subject distance increases, and should be measured as the sum of the distance between the flash unit and the reflector, and the reflector and the subject.*

Using fill-in flash in daylight

This technique is also known as "synchro-sun", which, in full, refers to synchronizing sunlight with the light of an electronic flash. It is used to fill in with additional light, the shadow areas of a scene lit by natural light. It is a particularly useful technique, especially when photographing people or animals in direct sunlight.

In hard light conditions outdoors, the quality of light will cause dark shadows to form, particularly under people's eyes, chin, and nose. These shadows can be unflattering and obtrusive in the picture composition. Also, if photographing a side-lit subject, the unlit side will contrast starkly from the lit side and exposure will become a real challenge, even impossible. Turning the subject with their back to the sun won't help much either, since, again, the face will be in shadow, and exposing for the shadow will render the brightly lit background washed out.

What to do? Well, you can "synchro-sun", or, to put it more succinctly, you can fill in the areas of shadow with a short burst of flash. The basic technique is to position the flash unit on the unlit side of the subject. When the picture is taken, the flash will add light into the shadow areas, bringing out detail and evening out the tonal balance. The real trick is to give just the right amount of light. Too little will be ineffectual and too much will overpower your main light source and detract from your original composition. The effect you are looking for is one where the viewer is completely unaware of the flash at all. Getting the level right will most likely be a case of trial and error. The best thing to do is to find a willing friend or partner and run some test shots.

PORTABLE FLASH EXPOSURE

With the level of sophistication in modern camera and flash technology, you would be forgiven for completely skipping this section of the book and moving on to less daunting subjects. To do so, however, would be to limit your creative opportunities with the camera. It is true that modern TTL-flash exposure systems will give perfectly adequate results if left on the fully automatic setting. The operative word in that sentence was "adequate". One of the ways to achieve "wow" factor pictures, is to understand flash exposure. Doing so will provide you with an excellent grounding to explore more creative techniques, and give you the confidence to experiment with style and composition, and develop your own photographic signature.

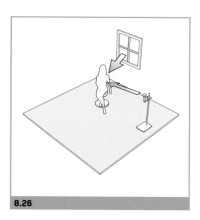

8.26 & 8.27 *Without a reflector, the light from the window leaves half the model's face in shadow.*

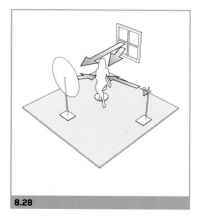

8.28 & 8.29 *Regardless of the model's position, adding a reflector to the side of the model, opposite the window, throws light back into the shadows and evens up the tones.*

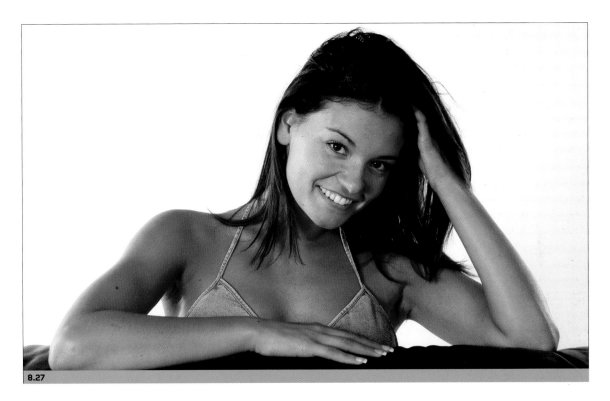

8.27

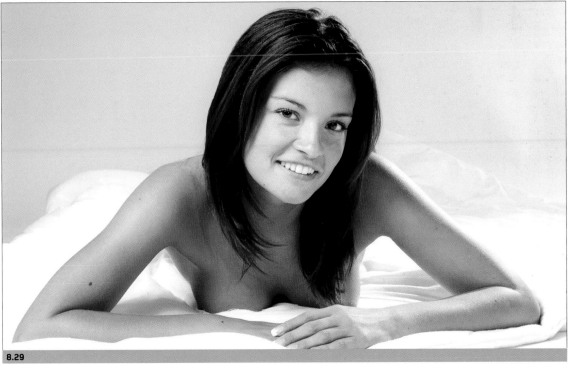

8.29

8.30

8.31

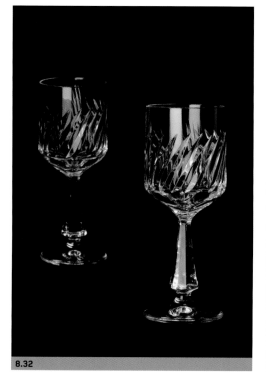

8.32

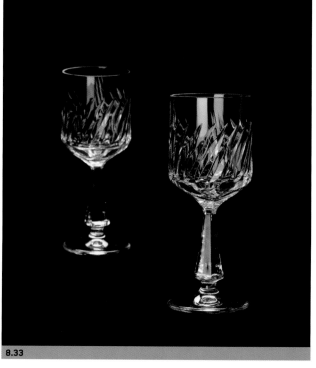

8.33

The role of the shutter

The first thing you need to do is leave behind some preconceptions about general photographic exposure. Principally, shutter speed plays no influential role in flash exposure. That is not to say it is irrelevant or unimportant. The shutter speed will influence areas of the scene not lit by the flash, since those areas are relying on natural light and will be governed by exposure in the normal way. However, the main relevance of shutter speed in flash exposure is related directly to the flash synchronization speed.

Flash synchronization is specific to cameras with a focal-plane shutter. Some cameras (mainly medium- and large-format), operate leaf shutters, where the shutter is built into the lens and flash synchronization is possible at all shutter speeds. The focal-plane shutter is built into the camera and consists of two shutter curtains—one to begin exposure and one to end it—that travel horizontally or vertically over the film aperture. At very high shutter speeds, the second curtain will begin to close

the exposure before the first curtain has traveled fully across the frame, which is how shutter speeds of thousandths of a second are achieved. Effectively, this creates a slit of light through which exposure is attained. This is where the problem begins. In flash exposure, the duration of the flash effectively acts as the shutter speed. To the naked eye, flash duration can seem a relatively long time. In reality, however, flash exposure usually lasts no more than 1/10,000th of a second, and can be even quicker. At these speeds, if the shutter speed set on the camera is too fast—in other words, beyond the pre-set flash synchronization speed, then the only part of the film/photo sensor that will record light is that visible through the tiny slit between the two shutter curtains as they respectively open and close.

So, when using a camera with a focal-plane shutter, which includes most modern cameras, you must set the shutter speed of the camera at the maximum synchronization speed available (usually 1/60th, 1/125th or 1/250th of a second, or slower).

The role of the lens aperture

Lens aperture, then, plays a very influential part in flash exposure and, together with flash duration and distance to subject, is one of the controlling factors. Working with lens aperture, it is possible to control exposure in one of two ways: either by keeping a fixed lens aperture and altering the power output of the flash unit to suit, or by altering the lens aperture and keeping the power output fixed. Whichever option you choose will be governed by flash-to-subject distance and depth of field.

Flash–to–subject distance

Because of the inverse square law, flash-to-subject distance is a key ingredient in the calculation of exposure. The further away from the subject the flash is, the less illumination the subject will receive, and the less flexibility you will have with setting lens aperture (because shutter speed is, to all practical purposes, fixed). So, if you want to work with smaller apertures then you will need to move the flash closer to the subject. But why not just keep the aperture open at its maximum setting and work with that? The answer, of course, lies in available depth of field.

Depth of field

Lens aperture controls the amount of depth of field you have to work with. The wider the aperture, the less depth of field, and subjects in front of and behind your point of focus will not be sharp. This may not be a bad thing. For example, with portraits you may want the background to appear out of focus so it doesn't detract from the main subject. But what happens if you're shooting a scene where front-to-back sharpness is important? Then you will need to close down the lens aperture to give greater depth of field.

8.30 & 8.31 *Flash-to-subject distance is a key ingredient in the calculation of exposure. The further away the subject, the less light it will receive, and vice versa.*

8.32 & 8.33 *A more powerful flash enables a greater range of lens aperture values to be used, meaning that generating additional depth of field is possible (see 8.32). At wide open, aperture's depth of field is reduced (see 8.33).*

The role of the flash unit

Automatic flash units work by measuring the amount of light falling on the subject and cutting off the flash once the exposure has reached its optimum level. How much flash is needed will depend on flash-to-subject distance and the set lens aperture. Sounds simple enough, but it has a flaw. Just like all light meters, the sensor in the flash unit is calibrated to give a technically accurate exposure for a mid-toned subject. If the subject is lighter than, or darker than mid-tone, then your flash-calculated exposure will either underexpose or overexpose the image. So, just as with non-flash exposure, you will need to make adjustments for non-mid-toned subjects. With an automatic flash, this is done by opening or closing the lens aperture from the suggested setting—opening it for lighter-than-mid-toned subjects and closing it for darker-than-mid-toned subjects. With dedicated flash units you can simply dial in the relevant level of exposure compensation on the flash unit (plus for lighter-than-mid-toned subjects and minus for darker-than-mid-toned subjects).

Manual flash exposure

If you are working with a non-automated flash unit or if automatic flash exposure is inappropriate for artistic or technical reasons, then you will need to calculate flash exposure manually.

The first point to remember is that flash exposure is calculated based on the flash-to-subject distance. This differs from natural light exposure calculations, which are based on camera-to-subject distance. Of course, with flash units set on the camera's hot-shoe, camera-to-subject and flash-to-subject distances will be the same. Knowing the range of your flash unit is important because if the flash is too far away from the subject then your pictures will come out underexposed. The first step in calculating flash exposures, then, is determining the range of your flash unit.

You will need to know the guide number (GN) of your flash unit. The GN is given by the manufacturer and refers to the amount of light generated by the flash unit at a given ISO.

With the manufacturer's GN and the base ISO rating, you can then calculate the GN for different film speeds. This is best done working in stops using the f/stop series of numbers. For instance, let's say your flash has a GN of 80 for ISO 100 film. To calculate the GN for, say, Fuji Velvia 50 film, first calculate the difference in stops in film speed. Fuji Velvia 50 is one stop slower than ISO 100 film. For the purpose of calculation, drop the zero from the original GN (80), giving you 8, and apply this to the f/stop scale: f/8. Now, open up one stop from f/8 (because of the slower film speed) and you have f/5.6. Multiply by the zero dropped earlier in the calculation and you get a guide number of 56.

Next, refer to the table, opposite, to work out all the calculations you need for working out manual flash exposure.

8.34

8.34 Many modern flash units enable output to be manually adjusted to increase or decrease the duration of light emitted, which is useful when photographing very light or dark subjects.

Now you know the GN of the film (or ISO equivalency) you are using you can calculate flash-to-subject distance using the following formula:	**Flash-shooting distance** =	**guide number (GN) ÷ f/stop (lens aperture)**
Working with my example above, take your GN of 56. Let's say that your set lens aperture is f/16. Your flash-shooting distance will be 3.5m (around 11ft).	**56 (GN) ÷ 16 (f/stop)** =	**3.5m (11ft) (flash shooting distance)**
Now that you have this base calculation, you can determine where to position the flash based on your preferred exposure settings. For instance, let's take the above example a step further. Say you want to shoot at f/8 rather than f/16. Where do you position the flash unit? Using the above equation, the answer is easily calculated.	**56 (GN) ÷ 8 (f/stop)** =	**7m (23ft) (flash shooting distance)**
Of course, there will be occasions when you are unable to move the flash unit closer to the subject, so you must alter the lens aperture instead. This can be done using a slight variation of the above formula.	**Lens aperture** =	**guide number (GN) ÷ flash-to-subject distance**
Keeping with the above example, let's say you can only move back a distance of 5m. The calculation would be, as follows:	**56 (GN) ÷ 5 (meters)** =	**f ÷ 5 (m)**

8.35 *A do-it-yourself diffuser for your flash.*

8.35

Calculating flash exposure with bounced flash

How to calculate exposure when bouncing the flash off walls or ceilings will depend on the type of flash unit used. Automatic TTL-flash will do the necessary calculation for you as it measures the light entering through the lens, (subject to any compensation required for non-mid-toned subjects). Similarly, non-TTL auto flash should give a reasonably accurate exposure so long as the light sensor on the flash unit is pointing at the subject.

If you are calculating flash exposure manually, then the same rules apply as those stated on the previous pages, except you must now calculate the exposure based on the total distance the flash has traveled, i.e. the distance between the flash head and the reflective surface, plus the distance between the reflective surface and the subject. In addition, however, you will need to add some compensation for the light lost through absorption and scatter.

Here's another example. Following the example on the previous page, you are now five meters from your subject but decide to bounce the flash off a wall that is three meters from you and four meters from the subject. The total flash-to-subject distance is around seven meters so your calculation would be 56 (GN) ÷ 7 (meters) = f/8. Allowing for light loss and scatter, I would apply a compensation factor of plus one stop giving a final lens aperture of f/5.6.

Calculating flash exposure with bounced flash | Calculating flash exposure with diffusers
Calculating exposure for fill-in flash

175

Calculating flash exposure with diffusers

When using a diffuser, the flash-to-subject distance remains the same but light is lost as it passes through the material of the diffuser. Once again, with TTL-auto and auto-flash units, so long as you do not obscure the sensor, the flash unit will take into account the level of lost light.

With manual calculations, you will need to run some tests to ascertain the exact amount of light being absorbed by the material.

Calculating exposure for fill-in flash

Calculating a sympathetic exposure for fill-in flash requires achieving a harmonious balance between daylight and flashlight. Even with modern auto-TTL flash units I would advise against relying on the system fully to get it right.

The problem with auto-fill flash is that the camera will give as near a balanced result as possible. That is, it will emit enough flash to render the shadows the same brightness as the highlights. This is all very well, but it will create flat lighting with little or no definition or form. A better effect would be an image where the shadows were half as bright as the highlights, creating some contrast and substance in the photograph.

This means that you have to limit the level of flash emitted from the flash unit. With auto-TTL systems this is achieved quite easily by setting exposure compensation to minus one stop. You can go further and darken the shadow area to a quarter of the brightness of the highlight area by setting exposure compensation to minus two stops.

With auto-flash, the technique is slightly more complicated, but is simple enough once you've learned the basics. Firstly, select a lens aperture. Next, take a light reading of the highlight area of the subject and set a shutter speed that will give a correct exposure. If the shutter speed is faster than your flash synchronization speed, you will need to reduce the shutter speed and close down the lens aperture by an equal amount. Once again, this will give you an exposure balanced equally between natural light and flash light.

To reduce the flash output by half, close the aperture down by one stop and reduce the shutter speed by one stop. This will achieve the desired result without affecting the exposure for the natural light.

PHOTOGRAPHING WITH ARTIFICIAL LIGHT

1 It is the attachments fitted to the flash head that provide the creativity in studio photography.

2 When photographing using artificial light, remember the inverse square law applies.

3 A lighting ratio of 3:1 gives an excellent balance between highlights and shadow areas and gives your model a three-dimensional form.

4 When photographing people or animals, it is usually best to light from above the eye line.

5 Generally, lighting coming from an angle is preferable to lighting coming from directly in front.

6 Use panel reflectors to provide fill-in light to shadow areas.

7 Light from a diffused source is soft, while light from a point source is hard.

ADVANCED TECHNIQUES

Slow-sync flash

Most of the time, flash pictures are taken with the camera set to its fastest synchronization speed (1/125th of a second). While this allows you to capture the main subject in well-lit conditions, the background is usually underexposed and lacking in detail. Sometimes, you want to achieve this effect, particularly if the background is drab. However, you will mostly want the background or surrounding areas to be well exposed.

The route to achieving this is slow-sync flash. As its name implies, with slow-sync flash the shutter speed is set to a much slower setting to enable the ambient light to record on film. An example would be children having a snowball fight late on a winter's day. Taken under normal flash conditions of say 1/125th second, the children would appear well lit but the background would be dark and featureless. By setting the shutter to around 1/8th second, the action of the children throwing snowballs would still be frozen by the flash, but the background would receive an exposure four stops longer, giving enough time for the film to record detail.

Rear-curtain sync

Flash units are programmed to fire at the beginning of an exposure sequence, that is, when the front of the two shutter curtains open. There is no particular reason for this other than a historical one relating to the technical practicalities of flash bulbs. The downside of this system becomes obvious during long exposures of moving subjects taken with flash. Let's use tennis as an example. A picture of a tennis player serving a ball, taken with flash set at front-curtain sync, would immediately freeze the motion of the racket. Any blur caused by ambient light after the flash had fired would then appear in front of the frozen image of the racket. Naturally, this does not sit well with us. We expect to see the blur appearing behind the racket, depicting forward motion. After all, that is what we consider normal. By setting the camera to rear-curtain sync, the flash will fire at the end of the exposure sequence, giving us an image that we perceive to be the right way round.

8.36

8.36 & 8.37 Where normal flash can produce dark backgrounds, slow-sync flash, reduces the shutter speed, thereby increasing the amount of light, and revealing better background detail in the picture (8.37).

8.38 & 8.39 If you shoot a subject using flash synchronized to fire when the shutter curtain opens, it can appear back to front (8.38). By using rear-curtain sync, the flash fires at the end of the exposure, which makes everything appear normal again (8.39).

8.37

8.38

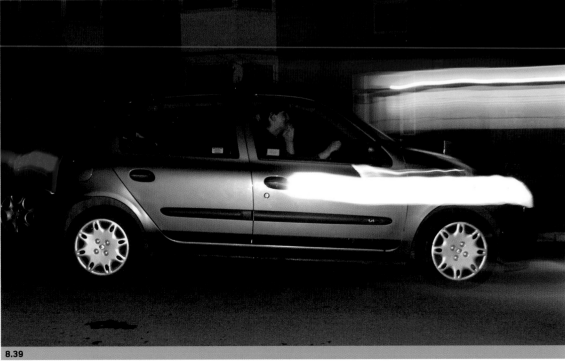

8.39

STUDIO LIGHTING

180 Lighting set-ups
 Flash heads
 Continuous light sources
 Tungsten lamps

182 Low-cost hot lights
 Professional
 tungsten lighting
 Fluorescent lighting
 Choosing the right
 lighting equipment

184 Power
 Ease of use
 Versatility
 Reliability
 Back-up system
 Choosing accessories
 Reflectors
 Wide-angle/umbrella
 General-purpose
 Key-light

186 High performance
 Grid

188 Soft light
 Sunlight
 Ring light
 Back-light

190 Snoots
 Honeycombs
 Barn doors
 Fresnel lenses

192 Umbrellas
 Soft boxes

194 Basic principles of studio
 portrait photography
 Lighting ratios
 Spacial relationships
 Angle of lighting
 Lighting-to-subject distance

196 Lighting set ups for
 studio photography
 Single-light set-up

198 Two-light set-up

200 Three-light set-up

Many of the principles of portable flash photography can be carried over into the studio. But the studio also opens up a whole new gamut of opportunity. It is a photographer's playground, where every essence of a photograph can be constructed from scratch. Studio lights are to photographers what brushes are to a painter.

It is important to set the scene. Studio lighting should be considered as two separate components that resemble the relationship between the camera body and the lens. The camera body is simply a dark chamber that holds a light-sensitive material. It is the lens that controls perspective and artistry. With studio lighting, this same relationship is shared between the flash unit and the accessories that complement it. Many people get caught up in the speeds and feeds of technical parlance surrounding studio heads. But, in reality, all they do is emit light. What controls that light and manipulates it to create the desired effect has little to do with the flash. In studio photography, perspective and artistry are controlled by the attachments.

Thus, while not ignoring the technicalities of the lights themselves, this chapter concentrates more on how to get the lights to create the results you want.

9.1 *Self-contained studio monobloc.*

9.2 *Generator pack floor unit that operates several independent flash heads.*

9.3 *Continuous light source (in this case a fluorescent unit designed to work with digital cameras).*

LIGHTING SET-UPS

When setting up a studio, or when deciding what equipment to hire for a studio shoot, there are many things to consider. For instance, what type of lighting are you going to use?

Flash heads

While studio flash heads fulfil the same basic role as portable flash, they differ in many ways. Studio flash units tend to be much larger and, since they run off mains electricity, are far more powerful. They recharge more quickly and, importantly, they can be used with an amazing array of accessories that allow you to radically alter lighting effects. Another very useful feature is that they also come with a modeling light that allows you to see how they will light the subject before they are discharged, giving you far more creative control over your composition. Two main units are available. Self-contained units (monoblocs) that incorporate all the electronics in the flash head, and the generator pack configuration that operates from a separate floor-standing unit to which the flash heads are attached. The latter are generally intended for heavy duty, professional use.

Continuous light sources

We tend to think purely of flash units when discussing studio lighting, but continuous light sources, such as tungsten and fluorescent lighting, can play an equally important role. It would be easy to categorize continuous light sources as the poor man's relation to flash units, but to do so would be wrong. What is important to understand is that flash lighting and continuous source lighting have developed from very different backgrounds, and so direct comparison can often be unfair. You'll find a table of the pros and cons on the page, overleaf, to help guide you.

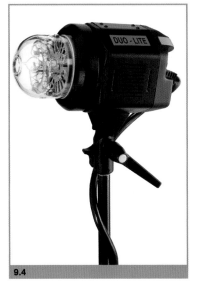

9.4

9.4 *Studio monoblocs come in many sizes, depending on your power needs.*

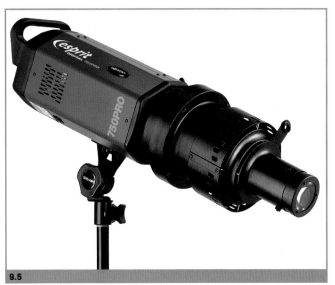

9.5

9.5 *With a self-contained monobloc, the electronics are built into the individual flash head.*

Tungsten lamps

You are probably most familiar with tungsten lighting because almost every household is lit by tungsten bulbs. If you have ever taken a photograph using daylight-balanced film under tungsten lighting, you will have noticed that the result is very orange—almost as if it had been shot outdoors during a particularly colorful sunset. This is because tungsten lighting has a color temperature very close to that of sunlight at sunset. Typically, there are two types of tungsten lighting: low-cost hot lights and professional tungsten lighting.

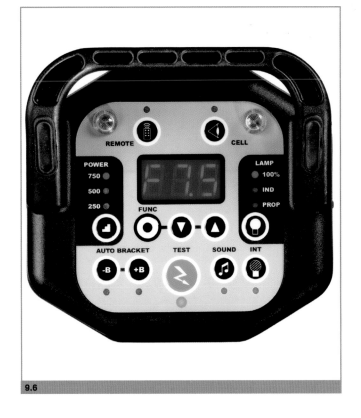

9.6 *Flash head control panel.*

9.6

Low-cost hot lights

So called because, quite simply, they *are* very hot, hot lights come in various strengths, including the 500W Photo-pearl (about ten times more powerful than a 100W household light bulb), to the lower wattage but more powerful 275W and 500W Photofloods, which are equivalent to around 8 and 16 domestic 100W light bulbs respectively.

Typically, they are used in conjunction with a reflector, the design of which can vary the quality of light from hard to soft. They can also be used with a diffuser, though you need to be careful when doing so. The heat generated by these lights can be quite intense and it is not unheard of for poorly selected or ill-placed diffusers to go up in flames.

Heat also causes another problem, particularly when photographing people or animals. While these lights may appear to be quite bright to the naked eye, they are less so to light-sensitive photographic material and so need to be used relatively close to the subject you're photographing. If left on for any length of time, your model will look rather hot, and may need a break. Similarly, certain still-life subjects may literally melt before your eyes.

Professional tungsten lighting

Professional tungsten lighting hails from the movie world and, until recently, individual lights tended to be designed for very specific purposes. While these types of tungsten light are still available today, you are far more likely to hire them than buy them and, considering their weight, size, and cost, you would probably only do so for a very special reason.

As manufacturers have become more aware of the commercial opportunities within the photographic market new, photo-specific designs have been released. This new generation of professional tungsten lighting is much smaller than its forebears and uses lamps in the 600W—1,000W range. Typically, however, these pro' lights tend still to be single-function lights (spot, flood, or "trough"), and are less versatile than other options.

Fluorescent lighting

Another form of continuous light is the fluorescent light, which works on the same principle as the fluorescent strip-lighting you see in many homes and offices. Like tungsten lighting, fluorescent lighting gives an intense color cast if used with daylight-balanced film, except that, whereas tungsten has an orange color cast, fluorescent lighting sheds an unpleasant green. While this can be overcome with color-correction filters, it is useful to note that different films react differently to the same fluorescent source, and so you may need to do some testing to obtain accurately balanced results.

The main attraction of fluorescent lighting is its softness, which can complement portraiture work. However, it can turn into a disadvantage if you need a hard light source. Unlike tungsten lighting, fluorescent lighting runs cool and suffers from no major heat problems.

CHOOSING THE RIGHT LIGHTING EQUIPMENT

With such a wide choice of lighting options, you may be uncertain which route to take when choosing what's best for your style of photography. Many people will make their decision based on the power of a particular system, thinking, "System A is 100W higher than System B, so I'll take System A." While this isn't wrong, it excludes an important factor in the decision-making process.

There is a tendency with photography for people to get caught up in the technology of the systems rather than to focus on what is the most important element. The question should really be, "What am I actually trying to achieve?". The problem with basing decisions purely on technology, without any reference to your end goal, is that you are allowing the equipment to dictate how you operate. A better decision would be to visualize in your mind the sort of pictures you want to make, and then choose the best equipment for the job.

Pros and cons	Advantages	Disadvantages
Studio flash	Versatile, with a wide range of lighting-effect accessories. Cool-running. Can be left on for long periods of time without overheating. Balanced to natural daylight. High-powered, giving more exposure options and greater depth-of-field.	Can be more expensive than some forms of continuous light source. Can seem complicated to use for the novice. Modeling light gives an idea of the lighting effect but actual flash exposure can vary the effects.
Low-cost hot lights	Relatively low entry cost. Simple to use, making them ideal for studio beginners. What you see is what you get (WYSIWYG).	Low-powered and need to be relatively close to the subject. Hot-running, inclined to overheat quickly. Need to be balanced with color-correction filters if used with daylight-balanced film.
Professional tungsten lights	Ideal for specialist applications. What you see is what you get (WYSIWYG).	Often need to work at maximum apertures and shallow depth of field. Single-function makes them inflexible. Expensive compared to low-cost hot lights and some flash set-ups.
Fluorescent lighting	Ease of use makes them an ideal tool for learning the ropes. Cool-running, which means they can be left on for longer without overheating. Newer models have largely overcome the shortcomings of older versions.	Need to be balanced with color-correction filters if used with daylight-balanced film. Cannot be mixed with flash lighting. Practically, can only be used as a soft light source. Flickering can cause poor effects in the final image.

Power

Power will be one of your major considerations. However, power costs money and a good choice could save you hundreds of dollars. When you buy power what you are really buying is flexibility. The more powerful the system the more options you will have setting lens aperture for exposure and the greater will be your control over depth of field. Bear in mind, too, that power is relative to the size of your studio. A light that would be lost in a studio the size of a warehouse may be more than adequate in a studio based at your home. There is no need to waste money on power you'll never need to use.

Ease of use

Another important part of your equation is how easy you find the equipment to use. It's all very well acquiring an all-singing, all-dancing system, but unless you can get it to do what you want, you'll never achieve the results you're after. This is particularly important if you are relatively new to working in a studio. Getting to grips with new techniques can be frustrating, and that can easily turn to disillusionment if you spend more time reading technical manuals than actually taking pictures. Not only that, if you're working with a model, he or she will quickly lose patience and that will show in your photographs.

Versatility

No doubt your subject matter and the effects you are trying to create will change from one day to the next. Therefore, any system you acquire should be able to match your varying needs, both in the immediate and the longer term, as your photography develops and the demands you make on your equipment increases. When examining a studio lighting system, give some thought to how you can expand it in the future and whether it is capable of delivering different qualities of light. Again, this is important if you are just starting out in studio photography; the needs of the novice are likely to alter more radically than those of an experienced pro who has already gone through the learning process. It is also an important financial point, as choosing the right system at the outset— one that will grow with your photography—will negate the need for expensive trade-ins later down the line.

Reliability

The reliability of the system you're working with is a key consideration. What I mean by this is not simply whether the system works when you plug it in and switch it on, but how frequently the lighting element in the unit will need to be changed. There is nothing worse than spending hours getting your shoot set up, and paying for a model, only to find that your bulbs keep blowing.

Back-up system

In my mind, the available back-up system (the accessories you employ in order to alter the lighting effects) is by far the most important element in any decision you make on choice of system. After all, a light is really just a light. How that light falls on the subject, however, and how it can be manipulated for artistic exploitation and creative advantage is entirely dependent on what you are able to put in front of the light.

CHOOSING ACCESSORIES

Studio lighting needs to be managed. It needs to be told where to go and how to fall, much like directing actors in a play. How adept you become at directing your light will go a long way in determining the success of your pictures. At your disposal are an array of accessories that will help you. Quality of light, size of source, contrast, spread, and direction are all within your direct influence.

Reflectors

Studio lighting reflectors, which are also referred to as dish reflectors (because they are shaped like dishes), attach to the front of the flash head and produce a hard, directional light. They come in a variety of sizes and shapes, each having a particular role to play.

Wide-angle/umbrella

The wide-angle/umbrella reflector, also known as a "spill-kill" reflector, creates a very broad, even light source. They are designed for use with umbrellas, where the design complements and enhances the performance of the umbrella. They can also be used to fill broad areas with light. Usually small in size (around 15cm/6in), they create harsh shadows and high-contrast lighting.

Power | Ease of use | Versatility | Reliability | Back-up system | Choosing accessories
Reflectors | Wide-angle/umbrella | General purpose | Key-light

185

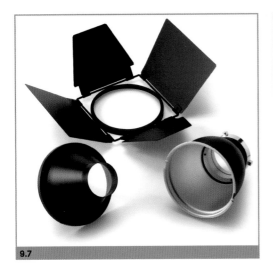

9.7

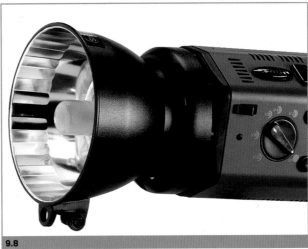

9.8

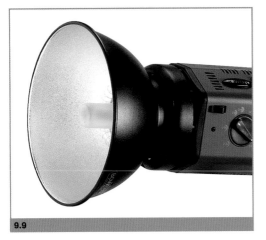

9.9

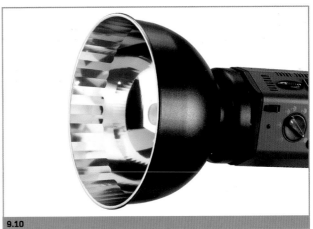

9.10

General-purpose

General-purpose reflectors have an even coverage and high light output. Depending on the size (usually around 21cm/8in), they produce medium- to high-contrast lighting.

Key-light

Key-light reflectors are designed to allow high f/stops. They have highly polished surfaces that can be one or two stops brighter than general-purpose reflectors. However, this brightness comes with a downside—the polished surface produces high specularity and contrast.

9.7 *Barn doors.*

9.8 *Wide-angle or umbrella reflector.*

9.9 *General-purpose reflector.*

9.10 *Key-light reflector.*

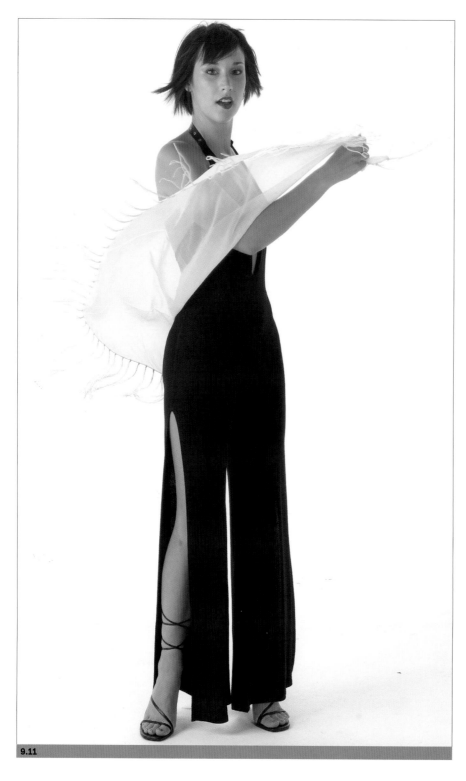

9.11 *When using two or more flash units, reflectors can be combined to produce the desired lighting effects. Here, high-performance and key reflectors were used together.*

9.12 *High-performance reflector.*

9.13 *Grid reflector.*

9.14 *Grid diffuser.*

9.15 *A grid diffuser was used here to produce a combination of soft and hard light that adds to the appeal of the picture.*

9.12

9.13

9.14

High-performance

High-performance reflectors are about power. They are designed to concentrate large quantities of light and to maximize light output. They are particularly good at bouncing light off ceilings and lighting large groups of people. Lighting quality tends to be softer than that produced by smaller reflectors.

Grid

Grid reflectors create a number of interesting lighting effects by creating very controlled pools of light, each giving a narrow coverage but without losing intensity. Again, depending on size, they can produce high-contrast lighting, but fall-off is relatively smooth.

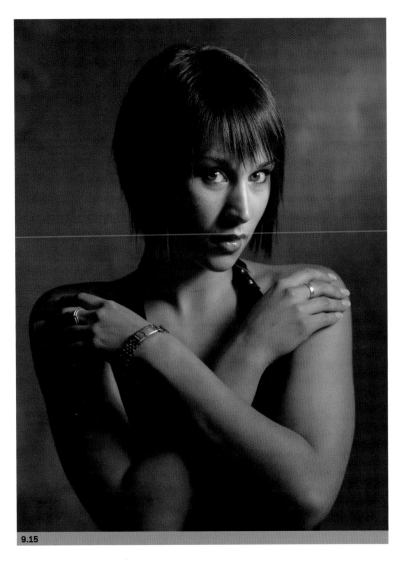

9.15

9.16

9.17

9.18

Soft–light

The large size of soft-light reflectors (typically around 40cm/16in) produces a very broad, even light source, soft in quality (as you might expect), which is ideal for fashion and glamor work, used close to the subject. However, removing the inner diffuser can increase brightness.

Sunlight

Sunlight reflectors are designed to replicate sunlight and are ideal for photographing subjects such as architectural models. They produce a broad beam of light and retain relatively high output levels. Without an internal diffuser (built into the soft light, described above), the light will be brighter and higher in contrast.

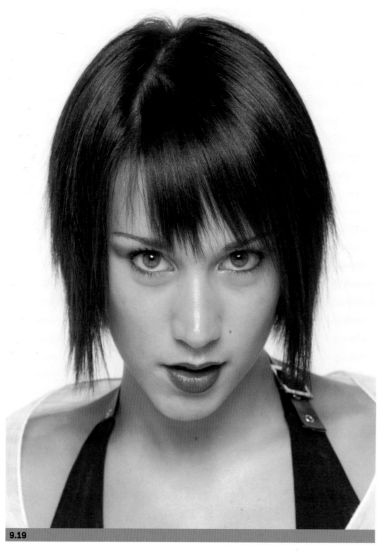

9.19

9.19 Adding soft light accessories to the flash unit helps to create a soft quality of light that reduces contrast and softens shadows.

9.16—9.18
*Soft-light reflector
(9.16), Sunlight reflector
(9.17), Super soft-light
reflector (9.18).*

9.20 & 9.21
*Ring flash (9.20), and
back-light (9.21).*

9.20

9.21

Ring light

Ring light is often more closely associated with close-up and macro photography, but large, powerful units can be equally employed for studio portraits. The effect is similar to having a large light source directly behind the camera. However, ring light is considerably more symmetrical. It is placed in front of the camera, with the lens poking through a centrally positioned hole in the flash unit.

The lighting effect from ring flash is highly distinctive, and when exposing for a subject lit with ring flash, you may want to overexpose by one or two f/stops so that the resulting image doesn't appear flat.

Back–light

Back-light reflectors produce a natural oval vignette of light, ideally suited to illuminating backgrounds for portraiture.

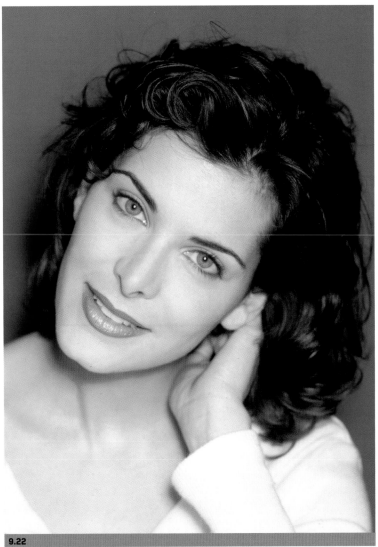

9.22 *Ring lighting is often
used by studio portrait
photographers to produce
an appropriate style of
lighting for this genre.*

9.22

9.23

9.24

9.25

9.26

Snoots

Commonly used in a secondary role to complement the main light, snoots produce a narrow beam of light that can be used to highlight key features of your subject. For example, they can highlight a model's hair, or pick out a brand name on a product or product packaging. The downside to snoots is that, while they produce a very defined, hard-edged pool of light, they also create a secondary ring of softer light around the primary light. They also reduce the brightness of the light quite considerably, sometimes by up to two stops. However, this can be turned to your advantage if you're working with flash units that have a limited power output range. With low-range output it is sometimes impossible to reduce the level of light low enough to create very subtle highlights. Adding a snoot may solve the problem because of this large loss in light.

Honeycombs

A Honeycomb is a metal, lattice-like grid that fits onto the front of the flash head and blocks all illumination on an axis other than straight forward. Honeycombs can be acquired with different cell sizes, and the smaller and deeper the cell, the greater the degree of blockage. The real advantage of a honeycomb is to minimize illumination falling in areas you don't want it to, and they are perhaps even better suited to highlighting very specific areas of a subject than snoots.

Barn doors

Most lighting accessories are designed to limit light spill in areas you don't want illuminated. The simplest accessories for achieving this are barn doors. Barn doors are made up of two, or more usually four, metal flaps hinged to a framework that fits over the light unit. By moving each flap, you can concentrate the light into the areas you want illuminated and block light from those areas you want to be in shadow. When using all four flaps together, you can "funnel" the light into specific areas, much as you would with a snoot.

Fresnel lenses

Fresnel lenses create that classic Hollywood style of lighting. They can achieve very tight control of the direction and size of the light beam, and are ideal for commercial product photography, as well as classic portraiture. Fresnel lenses are also one of the most efficient concentrators of light and can be used to gain high f/stops when needed.

9.23 *Snoot.*

9.24 *Honeycombs, for use with grid reflectors.*

9.25 *Barn doors.*

9.26 *Fresnel.*

9.27 *Spotlights are directional, and emit a narrow beam of light that can be used to highlight specific parts of a scene or subject.*

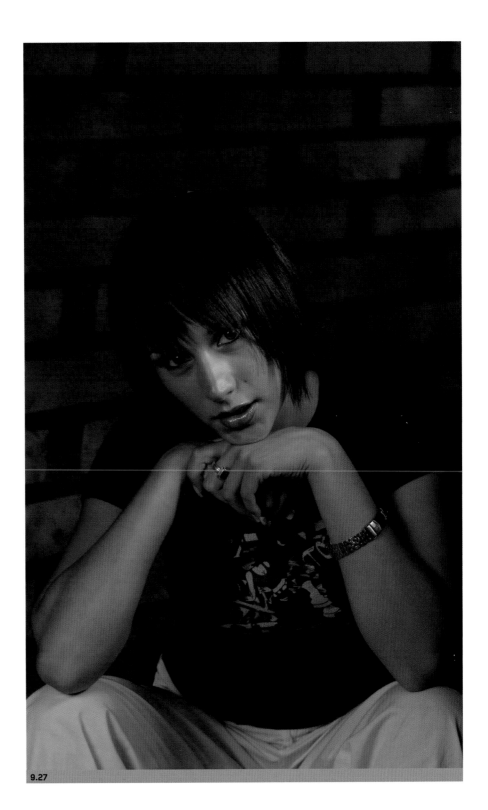

9.27

Umbrellas

Umbrellas, or "brollies", are arguably the photographer's most well-used accessory, and one of the first items you should acquire after the flash head itself. Like reflectors, they come in various sizes and with different surfaces. In addition, different colors are available, including white, silver, and gold.

An umbrella acts as either a reflector or a diffuser, depending on which way the flash head is pointing. With most types of umbrella, the flash head is turned away from the subject, and light is bounced back onto it (in other words, "reflecting" the light). Other umbrellas are made from translucent material, and are designed for the flash to fire through them, to act as diffusers.

The surface color will affect the quality of the light falling on your subject. White, the most popular color, produces soft, non-directional lighting. Metallic—silver and gold—umbrellas, produce a much harder, directional light, which increases contrast. Additionally, a gold surface will give a warm color cast to your subject.

The main advantages of umbrellas are their low cost, combined with high versatility, which makes them ideal for anyone starting out in studio photography. It is possible to get dual-sided versions that are white on one side and either silver or gold on the other. And, since they can be folded down, they save space and are highly portable.

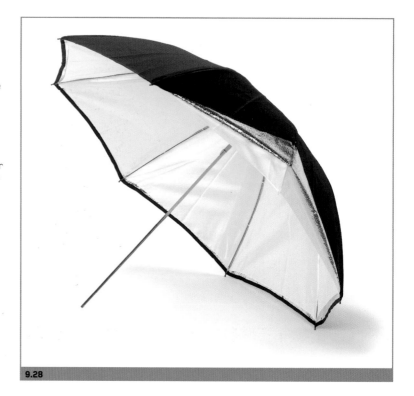

9.28

9.28 *Large, multicolored studio umbrella.*

9.29 *Small studio umbrella and square soft box..*

9.30 *Small, square soft box.*

9.31 *Large, square soft box.*

9.32 *Hexagonal soft box.*

9.33 *Large, round soft box.*

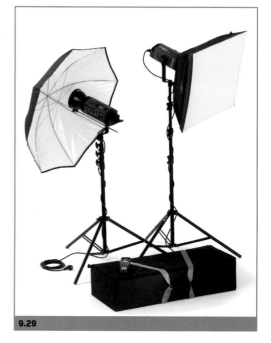

9.29

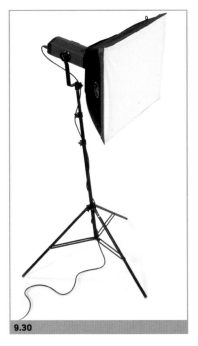

9.30

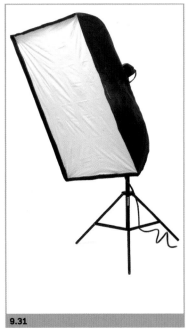

9.31

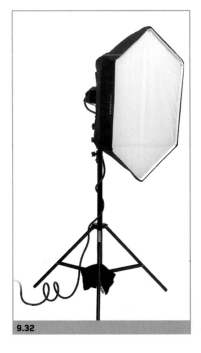

9.32

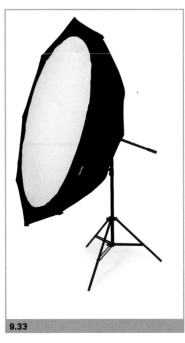

9.33

Soft boxes

Soft boxes are designed to produce an even spread of soft, diffused light. The effect is similar to that of indirect sunlight entering through a window. Like reflectors and umbrellas, they come in different sizes, from relatively small to very large. Generally speaking, the larger the box, the softer the lighting.

But this will depend on where the soft box is placed in relation to the subject. For example, if you move a small soft box close to the subject then it can produce lighting equal in quality to a larger soft box placed further away.

Better-quality soft boxes are made with an internal translucent diffuser that sits between the light source and the external material to produce even distribution of light across the whole surface, which is critical for the larger sizes.

The quality of light produced by a soft box makes it ideal for fashion, glamor, and portrait photography, as well as still-life work.

BASIC PRINCIPLES OF STUDIO PORTRAIT PHOTOGRAPHY

Lighting ratios

The level of highlight and shadow in a scene determines the lighting ratio. Strong highlight and shadow areas represent a high ratio and indicate a high level of contrast. A more even spread of tones represents a low ratio and indicates a scene with less contrast. A ratio of 3:1 (i.e. the highlights are three times brighter than the shadows), will always give good lighting. However, depending on the effect you are trying to create, you may want to increase or reduce the ratio.

To measure the lighting ratio, first take a meter reading from the secondary light source, making sure that no light spills onto the meter's cone from the main light. Then measure the light emitting from the key light. Finally, measure the light where the sources combine—usually face-on to the camera. The difference in stops between the illumination from the secondary light, and the key and secondary lights combined is your lighting ratio.

For example, let's say that the f/stop rating from the secondary light is f/5.6, and from the combined light sources the f/stop rating is f/16—a three-stop difference. In this example your lighting ratio would be 3:1.

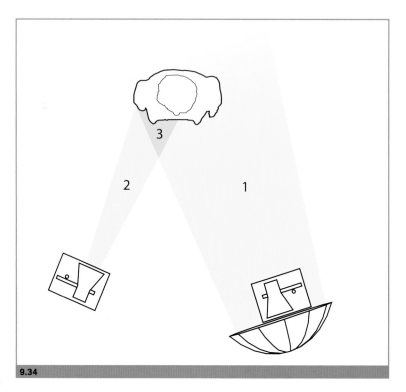

9.34

Spatial relationships

The primary consideration in studio portrait photography regarding spatial relationships is between the subject and the background. The question is whether you want the background to appear sharp and so be included as part of the scene, or whether the background should appear unfocused, and thus be excluded from the main picture.

Whether the background is included or excluded is determined by depth of field, which in turn is determined by your lens aperture, focal length, and camera-to-subject distance. The key to good portrait photography is mastering the art of depth of field in order to provide just the right amount. Too much front-to-back sharpness can reduce the impact of your picture by giving equal weight to objects of secondary importance.

Angle of lighting

We are used to seeing subjects lit, naturally, from above (as though by the sun), even when using artificial light. As soon as the lighting drops below the eye line, the effects can be quite disturbing—especially for your subject!

Lighting-to-subject distance

A common mistake that photographers make is to place the light too far away from the subject. The closer the subject, the softer the lighting becomes, and the greater your flexibility over exposure settings.

065660

Basic principles of studio portrait photography | Lighting ratios | Spatial relationships
Angle of lighting | Lighting-to-subject distance

195

9.34 *To measure the lighting ratio, take readings from the secondary light source, then light emitting from the key light, and, finally, from the point where the sources combine.*

9.35 *Normally, subjects are lit from angles to keep the lighting effects natural, but sometimes you can play with the angle of lighting to create a more dramatic effect.*

9.36 *Try to avoid dropping the angle of light below the eye line, unless you want to achieve this kind of effect.*

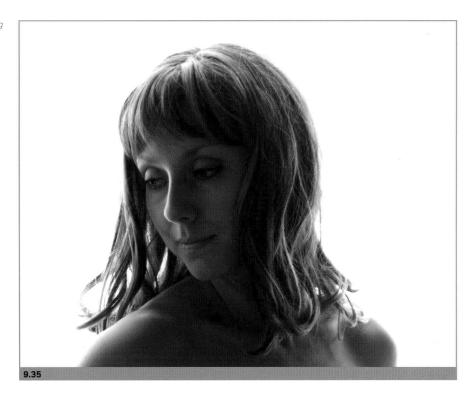

9.35

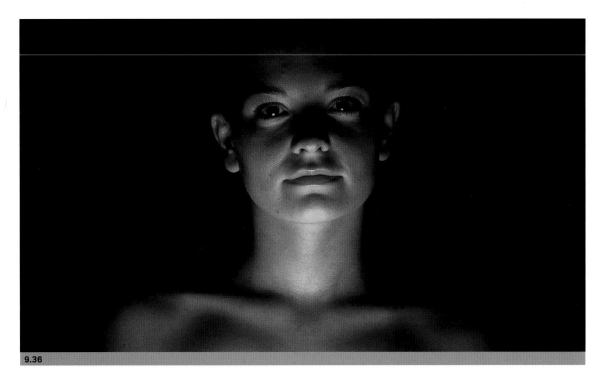

9.36

LIGHTING SET UPS FOR STUDIO PHOTOGRAPHY

Single-light set-up

What can you achieve with a single light? All photographs have a main, or key, light source that provides the energy in your picture. This light gives direction, character, and strength, and all other lights are in dialog with it. Mastering the key light is essential to creating compelling images, and the advantage of starting with a single light set up is that it will help you to focus on this point.

9.37—9.38 *A single-light set up can create very strong, well-defined portraits, and is a good place to start when experimenting with lighting. The lighting setup (9.37) makes use of a ring light placed around the camera lens (see page 189).*

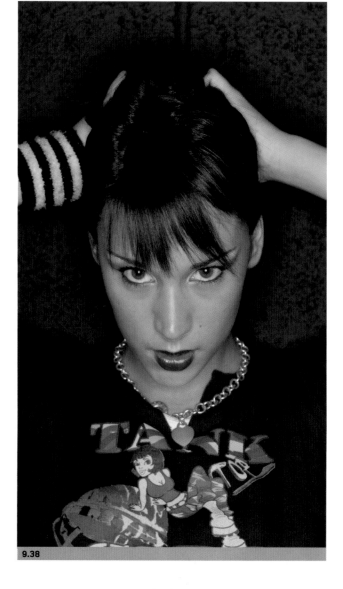

9.38

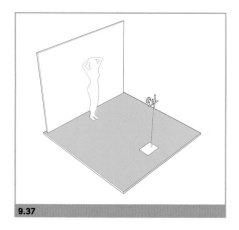

9.37

9.39

9.39—9.42 *With the single-light set up, you can introduce reflectors and diffusers to throw additional light on to the subject.*

9.40

9.41

9.42

Two-light set up

By adding a second light into the
equation, you can increase your
creative potential and add some
flexibility into the process. The first
light, however, remains the main (key)
light, and this second light will be used
to complement its effects.

9.43

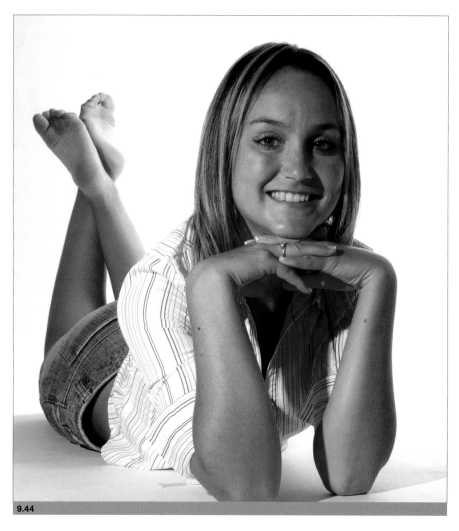

9.44

9.43 & 9.44 *Using a
second light enhances
your potential to shoot
more creative set ups.*

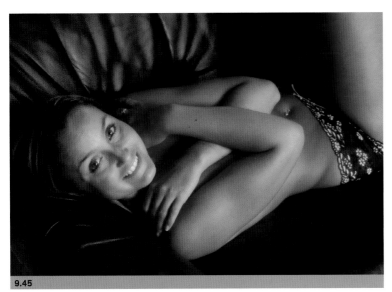

9.45

9.45—9.48 *A second light
in the set up, combined
with either a reflector or
diffuser can create a
softer ambience.*

9.46

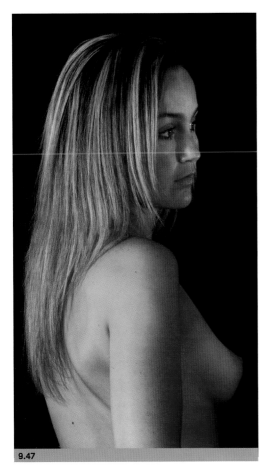

9.47

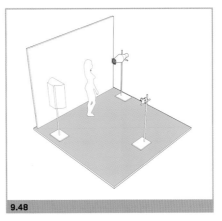

9.48

Three-light set up

With the addition of a third light,
you can consider more advanced
techniques and complex lighting
relationships. Notice, however,
that the first light that was used
is still the main light, and that the
two additional lights are working in
harmony with it.

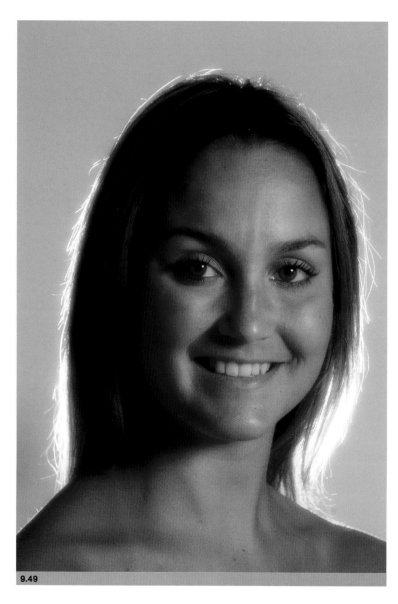

9.49

9.49 & 9.50 *In addition to
the main, or key, light, a third
diffused light from behind
backlights the model's hair
for added effect.*

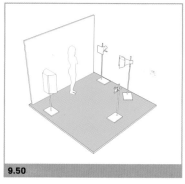

9.50

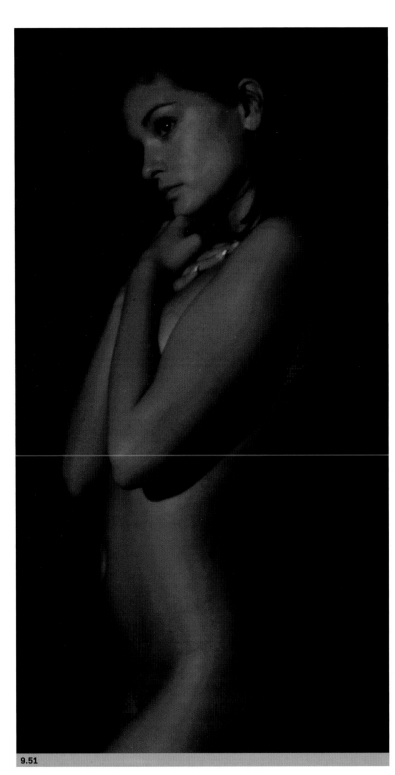

9.51

9.51 & 9.52 *The additional lights, combined with a colored film on the light, sheds a dramatic glow over the subject.*

9.52

APPENDIX

202 Index
208 Acknowledgments

absorption 15, 174–75
accessories 184–93
accessory-shoe flash 156
action shots 160
Adams, Ansel 24
additive color 12
afternoon 12, 75, 78, 92–93, 95, 98–99
altitude 59
amplification 126, 133
angle of incidence 167
angle of light 71, 81–82, 175, 194
angle of reflectance 167
angle of sun 73, 76–77, 79, 92–93, 97–100, 105, 141
aperture 19, 28, 32, 40–42
 artificial light 160, 163, 171–75
 daylight studios 143
 equipment 56
 low-light/night 116, 118, 120, 122, 128, 130–31
 metering/exposure 45
 studios 183–84, 194
architectural models 188
artificial backgrounds 139
artificial light 126, 136–38, 140, 143, 146, 151–77, 194
assistants 67
atmosphere 16, 19, 23, 28, 59, 75–76, 80, 89–90
auto WB (white balance) 13
auto-exposure 39–40, 57, 116
auto-fill flash 175
auto-focus 116, 122–23, 133
auto-TTL (through the lens) flash 136
automation 160, 163, 167, 172, 174–75

back-up systems 184
backlight reflectors 189
backlighting 27–28, 90–91, 108, 148
banding 44
bar coding 127
barn doors 69, 190
barns 148
beanbags 52–53, 120
bit depth 45
black 36, 39–40, 111, 136, 139
black reflectors 64–65
black-and-white shots 60
blur 42, 56, 121, 128, 143, 176
bounced flash 156, 158, 160, 166–67, 174
bracketing exposure 25, 44, 131, 151
breathing 53, 120
brightness 24, 32, 60, 118, 175, 188, 190
broken cloud 85–86, 98–99

brollies 192
buildings 77, 83, 148
built-in camera flash 154, 156
bulb setting 116
burning 128

cable release 51, 67, 116
calendars 106
calibration 36, 74, 116, 172
camera shake 42, 48, 53, 116, 120–21
camera-to-subject distance 123, 172, 194
Canon 34, 163
capacitors 132
ceilings 144, 167, 174, 187
center of gravity 48
changing light 100–103
chlorophyll 12
circular polarizing filters 57
cityscapes 80, 98–99, 115, 128
clamps 52, 67
clichés 151
clipping 128
close-ups 134–41, 157, 189
cloud 20, 23, 44, 57
 close-up/macro 141
 daylight studios 145
 equipment 60, 69
 natural light 73, 81, 85–86, 88, 90, 98–99, 108, 110–11, 113
coast 59, 98
cold colors 148
color balance 28
color cast 13, 55–56, 59, 73–77, 148, 182, 192
color correction filters 73–74, 182–83
color of light 12, 73, 148
color of reflectors 64
color temperature 12–13, 73–75, 77–79, 81, 90, 103, 181
combination meters 124
common errors 28
composition 28, 42, 78, 80
 artificial light 163, 168
 close-ups/macro 140–41
 daylight studios 144, 151
 low-light/night 115, 118, 122, 126
 natural light 85, 88–89, 93, 95, 97–98, 113
 studios 180
continuous light sources 141, 180, 182–83
continuous shooting 163
contrast 20, 24–25, 27–28, 34
 artificial light 158, 168, 175
 daylight studios 143, 146, 148, 151

equipment 57, 60, 65, 69
 low-light/night 122, 128
 metering/exposure 41, 44
 natural light 76, 79, 82–83, 85–87, 98–99, 103, 106, 108, 110–11, 113
 studios 184, 188, 194
contrast-detection 122
correction filters 57, 60, 73–74, 182–83
coverage of flash 160, 163
cramped conditions 52
CWM (center-weighted metering) 34

dark-current noise 133
darkrooms 144
dawn 13, 73, 80, 115
daylight 12–13, 15, 55–57, 74–77
 close-ups/macro 136
 low-light/night 80, 115, 118
 studios 141–51, 168, 175, 181–83
dealers 123
dedicated flash 163, 172
demonic eye 164
depth 26–27, 42, 64, 73
 artificial light 171
 close-ups/macro 135
 daylight 143, 149
 low-light/night 122
 natural light 77–78, 103, 106, 113
 studios 183–84, 194
detail 24–27, 76, 95, 105
 artificial light 168, 176
 close-ups/macro 135, 138
 daylight studios 151
 natural light 110–11
diffusers/diffusion 20, 23, 28
 artificial light 160, 163–64, 166, 174–75
 close-ups/macro 140–41
 daylight studio 146, 148–49
 equipment 65, 69
 metering/exposure 33
 natural light 85–86, 90
 studios 182, 188, 192–93
digital exposure 44
digital filters 60
digital sensors 126, 132
direct-attached reflector cards 160
direction of light 26–28, 105–8, 141, 145, 148
dish reflectors 184
doors 145, 148
double shadows 138
dusk 13, 73, 80, 115
dust 74, 79, 90, 93, 99
dynamic range 25, 28, 60, 126

ease of use 184
Ektachrome 130
electronic cable releases 51
emotional response 72
emulsion 130
equipment 46–69, 116–18, 120, 133,
 149, 182–93
evening 73
experiments 127, 136, 151, 168
exposing to the right 44
exposure 126–33, 151, 156, 163
 artificial light 158–60, 168–75
 compensation 37, 40–41, 130–31,
 172, 174–75
 metering 30–45, 124
 settings 42–45
 studios 183–84, 194
 value 32, 36–37, 44, 85, 124, 127
eyes 77, 133, 135, 140
 artificial light 168, 175
 demonic eye 164
 green-eye 154, 164
 red-eye 151, 154, 164, 166

faces 77
fall (autumn) 95, 98
fall-off 130, 135, 138–39, 187
fashion shots 157, 188, 193
fill light 24, 63, 124, 138, 149
fill-in flash 28, 145, 151, 154, 159,
 168, 175
film sensitivity 126–27, 130
film speed 116, 126
filters 25, 28, 54–60, 76–77
 close-ups/macro 138
 natural light 88, 91–92, 95, 97–99
 studios 182–83
fixed-head flash 160
flare 27–28, 62, 83
flash 23, 45, 151, 153–76
 close-ups/macro 136
 daylight studios 145, 148
 equipment 57
 exposure values 32
 heads 180
 low-light/night 124
 meters 32, 45
 studios 179
flash-to-reflector distance 167, 174
flash-to-subject distance 137–38, 158,
 167, 171–75
flat images 151, 164, 189
flat light 77, 93, 106, 108, 154, 175
flexibility 163
flickering 183
floodlights 182

floors 144
fluorescent light 13, 15, 57, 141, 180,
 182–83
focal length 120, 163, 194
focal-plane shutters 171
focus 116, 122–23
focus screens 123
fog 90–91
fold-up reflectors 66
foliage 57, 95, 97
foreboding 108
forensics 156
freezing motion 42, 98–99, 128, 176
fresnel lenses 163, 190
front-to-back sharpness 194
frontal lighting 27–28, 148
frost 55
Fuji 41, 74, 130, 172
funneling light 190

gels 148
general-purpose reflectors 184
glamor shots 148, 188, 193
GN (guide number) 160, 172–74
goals 182
golden hours 55
Gossen Sixtomat Digital meters 124
graduated neutral density filters
 25, 56, 88
grain 41, 126, 133
gray 36–37, 39–40, 44–45, 57, 60, 76, 86
green-eye 154, 164
grid reflectors 187
grids 190
group shots 187

halos 26–27, 82–83
hammerhead flash 156
hand-held techniques 34, 67, 120, 124,
 127, 133, 164
handling reflectors 67
hard light 20, 23, 146, 148
 artificial 164, 168, 175
 studios 182, 184, 190, 192
haze 59, 90–91, 93, 99, 141
haze filters 59
HDR (high dynamic range) imaging 25
heat from lighting 182–83
high-contrast scenes 128
high-performance reflectors 187
highlights 24–25, 28, 33, 41
 artificial light 175
 close-ups/macro 141
 low-light/night 128
 natural light 110
 studios 190, 194

hiring equipment 182
hiring studios 148
histogram 45, 127
Hollywood style 190
honeycomb grids 69, 190
horizon 92, 100
hot spots 140–41
hot-shoe flash 156, 172

image quality 41, 44, 126, 128, 133, 167
Image/Adjustment menu 60
improvisation 53, 67
incandescent light 13, 57
incident light 32
incident light meters 32–33, 45,
 124, 127
infrared distance-detection 122
intensity of light 19–20, 27–28
 metering/exposure 34
 natural light 81, 85–86, 88–89,
 93, 111
 studios 187
invercones 124, 127
inverse square law 19–20, 138, 175
ISO equivalency 32, 41, 116
 artificial light 160, 163, 172–73
 low-light/night 121, 126–28, 133

K (Kelvin) scale 12–13
key lights 194, 196, 198
key-light reflectors 184
Kodachrome 130
Kodak 130

landscapes 24, 33–34, 54–60
 low-light/night 115, 128
 natural light 74–76, 85–86, 88,
 93, 95, 100
large-format cameras 171
law of reciprocity failure 80, 126,
 130–31, 133
law of reflectance 16
LCD monitors 127
leaf shutters 171
lenses 118, 120, 123, 138
 artificial light 163, 171–75
 flare/hoods 27–28, 62, 83
 studios 179, 184, 189–90, 194
light boxes 81
light charts 127–28
light meters 32–37, 45, 76
 artificial light 156, 172
 daylight studios 151
 low-light/night 124, 127, 133
 natural light 85, 88–89, 111
 studios 194

lighting ratios 194
lighting-to-subject distance 194
linear polarizing filters 57
long exposures 130, 132–33
low light exposures 127
low lighting 41, 48, 52, 114–33
low-cost hot lights 181–83

macro 134–41, 157, 160, 189
macroflash 138
making reflectors 67
manual flash exposure 172–73
manual override 127
manufacturers 123, 156, 160, 172, 182
measurement of light 32
medium tone 36
medium-format cameras 171
metallic reflectors 67
metering 32–37, 45, 76, 85
 artificial light 156, 172
 daylight studios 151
 low-light/night 124, 127, 133
 natural light 88–89, 111
 studios 194
mid-range cameras 116
mid-tones 33, 36–37, 40, 76, 124,
 127–28, 172, 174
midday 12–13, 24, 37, 73, 77, 98–99,
 106, 111
mirror lock-up facility 116
mirrors 16
mist 90–91, 98
modeling lights 180
models 144–45, 148, 151, 175, 182,
 184, 190
monoblocs 180
monopods 52, 120
mood of light 71, 73, 81, 100, 103, 108
morning 12, 37, 73–76, 78
 close-ups/macro 141
 natural light 90–91, 93, 95,
 98–99, 105
motion blur 42, 128, 143, 176
motor sports 163
movies 182
moving in 138
MSM (multi-segment metering) 34
multiple wireless flash 156
multiple-surface 15, 18

natural light see daylight
nature 92
ND (neutral density filters) 25, 28,
 56–57, 88, 138
night shots 48, 52, 114–33
Nikon 127, 163

noise 41, 44, 126, 132–33
noon see midday
novices 184

off-camera flash 164
on-camera flash 164
optical filters 25, 57
overcast days 39, 55, 65, 86–87,
 98–99, 110, 136
overexposure 36–37, 127–28, 136,
 172, 189
overhead lighting 27–28, 83, 106
overtones 136

packaging shots 190
panel reflectors 63–64, 175
partial metering 34
patio doors 145
PC leads 156–57
Photofloods 182
Photomatix 25
photons 15, 133
Photopearl 182
Photoshop 25, 60
picture editors 120
pitfalls 139
pixels 41, 44–45, 132
playback 127
point of focus 42
polarizing filters 57, 92, 95, 97–99
portability 66
portable flash 154–60, 164,
 168–75, 180
portraits 27–28, 77, 83, 85–86
 artificial light 171
 daylight studios 143
 natural light 98
 studios 182, 189–90, 193–94
posing 144–45
position of flash 138
position of reflectors 64
post-processing 88
postcards 85, 93, 98, 106
power 160, 184, 190
PR shots 156
prediction 72
presets 56–57
press shots 156, 163
print size 126
privacy 148
problems 139–41
product shots 190
professional studios 148
professional tungsten light 181–83
props 144
Provia 130

quality of light 141, 146, 184,
 187–88, 193

rainbows 17, 88–89
range of flash 172–73, 190
rangefinder cameras 118
RAW files 45, 127
rear-curtain sync 176
reciprocity failure 80, 126, 128,
 130–31, 133
recycling times 156, 160, 163
red-eye 151, 154, 164, 166
reflectance 15–16, 18, 36, 167
reflected light 15, 32
reflected light meters 32–33, 124
reflectivity 27, 57, 99, 140
reflector cards 160, 164
reflector-to-subject distance 167, 174
reflectors 28, 63–67, 73, 75
 artificial light 158, 175
 close-ups/macro 141
 daylight studios 149, 151
 natural light 98
 studios 182, 184, 187–89, 192–93
refraction 15, 17
reliability 184
remote shutter release 67, 133
reportage 160
reproduction ratio 138
review functions 127
rim-lighting 82, 108
ring flash 157
ring lights 189
rooms 144
rotating flash 158
rotating heads 167

salespeople 160
saturation 74, 95, 97, 99
scattering 15–16, 174
scene contrast 25
seasons 8, 71, 92–99
secondary lighting 138, 194
selective tools 60
self-timers 116
semi-automatic AE 40
80 series filters 56–57
81 series filters 55–57, 91
82 series filters 56–57
shadow-free images 26
shadows 20, 23–28, 33, 41
 artificial light 158, 167–68, 175
 close-ups/macro 135–36, 138, 141
 daylight studio 143, 149, 151
 equipment 63–65, 69
 low-light/night 128

metering/exposure 44
 natural light 73–80, 82, 86–87,
 92–93, 97–100, 105–6, 110
 studios 184, 190, 194
shape 73–74, 79, 97, 113
sharpness 42, 138, 171, 194
shooting data 127
shut-off 23
shutter role 171
shutter speed 19, 28, 32
 artificial light 160, 171, 175–76
 daylight studios 143, 149
 equipment 48, 56
 low-light/night 116, 118, 120–21,
 127–28, 130–31, 133
 metering/exposure 41–42
 natural light 98–100
side-lighting 27–28, 75, 105, 108, 145,
 148, 168
silhouettes 26, 82–83, 98–99, 108
silver halide 41, 126
single flash 136
single-function lights 182–83
single-light set-up 196
size of lighting 20, 145–46, 149, 184
size of reflectors 66
skies 13, 16, 36–37, 44
 equipment 56–57, 60
 low-light/night 115
 natural light 73, 76, 80, 82–83,
 85–87, 89, 93, 99–100, 110–113
skylight filters 59
skylights 145, 148
slave flash 159
slow-sync flash 176
SLR (single lens reflex) cameras 33,
 116, 118, 154
SM (spot metering) 34
smog 99
snoots 190
snow 55, 99, 105, 110, 176
snowmen 36
SNR (signal-to-noise ratio) 126, 132
soft boxes 20, 23, 65, 160, 193
soft light 20, 23, 65
 artificial light 158, 160, 175
 daylight studios 146, 148
 reflectors 188
 studios 182–83, 188, 190, 193–94
software 25, 44, 60
solid neutral density filters 56
spatial relationships 194
spectrum 12, 37
specularity 184
spill-kill reflectors 184
sports 52, 128

spot meters 124, 151
spotlights 81, 182
spring 92, 95, 98–99
still life 99, 182, 193
stops 24, 36, 39–42, 44
 artificial light 172, 174–76
 close-ups/macro 136, 138
 daylight studios 151
 equipment 56
 low-light/night 118, 126–27
 studios 184, 189–90, 194
storms 57, 81, 88
stray light 65
strip-lights 182
studio set-ups 8, 32, 45, 142–51
 artificial light 160, 175
 close-ups/macro 136
 equipment 47, 65–67, 69
 natural light 71–72
subject-to-background separation
 136
subtractive color 12
summer 55, 60, 93, 98–99
sunlight 23, 82, 110, 151, 168
sunlight reflectors 188
sunny f/16 rule 41
sunny f/22 rule 41
sunrise/sunset 12–13, 55–56
 natural light 73–75, 77–79, 90–93,
 95, 97–99, 101, 103
 studios 181
supports 48–53, 120–21, 137
surfaces 26–28, 44, 64, 73, 140,
 167, 184
synchro-sun 168
synchronization speed 171, 175–76

telephoto lenses 163
temperature of light 28
tests 39–40, 45, 131, 136–37, 168,
 174–75, 182
texture 27, 73–74, 76
 close-ups/macro 138, 141
 daylight studios 145
 natural light 78, 92, 95, 97, 99, 105
three-dimensionality 6–7, 27, 79,
 99–100, 105–6, 164, 175
three-light set-up 200
Tiffen Dfx Digital Filter Suite 60
tilting heads 158, 167
time of day 12–13, 72–82, 98–99
tints 55
tonality 34, 36, 40, 44–45, 168
top lighting 106, 108
trade-ins 184
transparency 15

tripods 6, 48, 51–52, 120
 artificial light 174
 close-ups/macro 137
 daylight studios 149
 low-light/night 131, 133
trough lights 182
TTL (through the lens) meters
 artificial light 156, 167–68, 174–75
 close-ups/macro 136
 daylight studios 151
 equipment 57
 exposure 33, 36
 low-light/night 124
tungsten light 13, 15, 56–57, 141,
 180–83
twilight 55
twin flash 138, 140
two-dimensionality 7, 105
two-light set-up 198

umbrellas 69, 136, 184, 192–93
underexposure 36–37, 44, 127–28,
 131, 151, 172, 176
UV (ultraviolet) filters 59

Velcro 160
Velvia 41, 74, 130, 172
versatility 184
viewfinder 33, 116, 118, 122–23, 144
vignetting 62, 163, 189

walls 167, 174
warm colors 74, 79–80, 148, 192
warm filters 55–56, 75, 79, 91
wavelengths 12
WB (White Balance) 12–13, 15, 28,
 56–57, 73–77
weather 67, 71–72, 81–92, 98–99,
 110–13
websites 123
wedding shots 156
Weston, Edward 98
white 36, 39, 44, 86, 111, 136
wide-angle lenses 163
wide-angle/umbrella reflectors 184
wildlife 52, 76, 98, 115, 163
windows 144–46, 148
windy conditions 67
winter 92, 97–99, 176
wireless technology 156
wow factor 7, 88, 168

zone of acceptable sharpness 42
zoom heads 163

Like many things in life, this book is the culmination of the efforts of team of people without whom this book would not have been possible. In particular I would like to thank the following people for their wisdom, kindness, and generosity over the past few months: the entire team at Rotovision who commissioned me to write the book, and have been with me all the way; Steve Aves and Guy Shirm for their ideas and explanations; Bowens International for the use of their studio, equipment, and images; Jane Nicholson at Intro2020 for her continued support of my work; Ian Webster at Lastolite for the use of images; Paul Harcourt-Davies, whose big knowledge of things little has helped me enormously; and finally to my "home team"—Claire and Josh—who give me the inspiration to carry on.

The publishers would like to thank the following for giving permission to reproduce their photographs in this book: Paul Harcourt-Davies and John Brackenbury for their macro photographs, Tony Blake, Jennifer Dunlop, and Gary, Lauren, and Beth French. Additional thanks are extended to Julia Faiers and Servane Heudiard for their editorial help with this book.